故宮

博物院藏文物珍品全集

故宮博物院藏文物珍品全集

明清家具（下）

主編：朱家溍

商務印書館

明清家具（下）
Furniture of the Ming and Qing Dynasties (II)

故宮博物院藏文物珍品全集
The Complete Collection of Treasures
of the Palace Museum

主　　編	朱家溍
副 主 編	胡德生
編　　委	宋永吉　芮　謙　周京南
攝　　影	馮　輝　趙　山

出 版 人	陳萬雄
編輯顧問	吳　空
責任編輯	田　村　徐昕宇
設　　計	張婉儀
出　　版	商務印書館（香港）有限公司 香港筲箕灣耀興道 3 號東滙廣場 8 樓 http: // www.commercialpress.com.hk
製　　版	中華商務彩色印刷有限公司 深圳市龍崗區平湖鎮春湖工業區中華商務印刷大廈
印　　刷	深圳中華商務聯合印刷有限公司 深圳市龍崗區平湖鎮春湖工業區中華商務印刷大廈
版　　次	2002 年 12 月第 1 版第 1 次印刷 © 2002 商務印書館（香港）有限公司 ISBN 962 07 5357 7

總序

楊新

故宮博物院是在明、清兩代皇宮的基礎上建立起來的國家博物館,位於北京市中心,佔地72萬平方米,收藏文物近百萬件。

公元1406年,明代永樂皇帝朱棣下詔將北平升為北京,翌年即在元代舊宮的基址上,開始大規模營造新的宮殿。公元1420年宮殿落成,稱紫禁城,正式遷都北京。公元1644年,清王朝取代明帝國統治,仍建都北京,居住在紫禁城內。按古老的禮制,紫禁城內分前朝、後寢兩大部分。前朝包括太和、中和、保和三大殿,輔以文華、武英兩殿。後寢包括乾清、交泰、坤寧三宮及東、西六宮等,總稱內廷。明、清兩代,從永樂皇帝朱棣至末代皇帝溥儀,共有24位皇帝及其后妃都居住在這裏。1911年孫中山領導的"辛亥革命",推翻了清王朝統治,結束了兩千餘年的封建帝制。1914年,北洋政府將瀋陽故宮和承德避暑山莊的部分文物移來,在紫禁城內前朝部分成立古物陳列所。1924年,溥儀被逐出內廷,紫禁城後半部分於1925年建成故宮博物院。

歷代以來,皇帝們都自稱為"天子"。"普天之下,莫非王土;率土之濱,莫非王臣"(《詩經·小雅·北山》),他們把全國的土地和人民視作自己的財產。因此在宮廷內,不但匯集了從全國各地進貢來的各種歷史文化藝術精品和奇珍異寶,而且也集中了全國最優秀的藝術家和匠師,創造新的文化藝術品。中間雖屢經改朝換代,宮廷中的收藏損失無法估計,但是,由於中國的國土遼闊,歷史悠久,人民富於創造,文物散而復聚。清代繼承明代宮廷遺產,到乾隆時期,宮廷中收藏之富,超過了以往任何時代。到清代末年,英法聯軍、八國聯軍兩度侵入北京,橫燒劫掠,文物損失散佚殆不少。溥儀居內廷時,以賞賜、送禮等名義將文物盜出宮外,手下人亦效其尤,至1923年中正殿大火,清宮文物再次遭到嚴重損失。儘管如此,清宮的收藏仍然可觀。在故宮博物院籌備建立時,由"辦理清室善後委員會"對其所藏進行了清點,事竣後整理刊印出《故宮物品點查報告》共六編28

冊，計有文物117萬餘件（套）。1947年底，古物陳列所併入故宮博物院，其文物同時亦歸故宮博物院收藏管理。

二次大戰期間，為了保護故宮文物不至遭到日本侵略者的掠奪和戰火的毀滅，故宮博物院從大量的藏品中檢選出器物、書畫、圖書、檔案共計13427箱又64包，分五批運至上海和南京，後又輾轉流散到川、黔各地。抗日戰爭勝利以後，文物復又運回南京。隨着國內政治形勢的變化，在南京的文物又有2972箱於1948年底至1949年被運往台灣，50年代南京文物大部分運返北京，尚有2211箱至今仍存放在故宮博物院於南京建造的庫房中。

中華人民共和國成立以後，故宮博物院的體制有所變化，根據當時上級的有關指令，原宮廷中收藏圖書中的一部分，被調撥到北京圖書館，而檔案文獻，則另成立了"中國第一歷史檔案館"負責收藏保管。

50至60年代，故宮博物院對北京本院的文物重新進行了清理核對，按新的觀念，把過去劃分"器物"和書畫類的才被編入文物的範疇，凡屬於清宮舊藏的，均給予"故"字編號，計有711338件，其中從過去未被登記的"物品"堆中發現1200餘件。作為國家最大博物館，故宮博物院肩負有蒐藏保護流散在社會上珍貴文物的責任。1949年以後，通過收購、調撥、交換和接受捐贈等渠道以豐富館藏。凡屬新入藏的，均給予"新"字編號，截至1994年底，計有222920件。

這近百萬件文物，蘊藏着中華民族文化藝術極其豐富的史料。其遠自原始社會、商、周、秦、漢，經魏、晉、南北朝、隋、唐，歷五代兩宋、元、明，而至於清代和近世。歷朝歷代，均有佳品，從未有間斷。其文物品類，一應俱有，有青銅、玉器、陶瓷、碑刻造像、法書名畫、印璽、漆器、琺瑯、絲織刺繡、竹木牙骨雕刻、金銀器皿、文房珍玩、鐘錶、珠翠首飾、家具以及其他歷史文物等等。每一品種，又自成歷史系列。可以說這是一座巨大的東方文化藝術寶庫，不但集中反映了中華民族數千年文化藝術的歷史發展，凝聚着中國人民巨大的精神力量，同時它也是人類文明進步不可缺少的組成元素。

開發這座寶庫，弘揚民族文化傳統，為社會提供了解和研究這一傳統的可信史料，是故宮博物院的重要任務之一。過去我院曾經通過編輯出版各種圖書、畫冊、刊物，為提供這方面資料作了不少工作，在社會上產生了廣泛的影響，對於推動各科學術的深入研究起到了良好的作用。但是，一種全面而系統地介紹故宮文物以一窺全豹的出版物，由於種種原因，尚未來得及進行。今天，隨着社會的物質生活的提高，和中外文化交流的頻繁往來，

無論是中國還是西方，人們越來越多地注意到故宮。學者專家們，無論是專門研究中國的文化歷史，還是從事於東、西方文化的對比研究，也都希望從故宮的藏品中發掘資料，以探索人類文明發展的奧秘。因此，我們決定與香港商務印書館共同努力，合作出版一套全面系統地反映故宮文物收藏的大型圖冊。

要想無一遺漏將近百萬件文物全都出版，我想在近數十年內是不可能的。因此我們在考慮到社會需要的同時，不能不採取精選的辦法，百裏挑一，將那些最具典型和代表性的文物集中起來，約有一萬二千餘件，分成六十卷出版，故名《故宮博物院藏文物珍品全集》。這需要八至十年時間才能完成，可以說是一項跨世紀的工程。六十卷的體例，我們採取按文物分類的方法進行編排，但是不囿於這一方法。例如其中一些與宮廷歷史、典章制度及日常生活有直接關係的文物，則採用特定主題的編輯方法。這部分是最具有宮廷特色的文物，以往常被人們所忽視，而在學術研究深入發展的今天，卻越來越顯示出其重要歷史價值。另外，對某一類數量較多的文物，例如繪畫和陶瓷，則採用每一卷或幾卷具有相對獨立和完整的編排方法，以便於讀者的需要和選購。

如此浩大的工程，其任務是艱巨的。為此我們動員了全院的文物研究者一道工作。由院內老一輩專家和聘請院外若干著名學者為顧問作指導，使這套大型圖冊的科學性、資料性和觀賞性相結合得盡可能地完善完美。但是，由於我們的力量有限，主要任務由中、青年人承擔，其中的錯誤和不足在所難免，因此當我們剛剛開始進行這一工作時，誠懇地希望得到各方面的批評指正和建設性意見，使以後的各卷，能達到更理想之目的。

感謝香港商務印書館的忠誠合作！感謝所有支持和鼓勵我們進行這一事業的人們！

1995年8月30日於燈下

目錄

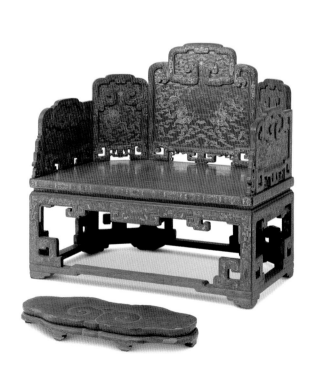

 *9*

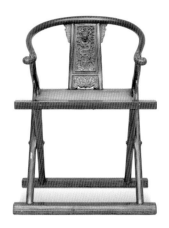

文物目錄

椅凳墩

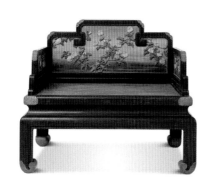

導言 朱家溍

欣賞中國傳統家具，常有偏重明代風格，而輕視清代新式家具的看法。應該說，明清兩代都是中國傳統工藝的興盛期，家具亦如此。清代新風尚的家具，是時代審美變化的結果，明清家具合觀，才能見到中國傳統家具的全貌，而清代家具運用各種新工藝，造成各種新式樣，其中亦有精品，是明及以前所未見的。

本卷收錄清代硬木家具和漆家具精品，及小部分一般的漆家具和柴木家具。後者雖然不是家具中的精品，但從清代家具史的角度來看，卻是用途最廣的家具。不但民間百姓普遍使用，就是在紫禁城中的乾清門外軍機大臣值房、軍機章京值房、九卿值房、散秩大臣值房、內務府大堂、太和門內外兩廡各庫及內閣大堂等許多地方也都使用這類家具，其中"榆木擦漆"的桌、案、椅、凳、櫃、架、箱、櫥等，是這類家具中最有代表性的品種，在清代家具中佔有重要的一席。本卷藏品均來自故宮博物院，故宮所藏清代家具，品種齊全、精品特多，於中國及全世界均可稱首屈一指。

清代新式樣家具的形成和特點

清代家具有一部分直接繼承明代式樣，並流傳始終，被統稱為"明式家具"，明代及清代明式家具在另卷介紹。到清康熙年間（1662—1722），家具的製作才出現一些新的工藝、造型和裝飾，這些新式樣的家具被稱為"清式家具"，是本卷介紹的內容。

過去根據家具的造型風格，通常把清代的家具分為四個時期：順康（1644—1722）、雍乾（1723—1795）、嘉道（1796—1850）、同光（1862—1908）。和其他工藝品的發展規律一樣，康熙、雍正、乾隆三朝的家具代表了清代家具製作的最高水平。乾隆以後，一切工藝美術品的水平下降，家具製造業也逐漸衰落。

由明式向清式家具風格變化的最早時間，現在還難以清楚劃定，但根據實物和文獻，已經可

以勾出輪廓。清順治年間（1644—1661）和康熙初年所製作的工藝品，無論在式樣還是風格上，完全承繼明代，比如順治年間刻的《孝經》、《資政要覽》的字體、刀法、版式就和明朝的經廠刻本完全一樣。因為當時的工匠主要還是明末的人，其作品沒有發生甚麼變化。清代初年的家具製作也是如此，仍延續明代式樣。加之清代家具中有款識的是極少數，大量清代家具是無款的，在考察中未見過順治年款的家具，所以也就不能明確指出順治年間家具與明代家具的區別。

家具風格的變化，從康熙後期，可以看到端倪，到雍正時已經有相當的發展。文物工作者們以往對於清代無款的工藝美術品，大都認為是乾隆年間的作品，現在根據《養心殿造辦處活計清檔》可知，很多以往認為乾隆造的家具，其實出於雍正時，或者雍正時的器物已有這種做法。在雍正、乾隆朝的檔案中有很多製造家具的諭旨，例如造辦處檔案記載："雍正十年六月二十七日，內大臣海望奉上諭：着傳旨年希堯，將長一尺八寸，寬九寸至一尺，高一尺一寸至一尺三寸香几做些來，或彩漆，或鑲斑竹，或鑲棕竹，或做洋漆，但胎骨要淳厚，款式要文雅。再將長三尺至三尺四寸，寬九寸至一尺，高九寸至一尺小炕案亦做些。或彩漆，或鑲斑竹，或鑲棕竹，但胎骨要淳厚，款式亦要文雅，欽此。"彩漆鑲斑竹桌等等新穎的精緻桌案，都是前所未見，細心尋繹這些檔案記載，包括尺寸比例等，可見雍正朝已有很多新式樣的家具。

社會的審美觀，從欣賞紋飾、造型簡潔的家具轉向追求華麗繁縟，加上當時從廣州進口洋貨，嵌玻璃等新工藝傳入中國，結合中國手工業技術水平的提高，清式家具的新工藝和風格，終於在雍正、乾隆兩朝奠定。清式家具風格可以概括為"精巧華麗"四個字。

木匠行裏流傳一句古老的諺語："幹活不由東，累死也無功。"意思是說，工匠必須尊重"東家"的好惡，在此前提之下，施展自己的才藝。有人喜歡仿古，有人追求出新，一時的風尚也會左右工匠的創作構思，也就影響家具造型的演變。清王朝雖然是滿族建立的，但滿族的文化比較落後，家具的製作和使用也極其簡單。入關後，滿族仍保留部分自己的傳統文化，但更多的是吸收漢文化，反映在家具的製造和使用上也是如此。清式家具的出現，是經濟發展、審美觀念變化的結果，沒有明清易代，仍然可以出現這種變化。從文獻可知，康熙年間的漢族文人名士，也在改變家具的設計和製作觀念。據清人劉廷璣的《在園雜志》記載："近日所用之墨及瓷器、木器、漆器仍遵其舊式，而總不知出自劉伴阮者。"劉伴阮名劉源，祥符（今河南開封）人，康熙年間曾供奉內廷，負責管理養心殿造辦處。他在許多種工藝上都有自己獨創的式樣，而且多為後來者遵循。劉廷璣和劉源是朋友，所以劉廷璣的記載，當是可信的史料。清初浙江名士李漁（1610—1680）的《笠翁偶集》也提到家具的設計和創作，他主張桌子多安抽屜，立櫃要多加隔板和抽屜。另據《夢窗小牘》記載："大汕，

字石濂，東吳僧，後主廣州長壽寺。多巧思，以花梨、紫檀、點銅、佳石做椅、桌、屏、櫃、架、盂、碗、杯諸物，往往有新意。持以餉諸當事及士大夫，無不讚賞。”由此可知，生活在康熙年間的大汕，也是對日後產生的廣式家具頗有影響的木器設計者。劉源、李漁、大汕都是當時的名士，他們對家具的設計得到社會重視，改變了家具設計和製作一些舊有的模式，為清式家具的出現創造了條件。

清式家具的風格與室內裝修的變化有很大關係。雍正御纂的《聖祖仁皇帝庭訓格言》有這樣一段話：“朕（康熙）從前曾往王大臣等花園遊幸，觀其蓋造房屋率皆效法漢人，各樣曲折隔斷，謂之套房。彼時亦以為巧，曾於一兩處效法為之。久居即不如意，厥後不為矣。爾等俱各自有花園，斷不可作套房，但以寬廣宏敞，居之適意為宜。”這說明在康熙年間蓋造房屋效法漢人，成為一種新時尚。清代流行的室內裝修多用細木製作裝飾性很強的碧紗櫥，精雕細刻的欄杆罩、落地罩、飛罩、炕罩等等，均體現了康熙說的“巧”的效果。雍正雖然把這條庭訓記載下來，但並未嚴格執行。從圓明園的《陳設檔》可以看到，寬廣宏敞的房屋固然有，帶有各樣曲折隔斷的房屋也不少。而室內陳設，有如建築格局，既要合乎生活需要，也要美觀。家具的陳設雖然沒有甚麼公式，但需審度其造型和周圍環境進行佈置。室內環境變了，家具的風格也相應改變，既然室內裝修很精巧，室內陳設的家具自然也相應精巧，再像明朝家具造型那麼簡練就不相配了。康熙後半期就有做得很細、很精緻的家具，比如帶康熙款的，嵌有幾十種花紋的黑漆嵌螺鈿的書架，說明從康熙年就開始做這種精巧華麗的作品了。雍正、乾隆時雕工和各種鑲嵌裝飾很多，硬木和漆可以結合，家具總體朝着精巧、華麗方向發展。

由這室內裝修和陳設的變化，也做成清式家具與明式家具第二個不同點，即清代的許多家具都是“合着地步打就的”，即是為某一個房間、某個地點特製的。由於套房流行，再按固定尺寸做家具，就容易與房間的大小不合襯，因而特意訂製家具就增加了。也就是說，有固定位置的家具多起來，甚至可以為某一位置製作某一式樣的家具。這種情況明代也有，但不多，雍正、乾隆時就比較普遍了。比如故宮三大殿內的寶座、屏風乃至櫃格等，都做得比較高大，並通體飾金，就是為了適應宮殿威嚴、高貴的整體建築風格。又如養心殿後寢殿內的紫檀雲龍紋櫃（圖249），三櫃合為一體，兩高櫃之間的空當上部作一垂花罩門，下部連一矮櫃，既美觀又莊重，且恰與牆的尺寸吻合，是專門為這裏設計定做的。另一件養心殿西過道門內的穿衣鏡（圖250），由於地方狹小，故只設計成半出腿式，鏡子的背面靠牆，不但節省了空間，而且可以為大臣覲見皇帝時整肅儀容之用。還有太極殿西次間南窗炕上（圖256）的炕桌，其長度與炕的寬度相等，都屬於按照“地步”打造的家具。故宮的養心殿西暖閣、三希堂、長春書屋等許多地方也是這種室內裝修和陳設的典型代表。參看《紅樓夢》第十七回，可知不光皇宮如此，外面的住宅也很講究這種做法。這種專門為某些位置特製的家具，

搬離該環境，單獨去看，容易引起不合比例的意見。

康雍乾盛世以後，隨着國勢逐漸衰落，清式家具的製作水平也日趨下降，可與盛世時期媲美的家具精品不再出現。宮廷中所用家具更是江河日下，已無法同前期相提並論了。故宮藏有同治皇帝大婚時所製的一批以雕刻腫鼻子龍為特點的桌、椅、凳、櫃和光緒年間重修頤和園以後新進的一批更為粗俗的硬木家具，是晚清的典型作品。

清式家具的製造者

內務府檔案記載："雍正四年（1726）九月初四日，郎中海望持出榆木罩漆膳桌一張，奉旨：爾等做漆桌時照此桌款式，將上面水欄邊放寬，批水牙收窄，其批水牙有尖稜處着更改，腿子下截放壯些，不必起綫，上面應畫何樣花樣，爾等酌量彩畫，欽此。"可見當時宮中所用家具，主要是按照皇帝的要求製作的。但皇帝之外，也有其他設計宮中所用家具的人。雍正至乾隆年間，負責管理養心殿造辦處事務的有海望和年希堯等人，同時也是宮中家具的設計者。據內務府檔案記載："雍正二年八月初九日，員外郎海望畫得花梨木書格樣四張。"類似的記載在內務府檔案中還有很多。年希堯、海望、唐英等既有藝術修養又具管理能力的人才，是怡親王允祥兼管造辦處時相繼任用的，他是雍正最信任的兄弟，也是藝術修養很高的人。除了任用藝術管理人才，他並遴選了許多優秀工匠進入造辦處。在檔案中還見到部分優秀木匠的名單："雍正七年（1729）十月初三日，怡親王府總管太監張瑞交來年希堯送來匠人摺一件，內開……細木匠余節公、余君萬等二名。祖秉圭處送來……木匠霍五、小梁、羅鬍子、陳齋公、林大等五名。傳怡親王諭：着交造辦處行走試看"。"海保送來匠人摺一件，內開……木匠方升，鄧連芳等"。皇宮中的家具，由於是挑選民間優秀的木匠到造辦處來成造活計，這些工匠很自然要充分施展自己才能，把民間好的樣式、花紋展現出來，生產出的家具必然會受民間流行的風尚影響。而造辦處有些設計圖樣和工料由於要交給各地督撫、織造、關差來承辦，也就會出現在民間作坊之中，使得民間爭相效仿，也就自然影響到民間家具的發展方向。造辦處的製作網是全國性的，因此根據宮中的家具，也可以看到民間流行使用的木器。

上列只是兩份木匠名單，但足以說明當時造辦處的木匠有廣東和蘇州兩大來源。據史料記載，年希堯當時在江西監督燒造瓷器，他送來的細木匠，當是江南傑出的匠人。祖秉圭當時是粵海關監督，他送來的木匠當是廣東木匠。海保是蘇州織造，他送來的木匠當是蘇州木匠。此外，造辦處透過遴選，彙集了全國各地許多優秀工匠，他們不斷將各地家具工藝融會貫通，從而形成了"京作"。具體說來，廣作家具用料充裕，一件家具只用一種木材，絕不攙雜其他木材，且不加漆飾，各部構件不論彎曲度有多大，一般不用拼接做法，

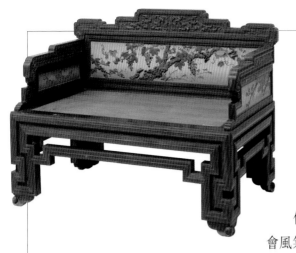

而是由一塊整料挖成。廣作家具極重雕刻，多為高浮雕手法，裝飾花紋在一定程度上受西方藝術影響，如本卷收錄的紅木雲龍紋架子牀（圖1），用材充裕，器物雖大而一氣呵成，又如紫檀嵌黃楊木捲草拐子紋寶座（圖15）通體裝飾大量西洋捲草紋，都是典型的廣作家具風格。蘇作早在明代已經形成，發展到清代受社會風氣影響，開始追求紋飾繁縟。其用料比較節儉，家具總體尺寸較廣作要小，且常用拼接技法，大件家具多以硬木作成框架，以柴木髹漆為面心，如紫檀嵌染牙菊花圖寶座（圖19），邊框為紫檀料，而座面即為楠木。蘇作家具裝飾手法以鑲嵌和彩繪為主，紋飾則採用傳統題材，極少帶有西洋痕跡，如紫檀百寶嵌花果圖寶座（圖22）即為此類。所謂京作家具，一般指清代宮廷造辦處所做的家具，造辦處工匠來自全國各地，生產的家具也就融合了多種風格，其用料多介於廣作和蘇作之間，一件家具不會攙雜多種木材。京作家具的裝飾題材多源於宮內收藏的古代青銅器、玉器和石刻上的紋飾，常見各種龍紋、饕餮紋、雲雷紋等，同時還有皇帝喜好的各種吉祥紋樣。如紫檀福慶紋扶手椅（圖37）和紫檀靈芝紋長桌（圖100）等就是比較典型的京作家具。

清代硬木家具材質

故宮的清式家具以優質硬木家具為代表，其中紫檀佔絕大多數，另有少量黃花梨、鐵梨、烏木、雞翅木等，其餘則是漆家具和雜木家具，從總體上說與明式家具相比並無多大變化，但對材料的選擇和使用卻有所不同，在風格上更有比較明顯的差異。

變化大體可分為三個階段：康熙以前的家具仍保持明式風格，被劃分到明式家具範疇，用材絕大多數為黃花梨木，其次是紫檀、鐵梨、烏木、雞翅木等，這種用材選擇與當時的建築特點密切相關。因為當時的建築採用直欞門窗，然後糊紙，室內光綫較暗，自然喜歡用色調明快的黃花梨或花梨木製作家具。除此以外，明朝後期開海禁以後，從海外輸入中國的此類木材到清初還比較多，是影響選材的另一個重要原因。

康熙至乾隆為清代的鼎盛時期，家具製作工藝取得很大成就，尤以廣州、蘇州、北京三個城市的家具製作最為著名。此時生產的清式硬木家具材質以紫檀居多，其原因一是黃花梨木由於此前過度使用，到雍正年間已經匱乏；二是歐洲平板玻璃製造技術在此時傳入中國，房屋的窗戶由糊紙改為安裝玻璃，室內採光條件明顯改善，顏色深沉的紫檀開始受到青睞。當時所用的紫檀木大部分是明代開採的，數量也已經十分稀少珍貴。據史料記載，雍正時，臣子為請用紫檀木常要奏啟主管造辦處的怡親王，遇有採購的機會，也會向民間採購，這些都說明當時高級木材的來源已經不太充裕。

嘉慶、道光（1796—1850）以後，由於優質木材更加短缺，紫檀木也已經極其稀少珍貴，故晚清的硬木家具多以酸枝木（即紅木）為主要材料，加之此時內憂外患不斷，戰亂頻繁，國運衰落，手工業遭到極大的破壞，硬木家具工藝也呈衰敗趨勢。雖然硬木家具的生產始終未曾停止，但其數量、質量較之前代，均有明顯的下降。而漆家具和雜木家具在宮廷中的使用則更加廣泛，它們雖不能代表最優秀的清式家具，但卻是清式家具重要的組成部分，且其中不乏工藝精美者。為反映清代家具全貌，本卷亦收錄了一些漆家具和雜木家具。

清式家具分類說明

清式家具與明式家具一起，以其不同時代、不同特點，成為中國傳統家具的優秀代表。本卷所選清式家具，依其造型和用途，分為六類，第一類為牀、寶座；第二類為椅、凳、墩；第三類為桌、案、几；第四類為屏風；第五類為櫃、格、箱、架；第六類為天然木家具。

第一類，牀、寶座。主要有架子牀、羅漢牀和寶座。故宮收藏的清式牀和寶座數量較明式的多，其風格與明式大不一樣。

1. 架子牀，本卷收錄的紅木雲龍紋架子牀（圖1），形體寬大，用料充裕，牀面四角及門柱的直徑近10厘米，牀圍攢邊鑲板，板心厚度均在2厘米左右。用料之費，在明式家具中尚未見到過。

2. 羅漢牀，在宮中絕大多數用於廳堂陳設，造型多取同一模式：牀圍是五屏或七屏式，正中稍高，兩側依次遞減；多攢框鑲心，上或透雕、或浮雕、或鑲嵌、或彩繪，很少有攢櫺作法，成為清式家具風格特點之一。

3. 寶座，清代宮中寶座數量較多，一般在皇帝和后妃寢宮的正殿明間，都陳設一組寶座，寶座周圍常有屏風、宮扇、香筒、甪端、香几和太平有象等配合，是宮中一種特殊的陳設形式，象徵皇權至高無尚。寶座都是單獨陳設，而且要放在室內最顯要位置。故宮太和殿中的金漆龍紋寶座，是最典型的代表。清代牀、寶座中髹漆工藝有黑漆描金、紫漆描金、罩金漆和黑素漆嵌瓷四種，都是家具中的上乘精品。

第二類，椅、凳、墩。種類與明代大體相似，造型及裝飾風格卻大不相同。如黑漆

鬆金雲龍紋交椅（圖29），一改明式簡練、舒展的風格，做成蜿蜒起伏的波浪式椅圈，扶手圓雕龍頭，椅背雕雲龍紋和道教象徵五大名山的《五嶽真形圖》。極盡雕飾之能事，並兩面貼金，顯得異常華麗。

1. 交椅、圈椅。交椅和圈椅逐漸退出歷史舞台。本卷收錄的交椅，其中有兩件是清代鹵簿儀仗中的交椅（圖31、圖32），另一件紅漆鬆金雲龍紋大交椅（圖30）形體異常寬大，並非實用之物。圈椅在清代初期製作和使用已明顯見少，至乾隆時期，前代器物雖然還繼續使用，但基本上無人再製作了。

2. 官帽椅、扶手椅。官帽椅在清中期大量使用，但其風格特點卻與清代康熙朝以前乃至明代的大不相同。明代流行四出頭官帽椅和南官帽椅，而且背板多作曲綫形。後邊柱上部向後彎曲，形成一定角度的背傾角，使人坐起來更為舒適。而清中期的官帽椅的椅背大多垂直安裝。椅背和扶手絕大多數做成屏風式，分三塊，用走馬銷結合。正中稍高，兩側依次遞減。面下多數都帶束腰，直腿，迴紋足，腿間橫棖常常裝在同一個水平綫上，俗稱"四面平"底棖（圖40）。這些椅子與明式相比，雖然紋飾更為華麗，工藝也更加精湛，但卻忽略了造型的科學性和實用性。

3. 靠背椅。沒有扶手的椅子的統稱。靠背椅依其搭腦兩端是否出頭，可分為"燈掛式"如黃花梨拐子紋靠背椅（圖58）和"一統碑式"如黑漆描金福壽紋靠背椅（圖61）兩種，清代靠背椅使用較為普遍。

4. 凳。清式凳的造型也有別於明式，明式的棖子多數在腿的上截，清式的橫棖多數在腿的下半截。且明式有相當數量的無束腰杌凳，而清式卻很少見到。

5. 坐墩。坐墩又稱"繡墩"，清式坐墩造型非常豐富，有圓形、海棠形、多角形、梅花形、瓜稜形等。明顯較明式俊秀，普遍坐面較小，尤其是圓形坐墩，如紫檀雲頭紋五開光坐墩（圖78）。而明式坐墩造型較墩實，少有如此修長俊秀者。清代的方凳、圓凳和坐墩一般都不大，宜設在小巧精緻的房間，而且這類坐具四面都有裝飾，最適宜不依不靠，哪裏需要就設在哪裏。比如儲秀宮東梢間陳設（圖252），牆和落地罩結合部的空間比較狹窄，而放置一坐墩，則顯得恰到好處。

第三類，桌、案、几等承具。存量最多，品種也很豐富，大體包括桌、炕桌、案、炕案、炕几、香几等。清宮中正式的筵宴，保留歷代大宴的慣例席地而坐，用矮桌；還有北京流行土木結合的木炕，面積比牀大很多，因此炕桌、炕案、炕几等的需求量大，並且產生摺疊腿、

活腿等地下炕上兩用的桌，以及拐彎掐坐褥的香几等等。這些尺寸較矮的桌、案、几，和抽屜桌逐漸多起來一樣，是清代製作傾向。

1. 桌，有方桌、長桌、條桌、畫桌等區別。清式桌大多都有束腰。牙條最常見的是正中下垂窪堂肚，或雕刻玉寶珠紋。足端削出硬角拐彎的迴紋馬蹄。用材方面也較前代豐富得多，除去各類優質木材之外，還有很多附屬材料。如各種木雕，竹黃包鑲、棕竹包鑲、嵌竹、嵌影木心等。製作精巧，為前代所未有。

2. 案，泛指腿足由兩端向裏縮進安裝，腿子外側留有牙頭的承具。案面有平頭和翹頭兩種。面下牙條、牙頭和腿子，有明式家具常見的夾頭榫、插肩榫做法，又有托角榫，是清代常見的做法，但因嵌入腿足內，在外表較難辨認；面下牙條分三段安裝，另在腿子兩邊鑲牙頭，腿子兩側只開出淺槽，不開透。腿足的做法大體分有無托泥兩種。北京和蘇州兩地常用足下踩托泥造型；不用托泥的，將腿足向外撇出，為廣式家具常見作法。案的種類有書案、畫案、炕案等。炕案的作用相當於炕几，除了可供坐時憑伏外，形體稍大者，還可放在炕頭放置器物。

3. 几，有高和低兩種。高几又分香几和茶几。香几主要用於置爐焚香，以圓形居多，次為六、八角式，還有雙環式、方勝式、梅花式、海棠式等。絕大多數都用三彎腿。茶几多為方形，個別也有長方的。直腿居多，高度大體與椅子的扶手相當，使用時放在兩個椅子中間，擺放些茗瓶茶具。低几泛指各類炕几，它是牀榻和茵席之上常用的家具，形體較小，腿足較短，很少用於放置器物，主要是供坐時憑伏。清代還保留一種弧形三足憑几，弧形曲面，兩端及中間各垂一足，由於其弧形的特點，可以放在身體任意一側使用，俗稱"四面几"。這種几在魏晉南北朝時非常流行，到了清代，在皇帝出巡或狩獵的帳篷中多使用此几。

第四類，屏風。故宮收藏的清代屏風種類齊全，主要有插屏、掛屏、圍屏、座屏等，數量亦多，很能體現清式家具的風采。此外，木炕流行，也催生了炕屏，炕屏是典型的清式家具。清代屏風用材廣泛，各種木材；各種彩石、玉石；各種螺鈿、象牙、獸骨；各種金屬；各種紙製品；各種絲繡製品；各色漆；各色琺瑯等，無所不有。

1. 插屏，在宮中普遍使用，而且這類屏風沒有固定尺寸要求，大小不一，大者寬逾兩米，高逾三米，有當門而設者，也有書桌、案頭而設者。有既實用而又有觀賞價值者，又有純供觀賞者，本卷所收的紫檀嵌木靈芝插屏

（圖169）、花梨嵌玉璧插屏（圖171）等，皆屬此類。廣州進口外國玻璃後，插屏安裝「擺錫玻璃」成為穿衣鏡，也是典型的清式家具。

2. 掛屏，指單扇，無座無腳，掛在牆上的屏風。故宮內此類屏風數量亦不少，多和其他家具配套使用，起裝飾作用，如本卷收錄的剔紅蘭亭雅集圖掛屏（圖181）。

3. 圍屏，在清宮中佔很大比重。由於輕巧靈便，可以隨意摺疊，一般用於臨時陳設，有時也用來作娛樂活動。如乾隆御書夜亮木賦圍屏（圖192），就是乾隆將平時看書的隨感，寫成條幅，裱成屏風。有時也將大臣們的書畫條幅裱在屏風上，如黑漆點翠萬花獻瑞圖圍屏（圖188），屏心鑲嵌通景花卉圖紋，並題「萬花獻瑞」隸書文字，寓意吉祥。在眾多圍屏中，還有一套黑漆款彩圍屏（圖185、圖186），共二十四扇，十二扇為一組，正面雕通景花鳥圖，背面雕通景山水風景圖，至今保存完好，仍絢麗多彩，是目前國內傳世清式家具中極為罕見的品種。

4. 座屏，屏下有座，由多扇組成，形體較大，不易挪動，在室內陳設時位置相對固定。在皇宮各宮殿的正殿明間，都陳設一組屏風。屏風前配以寶座、香几、宮扇、仙鶴、燭台等，它是皇宮中特定的陳設形式，是皇權至高無尚的象徵。還有一部分屏風是臣子為皇帝祝壽而製的，內容都是祝頌長壽的詩句或散文。如本卷收錄的一套為康熙祝壽的屏風（圖196、圖197）。

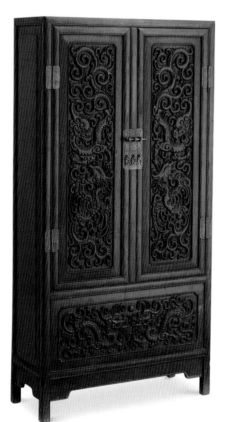

第五類，櫃、格、箱、架。

1. 櫃，清代櫃類家具品種有所增加，風格也與明式大不相同。明式櫃大多以光素為主，而清式櫃多飾有華麗的花紋，或雕刻、或鑲嵌、或金漆彩繪，很少有光素的。如紫檀八寶八仙紋頂豎櫃（圖209）、紫檀龍鳳紋立櫃（圖205）、紫檀雍正耕織圖立櫃（圖204）等皆滿飾圖案花紋。另外鑲玻璃、嵌竹絲、嵌瓷、嵌螺鈿以及彩漆裝飾的箱櫃也很多。

宮中收藏的櫃子大小不一，大者有坤寧宮和寧壽宮炕上陳設的兩對大立櫃。不但形體寬大，而且有三層頂櫃，最高層緊貼天花板，總高度達5.185米，其次是太和殿陳設的一對大立櫃，櫃身高3.7米。小件日

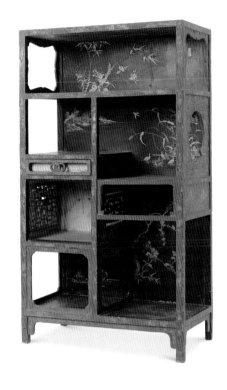

用家具屬於桌子、案子之上陳設的擺件，有小匣、小盒、小花几、小立櫃等，小巧精緻，屬於文玩類，本卷均未收入。

2. 格，在清代使用較為普遍，只是式樣與明代稍有不同。明式格大多將上格部分做成四面透空，而清式格則將左右及後面用板封閉，因而不如明式櫃格亮麗大方。格下的抽屜和櫃門多刻上繁瑣的花紋，有的花紋帶有明顯的西洋裝飾風格，如紫檀西洋花紋小櫃格（圖228）將西洋捲草紋與傳統的夔紋組合使用，構思獨特，工藝精湛。清代自雍正朝開始，流行一種屜板高低錯落的櫃格，俗稱"博古格"或"多寶格"（圖213），專門用來在書房中陳放文玩古器，有濃厚的清式家具風格。此外，安裝玻璃和洋鎖也是新的東西。

3. 箱，本卷所收清代箱子，均為世不經見之物。紫檀銀包角雙龍戲珠紋箱（圖235），雕刻花紋精美生動，箱子四角及箱座四角均包鑲銀質鍍金包角；黑漆識文描金九龍紋長套箱（圖234），係雍正元年為盛放孝陵所產耆草而製，箱體分外、內箱兩層，兩箱通體黑漆地，全部用識文描金手法裝飾雲紋和龍紋。此箱在《養吉齋叢錄》和《高宗御製詩》均有記載。另有柏木製成的冰箱（圖236），係宮中夏季儲冰消暑之物。

4. 衣架、盆架，清代衣架的造型結構較前代並無多大變化，只是用料和裝飾卻與前代大不相同。

盆架分高低兩種形式，高的實際是結合巾架和盆架，又叫高面盆架。低的即腿足等高，上端和下端各裝一組橫棖，用於坐盆。還有的將其中四個頭做成活榫，可以摺疊。有的將腿下端向外撇出，增加穩定感。花架是晚清出現的新品種，本卷未收錄。多用來放置花盆，因為常陳設在廳堂四角，故以方形居多。

第六類，天然木家具。天然木家具又稱"樹根家具"，是把樹根、古藤、癭木作必要的修整，用巧妙的手法拼接成家具形式，為家具工藝增添了色彩。

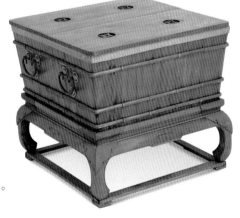

天然木家具雖很早就有記載，但明代才真正受到賞識，並競相仿效，清代更是風行一時。不少文人畫家還作專門的著錄，並把此類家具繪入畫中。至於實物，則在蘇州庭園、北京頤和園、故宮都藏有一定數量的天然木家具，大到寶座、條案、方桌、大圓桌、扶手椅、茶几、條几，小到花插、筆筒等，品類眾多，工藝精美。這些家具，表面看，似乎完全出自天然，絲毫不露斧斤痕跡，看不見接縫和鐵釘。這就需要利用樹根盤根錯節、變化無窮的特點，巧妙拼合。造型上，還要具備家具的各種功能和形態。如天然木圓桌（圖242），不但結構天衣無縫，而且可與天然木椅配套使用，既有觀賞價值，又有實用價值。天然木家具與一般家具相比，有回歸自然、品味高雅的效果。

（"清式家具分類說明"由胡德生執筆，朱家溍審定。）

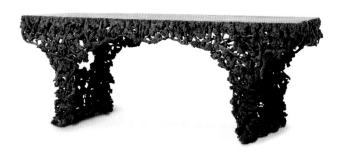

牀寶座

**Beds
and
Thrones**

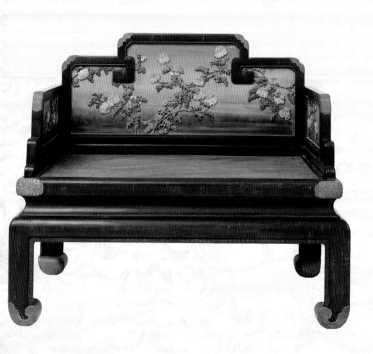

1

紅木雲龍紋架子牀

清
高240.5厘米　長256厘米　寬169厘米
清宮舊藏

Mahogany four-poster bed, decorated with dragon and cloud patterned carved openwork
Qing Dynasty
Height: 240.5cm　Length: 256cm
Width: 169cm
Qing Court collection

牀面上起六根雕龍立柱，立柱上部透雕雲龍紋倒掛牙子，頂部安透雕雲龍紋毗盧帽，立柱間飾以透雕雲龍紋牀圍，牀面下束腰，鼓腿彭牙，牙條及腿、足皆雕雲龍紋。內翻馬蹄。

此牀用料豐厚，工藝精湛，整體感覺高大而不笨拙，為清代家具中的精品。

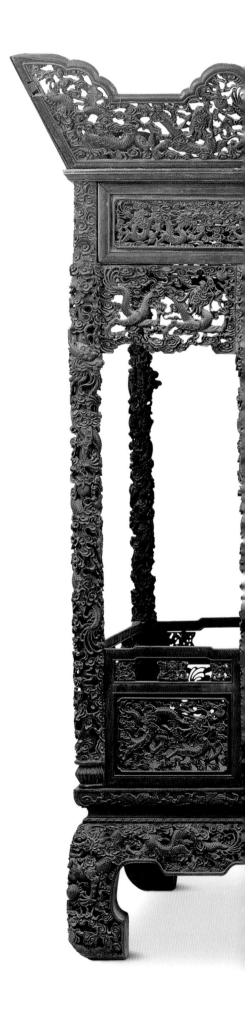

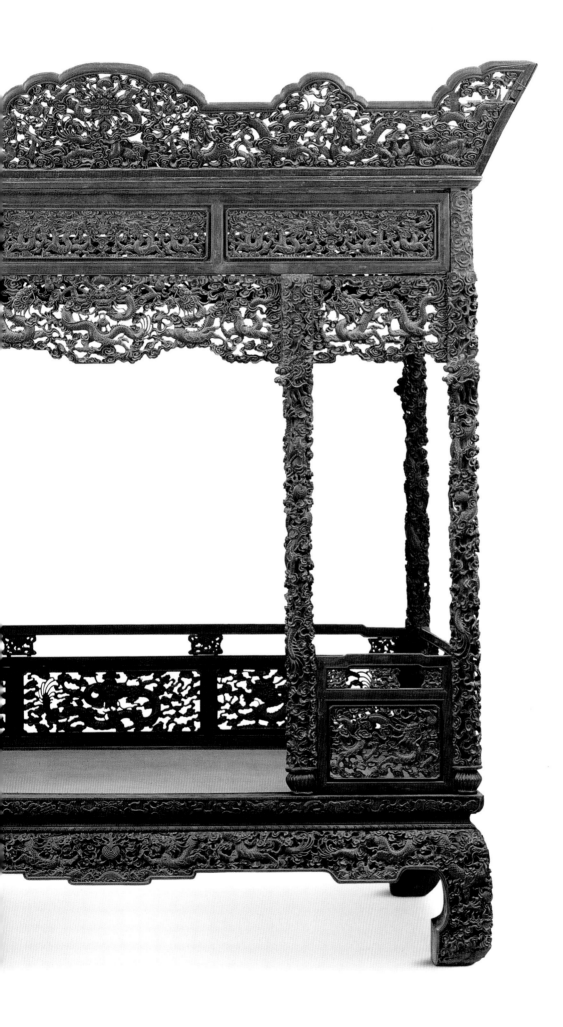

2

紫檀荷花紋牀
清早期
高116.5厘米　長224厘米　寬132.5厘米

Red sandalwood bed, decorated with
lotus patterned carved openwork
Early Qing Dynasty
Height: 116.5cm　Length: 224cm
Width: 132.5cm

三屏風式牀圍透雕荷花蓮蓬紋，牀面
裝屜盤，面下束腰，鼓腿彭牙。束腰
及牙條浮雕荷花蓮蓬紋，腿、足處雕
密不露地的荷花紋。內翻馬蹄。

此牀用材粗碩，紋飾雕刻精細，構圖
嚴謹。

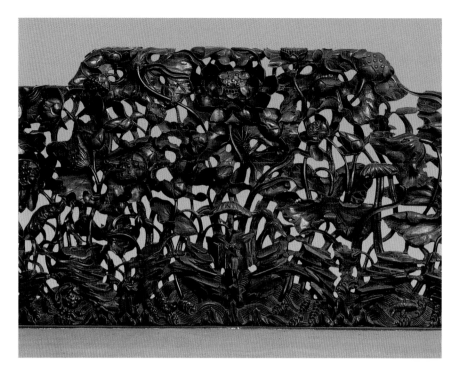

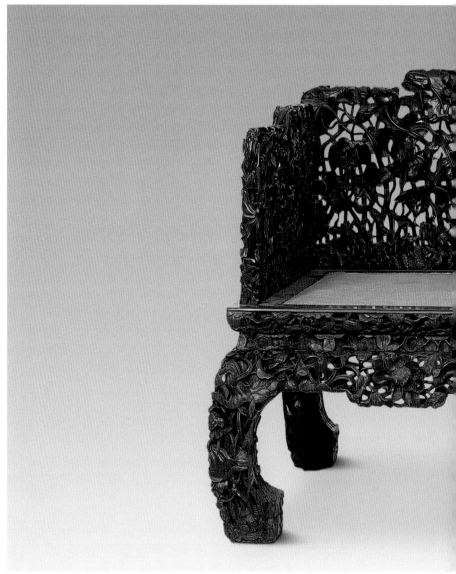

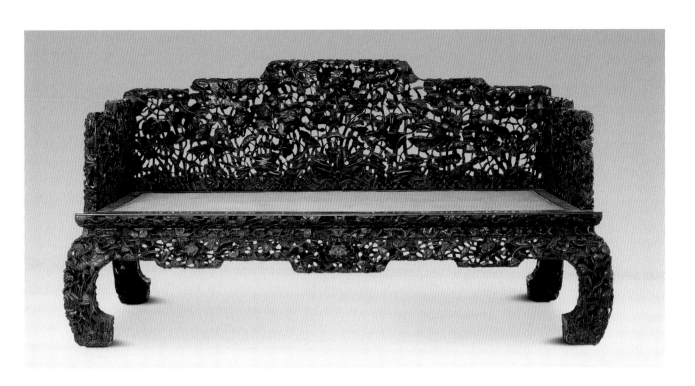

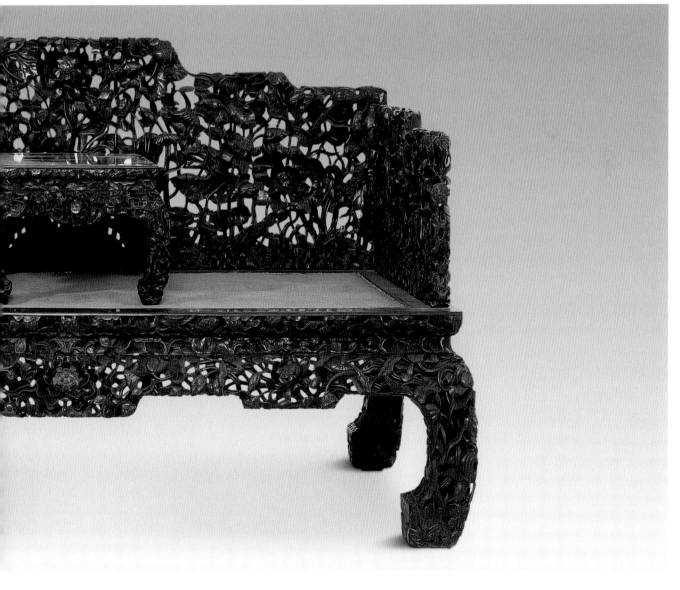

3

黑漆嵌瓷山水圖牀
清康熙
高76厘米　長216厘米　寬107厘米
清宮舊藏

Black lacquered bed, decorated with pictures of landscape on
porcelain inlays
Kangxi Period, Qing Dynasty
Height: 76cm　Length: 216cm
Width: 107cm
Qing Court collection

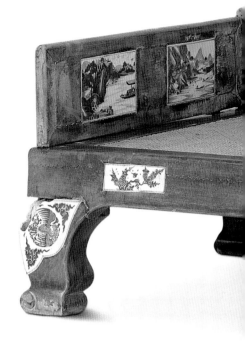

三屏風式牀圍上嵌繪有山水人物圖的瓷片。牀面外沿嵌繪
花鳥、花蝶紋的瓷片。三彎腿嵌繪團鳳祥雲紋瓷片，外翻
馬蹄。

此牀綫條簡練，給人以沉穩敦實之感，瓷片圖紋繪製亦頗
為精美，是康熙年間製作的家具精品。

4

黑漆描金捲草拐子紋牀
清雍正
高71厘米　長185厘米　寬83厘米
清宮舊藏

Black lacquered bed, decorated with gold tracery scrolled
grass and Kui[1] patterns
Yongzheng Period, Qing Dynasty
Height: 71cm　Length: 185cm
Width: 83cm
Qing Court collection

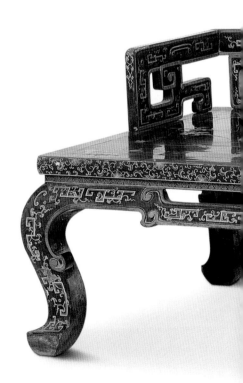

三屏風式矮牀圍透雕成圓璧及夔紋形狀，上繪拐子及捲草
紋。牀面及側沿亦有描金紋飾。面下束腰，飾水波紋，牙
條及三彎腿飾捲草和拐子紋。外翻馬蹄。

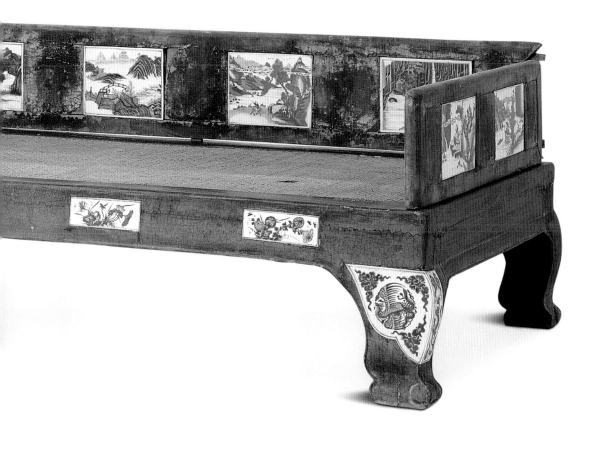

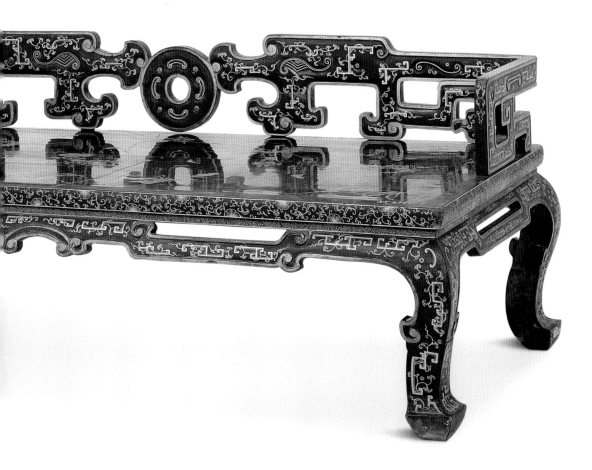

5

紫漆描金山水紋牀
清雍正
高89.5厘米　長205厘米　寬110.5厘米

Purple lacquered bed, decorated with gold tracery landscape patterns
Yongzheng Period, Qing Dynasty
Height: 89.5cm　Length: 205cm
Width: 110.5cm

五屏風式牀圍，採用攢框裝板心工藝製成。屏心飾山水人物樓閣圖，外框飾迴紋。牀圍外側及背面為折枝花卉圖。牀面藤編軟屜，邊沿飾纏枝花卉紋，牙條及牀腿飾雲蝠紋。內翻馬蹄。

此牀製作工藝精湛，紋飾精細，是雍正年間製作的家具精品。

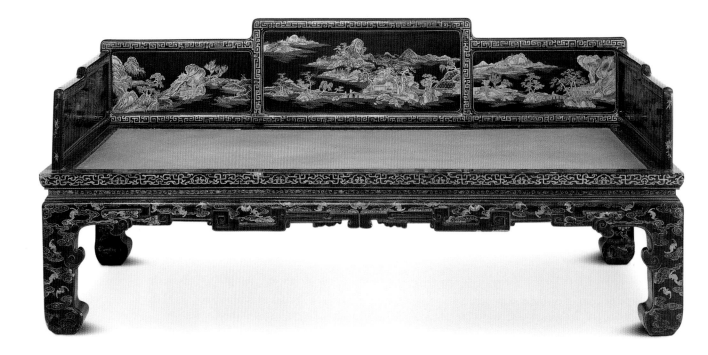

6

紫檀嵌瓷花卉圖牀

清乾隆
高92厘米　長248厘米　寬131.5厘米
清宮舊藏

**Red sandalwood bed, decorated with
pictures of flowers on porcelain inlays**
Qianlong Period, Qing Dynasty
Height: 92cm　Length: 248cm
Width: 131.5cm
Qing Court collection

七屏風式牀圍四面打槽裝板，板中心
嵌瓷片，瓷片上分別繪菊花、海棠、
葵花、天竺等花卉草蟲。落堂硬牀
屜，牀面下束腰，鼓腿彭牙，壼門式
牙條下垂窪堂肚。內翻馬蹄。

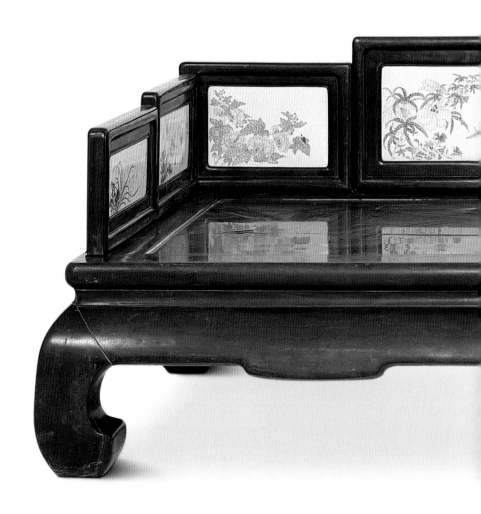

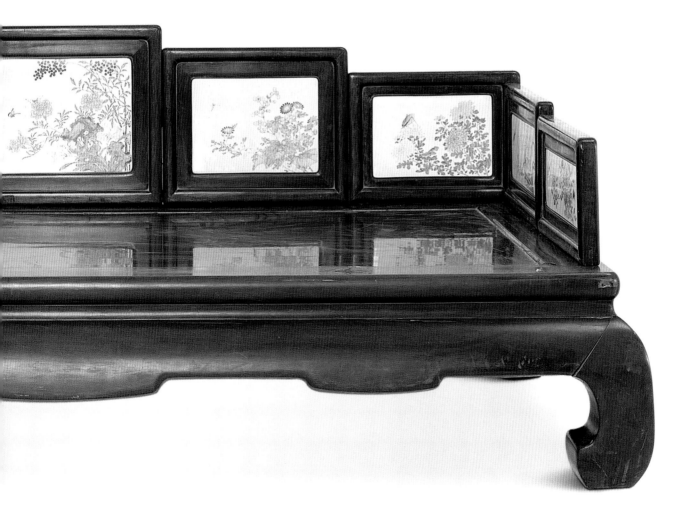

7

紅木九龍紋牀

清乾隆
高101厘米　長269厘米　寬168厘米
清宮舊藏

Mahogany bed, decorated with carvings of nine dragons
Qianlong Period, Qing Dynasty
Height: 101cm　Length: 269cm
Width: 168cm
Qing Court collection

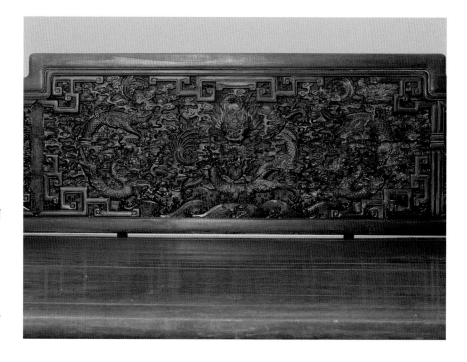

七屏風式牀圍雕九龍及夔龍紋。牀面
下束腰，雕如意紋，托腮雕水浪紋，
牙條雕夔龍紋和玉寶珠紋。三彎腿，
雕如意雲頭紋足。

此牀雕刻工藝精湛，其樣式、造型為
典型的清代家具製作手法。

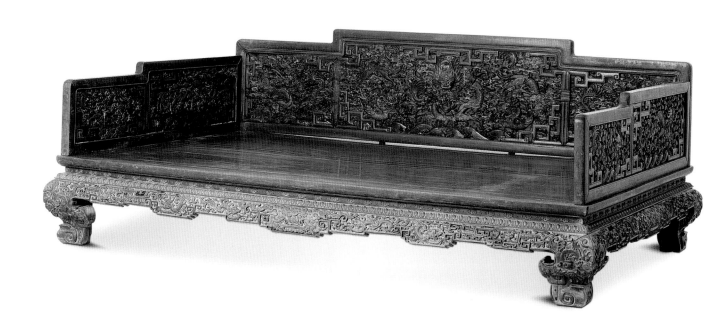

紫檀夔龍紋牀
清乾隆
高92.5厘米　長200厘米　寬103.5厘米
清宮舊藏

**Red sandalwood bed, decorated with
carvings of Kui[1]-dragons**
Qianlong Period, Qing Dynasty
Height: 92.5cm　Length: 200cm
Width: 103.5cm
Qing Court collection

七屏風式牀圍透雕夔龍紋，間有小花
牙子。牀面下束腰，牙條及腿部皆雕
夔龍紋，迴紋馬蹄，下承托泥。

此牀綫條簡練而雕工精細，為乾隆年
間製作的家具精品。

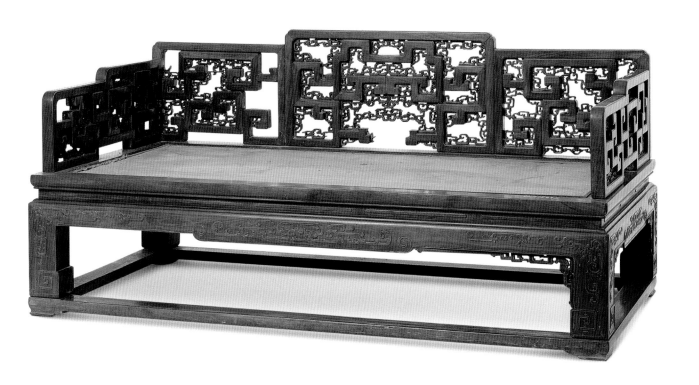

9

紫檀嵌楠木山水人物圖牀
清乾隆
高108.5厘米　長191.5厘米
寬107.5厘米
清宮舊藏

Red sandalwood bed, decorated with
figurines and landscape patterns made of
inlaid Nanmu² wood
Qianlong Period, Qing Dynasty
Height: 108.5cm　Length: 191.5cm
Width: 107.5cm
Qing Court colleciton

七屏風式牀圍，楠木心上雕表現農
耕、漁樵等內容的山水人物圖。席心
牀屜，牀面下束腰，牙條雕玉寶珠紋
及燈草綫，腿部邊緣亦起燈草綫。捲
雲馬蹄，下承托泥。

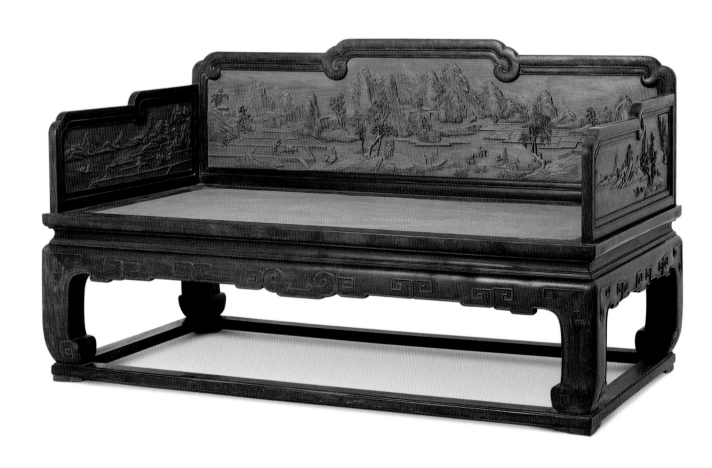

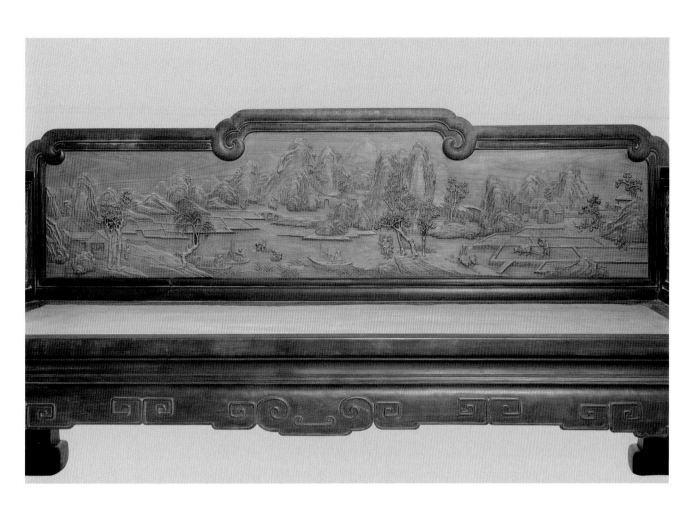

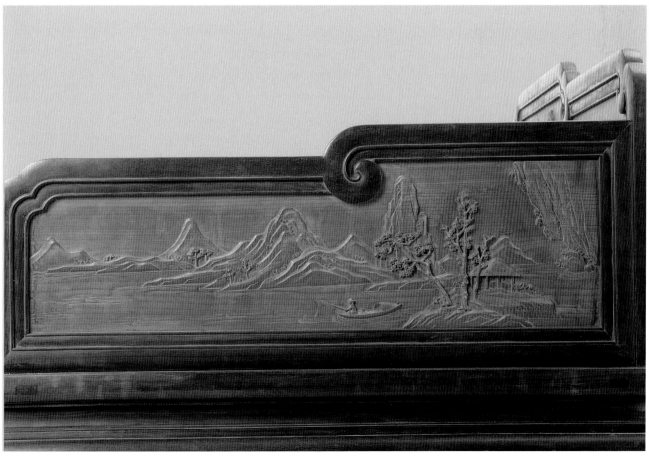

10

紅木三多紋羅漢牀
清晚期
高96厘米　長206厘米　寬110厘米
清宮舊藏

Mahogany Arhat[3] bed, decorated with
citron, peach and pomegranate patterns
Late Qing Dynasty
Height: 96cm　Length: 206cm
Width: 110cm
Qing Court collection

七屏風式牀圍攢框鑲心，"落堂踩鼓"
起地雕佛手、桃、石榴三多紋，寓意
"多福、多壽、多子"。硬屜襯席牀
面，束腰分段飾縧環板，下襯托腮。
鼓腿彭牙，牙條與腿轉角處透雕雲紋
角牙。內翻馬蹄，下承托泥。

"落堂踩鼓"是牀面、凳面及櫃門的一
種製作工藝，指面心或面心四邊低於
邊框平面。

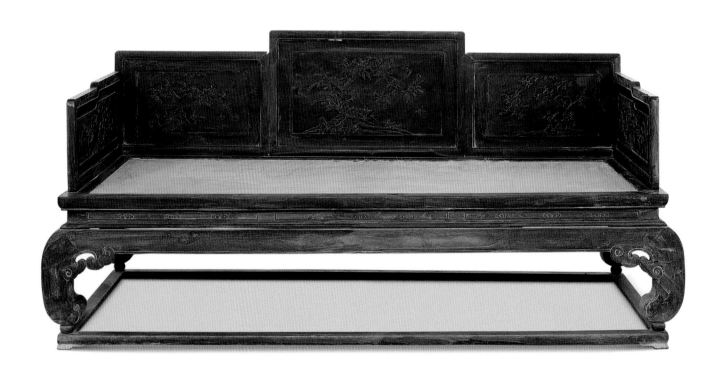

11

紅木嵌銅纏枝花紋牀
清
高109.5厘米 長188厘米 寬154厘米
清宮舊藏

Mahogany bed, decorated with intertwining floral patterns made with inlaid copper
Qing Dynasty
Height: 109.5cm Length: 188cm
Width: 154cm
Qing Court collection

七屏風式牀圍嵌銅製纏枝西番蓮及卍
字紋，牀圍下飾壺門式牙條，浮雕捲
草紋，兩側牀圍有雲紋站牙相抵。牀
面既寬且深，束腰上安立柱，嵌裝三
段浮雕捲草紋的縧環板，束腰下有托
腮，鼓腿彭牙，壺門式牙條上雕夔龍
紋，足踩圓珠，下承托泥。

此牀結構複雜，做工精細，銅活紋飾
細膩，是清代金屬鑲嵌工藝與木器家
具結合的代表性作品。

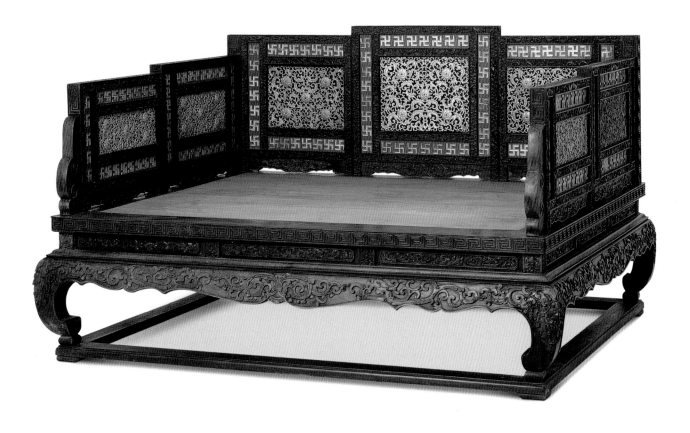

12

紫檀夔龍紋牀
清
高109厘米　長200厘米　寬93厘米
清宮舊藏

Red sandalwood bed, decorated with carvings of Kui[1]-dragons
Qing Dynasty
Height: 109cm　Length: 200cm
Width: 93cm
Qing Court collection

七屏風式牀圍雕夔龍紋，貼草蓆硬牀
屜。面下束腰，上下各起陽綫，牙條
雕玉寶珠紋，方材直腿外緣起陽綫，
迴紋馬蹄，下承托泥。

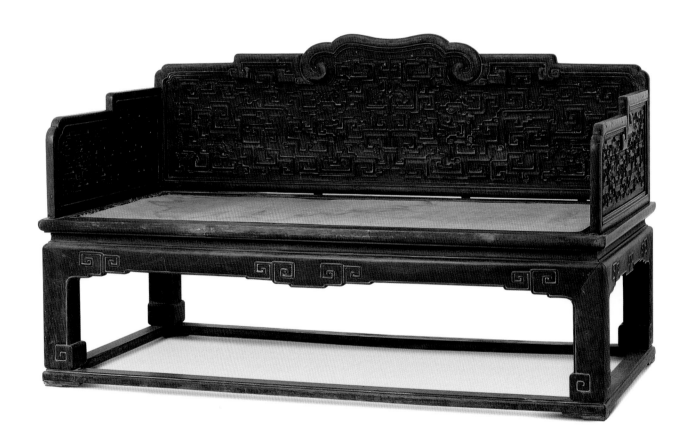

13

紅木嵌大理石羅漢牀
清
高108厘米　長200厘米　寬93厘米
清宮舊藏

Mahogany Arhat[3] bed, decorated with marble panel inlays
Qing Dynasty
Height: 108cm　Length: 200cm
Width: 93cm
Qing Court collection

牀圍四邊打槽攢框，中心裝板，嵌天然山水紋大理石。落堂硬牀屜，冰盤沿，牀面下束腰，上下各起陽綫，牙條浮雕玉寶珠紋，方材直腿外緣起陽綫，迴紋馬蹄。

清代宮廷中的羅漢牀一般用於客廳陳設，造型也基本相同。此牀嵌天然山水紋大理石則頗為獨到。

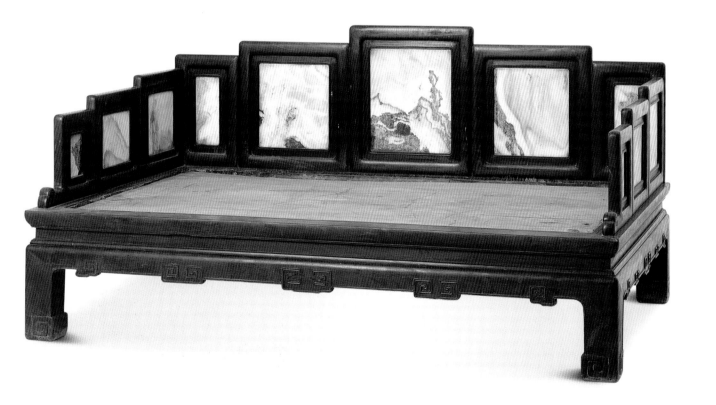

14

金漆龍紋寶座
清早期
高165厘米　長109厘米　寬60厘米
清宮舊藏

**Gold lacquered throne, decorated with
carvings of dragons**
Early Qing Dynasty
Length: 165cm　Length: 109cm
Width: 60cm
Qing Court collection

五屏風式座圍，上有透雕龍紋屏帽，兩端垂雲紋翹頭。三扇背屏上分三段嵌裝縧環板，上段及中段雕龍紋，下段鎪出壺門亮腳。座面嵌裝硬板，面下束腰，剷地浮雕結子花，有蓮紋托腮。鼓腿彭牙，外翻足，作龍爪抓珠狀，下承須彌座。座前附雙層腳踏。

此座為奉先殿所用之物，是清宮中供奉的神位。一般在皇帝和后妃寢宮的正殿明間，都有一組寶座陳設，是皇權的象徵。

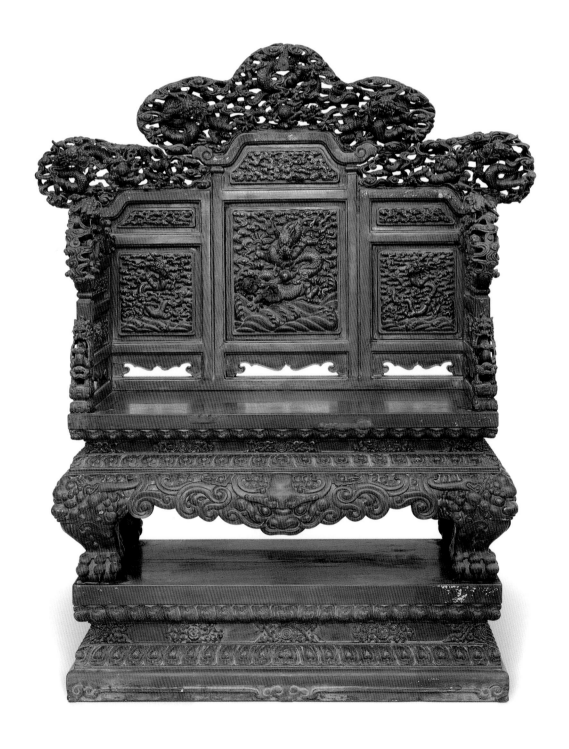

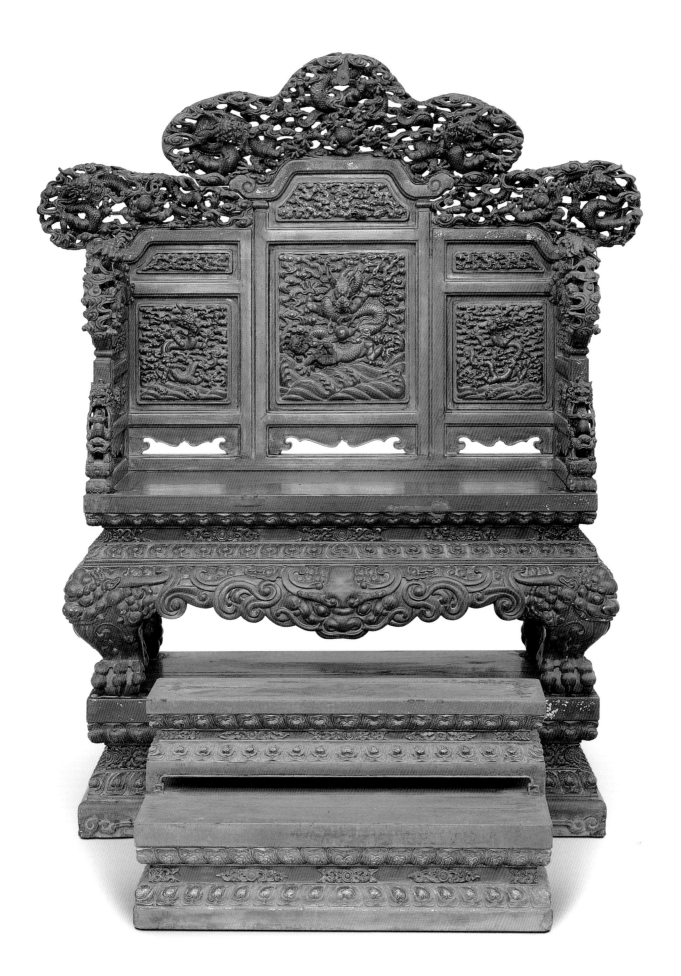

15

紫檀嵌黃楊木捲草拐子紋寶座
清乾隆
高113厘米　長102厘米　寬80厘米
清宮舊藏

Red sandalwood throne, decorated with
scrolled grass and Kui[1] patterns made
with inlaid boxwood
Qianlong Period, Qing Dynasty
Height: 113cm　Length: 102cm
Width: 80cm
Qing Court collection

座圍正中鑲紫檀木板心，嵌黃楊木雕
西洋捲草紋。歐洲巴洛克式搭腦，兩
側雕夔龍首，扶手邊框與後背邊框連
接，形成兩條蜿蜒向上的夔龍。座面
下束腰，浮雕窄絛環板。彭牙拱肩三
彎腿，牙條浮雕西洋捲草紋和夔紋，
外翻馬蹄，下承托泥。

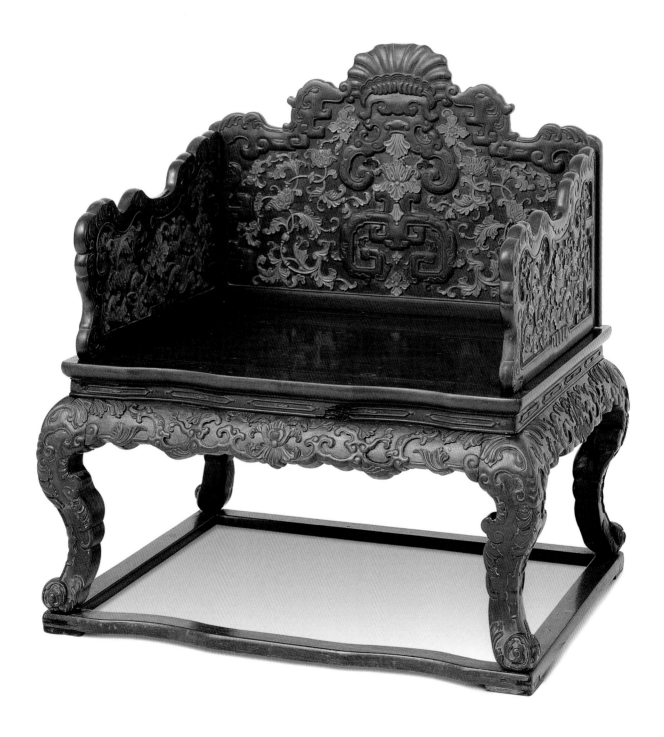

16

紫檀雕漆雲龍紋寶座
清乾隆
高103厘米　長112厘米　寬85厘米
清宮舊藏

**Red sandalwood throne, decorated with
dragon and cloud patterns carved in
lacquer**
Qianlong Period, Qing Dynasty
Height: 103cm　Length: 112cm
Width: 85cm
Qing Court collection

九屏風式座圍，內飾剔紅海水江崖及
雲龍紋，後背五龍，兩扶手各兩龍，
合為象徵皇權的九龍。搭腦後捲。席
心坐面，下有束腰，束腰上下裝托
腮，正中透雕炮仗洞。鼓腿彭牙，牙
條下垂窪堂肚。大挖馬蹄，下承托
泥。

雕漆是先在木胎或金屬胎上髹漆，之
後在漆上雕刻圖案，根據雕漆的顏色
不同，又有剔紅、剔黃、剔黑、剔彩
等區別。此座刀法精密，圓潤渾厚，
不露刀鋒，雲紋舒捲生動，在雕漆家
具中堪稱珍品。

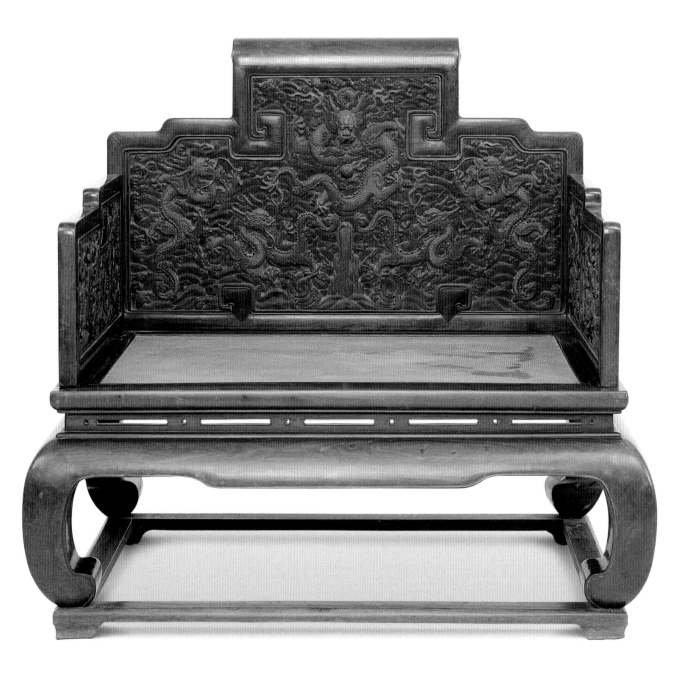

17

紫檀夔龍拐子紋寶座
清乾隆
高118厘米　長126厘米　寬104厘米
清宮舊藏

Red sandalwood throne, decorated with stylized dragon and Kui[1] patterns
Qianlong Period, Qing Dynasty
Height: 118cm　Length: 126cm
Width: 104cm
Qing Court collection

座圍皆以長短不一的小材料格角攢成對稱的拐子紋，雕夔龍紋。藤心座面，面下以同樣工藝攢成拐子紋支架，並以帶屜底座固定。

此寶座工藝獨特，既達到充分利用材料，使結構牢固的目的，同時又收到很好的裝飾效果，給人以空靈秀麗之感。

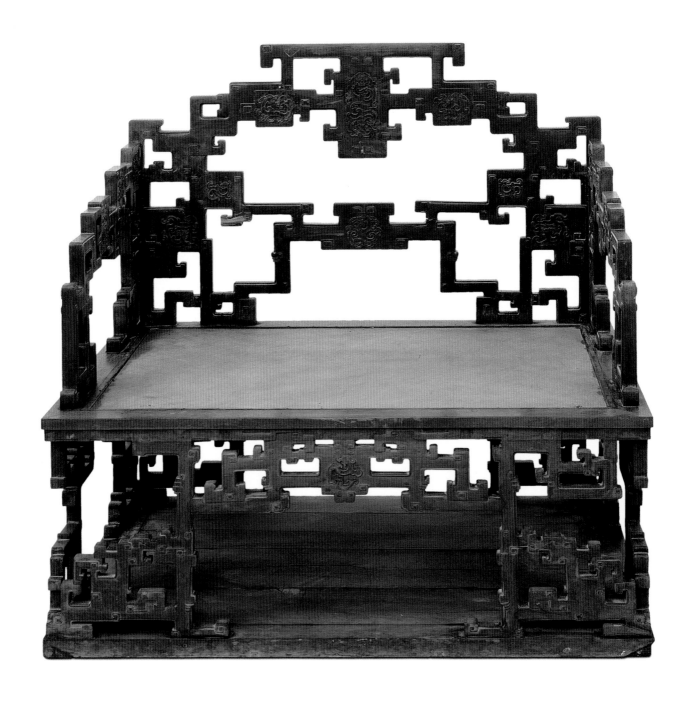

18

紫檀嵌玉菊花圖寶座
清乾隆
高108厘米　長110厘米　寬83厘米
清宮舊藏

Red sandalwood throne, decorated with
pictures of chrysanthemums made with
inlaid jade
Qianlong Period, Qing Dynasty
Height: 108cm　Length: 110cm
Width: 83cm
Qing Court collection

五屏式座圍鑲漆板，仿"周制"嵌玉雕菊花、洞石。搭腦後捲。席心座面，束腰鏤空炮仗洞，下承托腮。鼓腿彭牙，牙條正中垂大窪堂肚。內翻馬蹄，下承須彌座。

周制是清代康乾時期流行的一種家具鑲嵌工藝，創始人是明嘉靖年間揚州的工匠周翥。特點是所鑲嵌的紋飾隆起，具有立體感，有如浮雕。

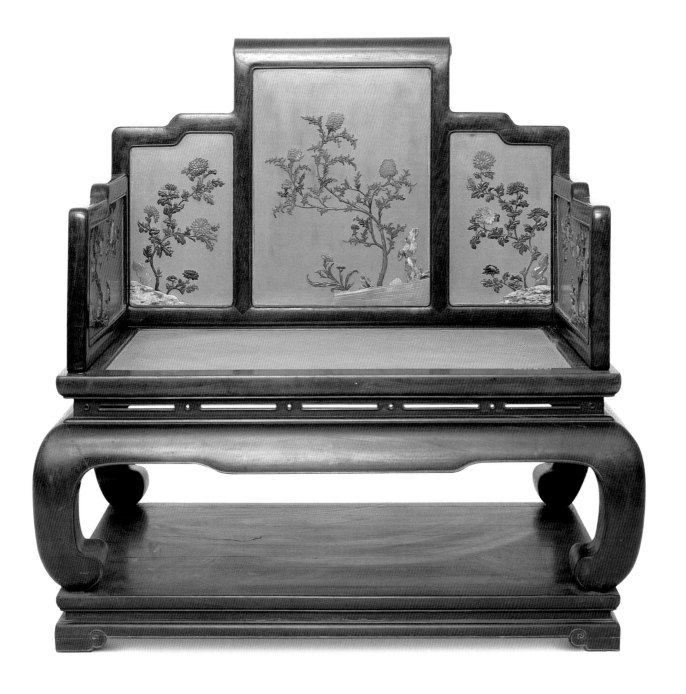

19

紫檀嵌染牙菊花圖寶座
清乾隆
高101.5厘米 長113.5厘米 寬78.5厘米
清宮舊藏

**Red sandalwood throne, decorated with
pictures of chrysanthemums made with
inlaid, stained ivory**
Qianlong Period, Qing Dynasty
Height: 101.5cm Length: 113.5cm
Width: 78.5cm
Qing Court collection

五屏式座圍，委角皆以銅製雲紋面葉
包裹，正中天藍色漆地，上仿"周制"
嵌染牙菊花圖。座面楠木製，四角亦
用銅製雲紋包角，面下打窪束腰，齊
牙條。拱肩直腿，內翻馬蹄，雲紋銅
套足。

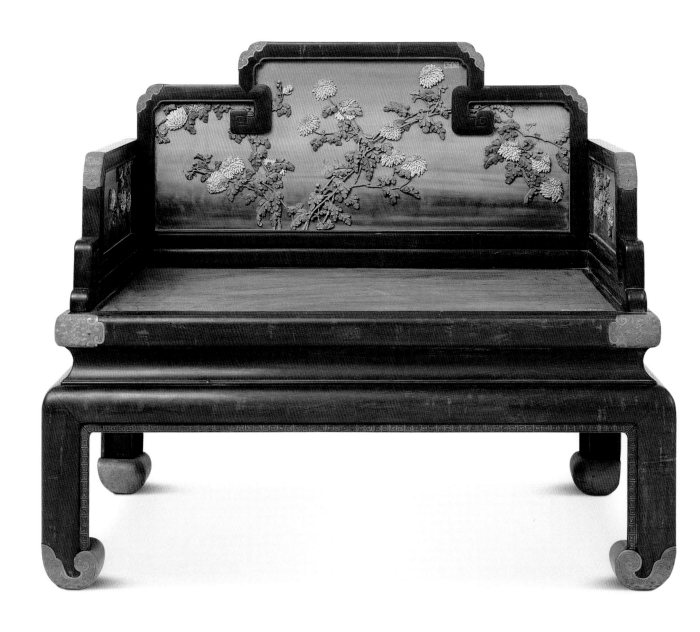

20

黑漆描金夔龍紋寶座
清中期
高121厘米　長137.5厘米　寬103厘米
清宮舊藏

Black lacquered throne, decorated with gold tracery Kui[1]-dragon patterns
Middle Qing Dynasty
Height: 121cm　Length: 137.5cm
Width: 103cm
Qing Court collection

三屏風式座圍，山形靠背正中圓形開光內飾番草紋，兩側為夔龍紋，靠背背面開光內外皆為《山水樓閣圖》。座面外沿和束腰上飾迴紋及花卉紋，寬牙條、腿部間飾山水樓閣及花卉圖紋。柱礎式足。

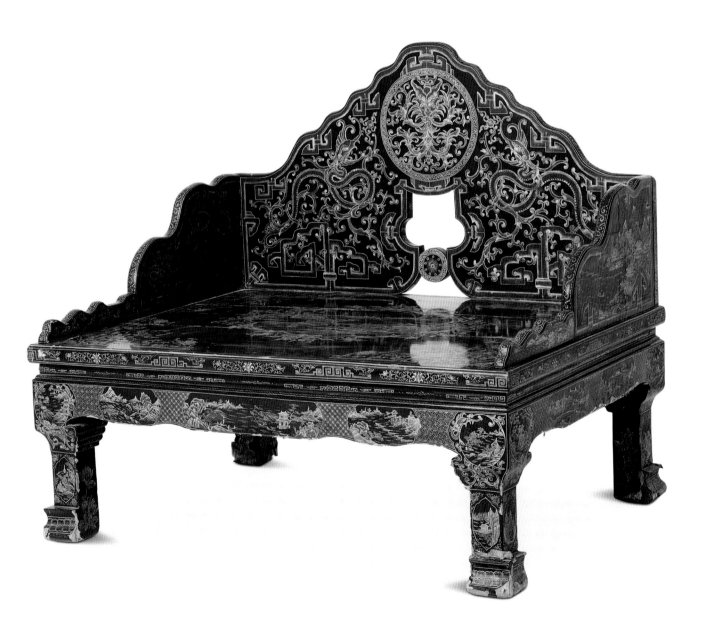

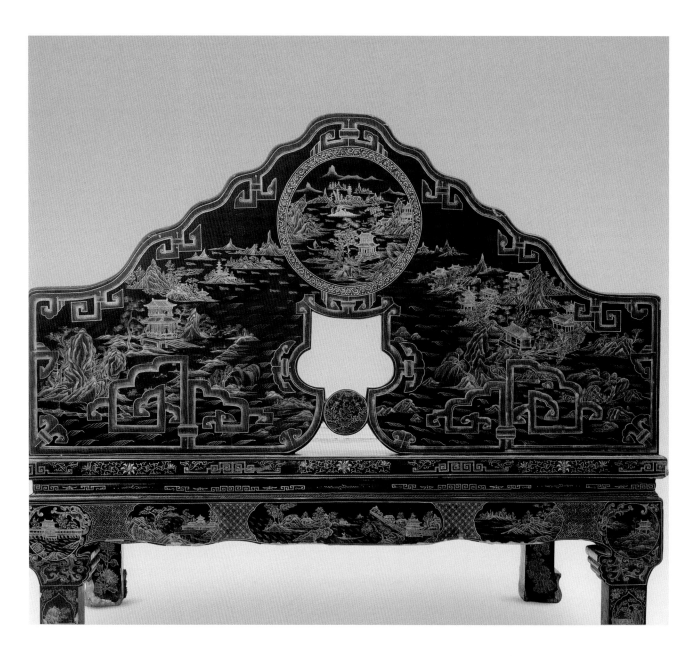

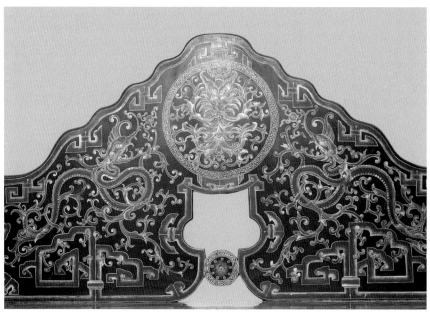

21

紫檀嵌瓷福壽紋寶座
清中期
高106厘米　長91厘米　寬67厘米
清宮舊藏

Red sandalwood throne, decorated with
inlaid porcelain panels featuring bats[4]
and the character "Shou" (longevity)
Middle Qing Dynasty
Height: 106cm　Length: 91cm
Width: 67cm
Qing Court collection

座圍嵌蝠壽紋瓷片。搭腦凸起，嵌一
塊條形瓷片。座面鑲嵌樺木板心，面
下高束腰，下有托腮，鼓腿彭牙，牙
條浮雕纏枝寶相花紋，雲紋曲沿，正
中垂窪堂肚。內翻馬蹄，下承須彌座
式托泥。

22

紫檀百寶嵌花果圖寶座
清中期
高99厘米　長127厘米　寬78厘米
清宮舊藏

Red sandalwood throne, decorated with
flower and fruit patterns made with
inlaid gems
Middle Qing Dynasty
Height: 99cm　Length: 127cm
Width: 78cm
Qing Court collection

三屏式座圍搭腦凸起似屏帽，向兩側
延伸成帽翅狀，雕海水雲龍紋，邊沿
雕迴紋。背板心淡藍色漆地上以百寶
嵌工藝飾葡萄及古樹。座面攢邊鑲板
心，面沿及腿、羅鍋棖皆做雙混面雙
邊綫。腿飾迴紋，如意雲頭紋足。

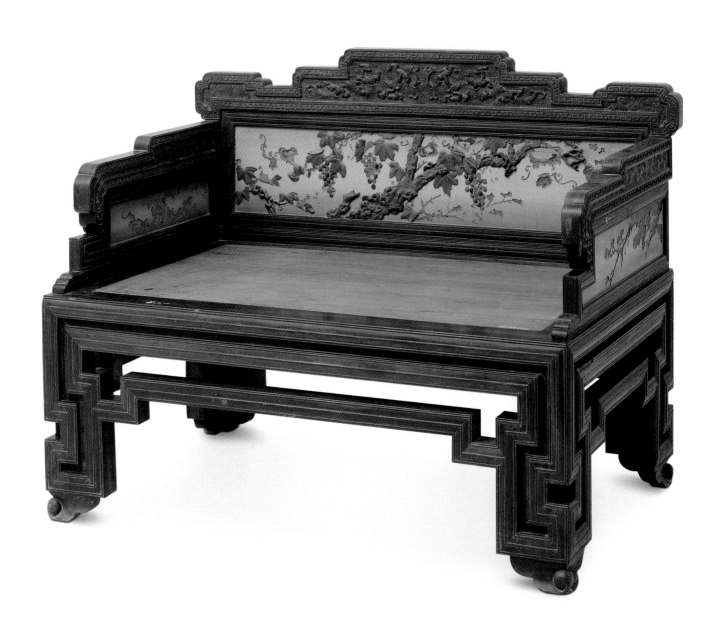

23

紅漆描金雲龍紋寶座
清
高130厘米 長130厘米 寬68厘米
清宮舊藏

Red lacquered throne, decorated with
gold tracery dragon and cloud patterns
Qing Dynasty
Height: 130cm Length: 130cm
Width: 68cm
Qing Court collection

五屏風式座圍鑲板心，飾雲龍紋、捲
草紋、蝙蝠紋，下透雕拐子紋亮腳。
座面下的束腰、壺門式牙條及方材直
腿上滿飾蝙蝠、花卉拐子紋。迴紋拐
子形足，下承羅鍋棖式托泥。座前附
雲紋腳踏。

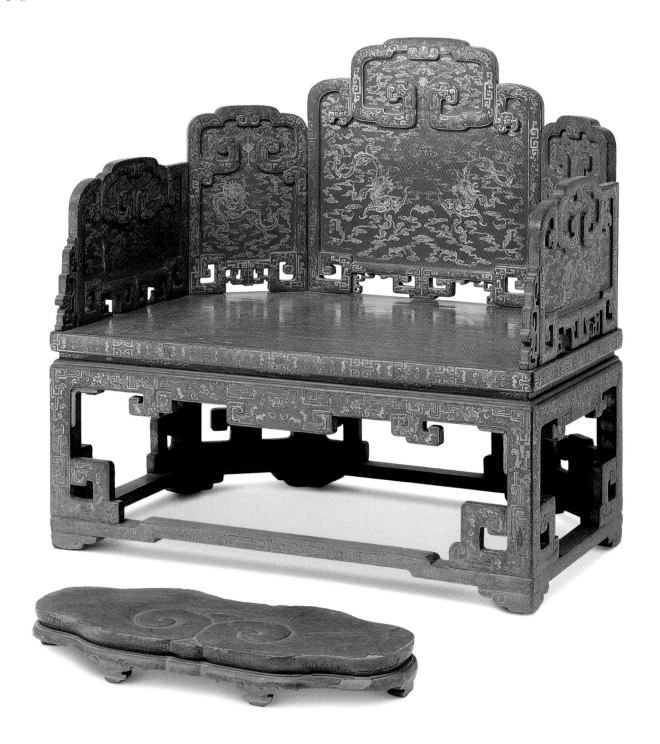

24

剔紅雲龍紋寶座
清
高108.5厘米　長231厘米　寬125厘米
清宮舊藏

Red lacquered throne, decorated with carvings of dragons and clouds
Qing Dynasty
Height: 108.5cm　Length: 231cm
Width: 125cm
Qing Court collection

三屏風式座圍雙面飾《魚龍變化圖》。座面理溝填金飾五龍，一條正面龍，四條行龍，並滿佈海水紋，座邊沿凸雕海水螭紋。座面下有海水紋束腰及牙條。內翻四足，下承雕海水紋托泥。

此寶座是目前所見剔紅器物之最大者。

25

紫檀嵌黃楊木福慶紋寶座
清
高112厘米　長118厘米　寬76厘米
清宮舊藏

Red sandalwood throne, decorated with a pattern consisting of bats[4] and the character "Shou" (longevity) made with inlaid boxwood
Qing Dynasty
Height: 112cm　Length: 118cm
Width: 76cm
Qing Court colleciton

五屏風式座圍鑲嵌黃楊木滿雕夔龍紋。靠背正中雕一蝙蝠紋懸磬，以諧音寓"福慶"之意。光素座面，外沿平直。面下束腰，上下托腮，牙條與直腿皆雕迴紋。內翻馬蹄，下承托泥。座前附長方形腳踏。

26

紫檀雲龍紋寶座
清
高132厘米　長126厘米　寬75厘米
清宮舊藏

Red sandalwood throne, decorated with carvings of dragons and clouds
Qing Dynasty
Height: 132cm　Length: 126cm
Width: 75cm
Qing Court collection

三屏風式座圍鑲板心，透雕雲龍海水紋，邊框雕捲草紋，扶手板心浮雕雲龍紋。曲形搭腦雕祥雲。座面光素，外側冰盤沿，面下打窪束腰，面沿及束腰浮雕輪、螺、傘、蓋、花、罐、魚、腸八寶紋。三彎腿，腿、牙皆浮雕雲龍紋，牙條正中垂窪堂肚。外翻馬蹄，下承鑲鎪空雙錢形托泥。

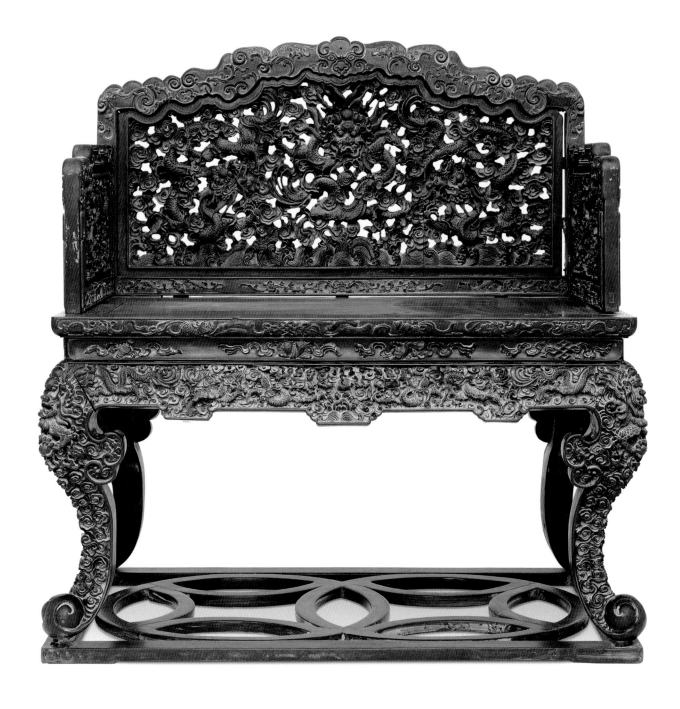

27

紫檀剔紅嵌銅龍紋寶座
清
高110厘米　長105.5厘米　寬78厘米
清宮舊藏

Red sandalwood throne, decorated with dragon-patterned copper appliqués on carved red lacquer-ware panels
Qing Dynasty
Height: 110cm　Length: 105.5cm
Width: 78cm
Qing Court collection

九屏風式座圍，以剔紅卍字錦紋地，嵌菱形正面龍紋鍍金銅牌。邊沿浮雕雲蝠紋和纏枝蓮紋，座面為紅漆地描金菱形花紋，邊沿雕迴紋，面下束腰嵌雲龍紋鍍金銅牌，牙條上雕蝠、桃、卍字及西番蓮紋，寓"福壽無邊"之意。腿部雕拐子紋，足下承雕迴紋托泥。

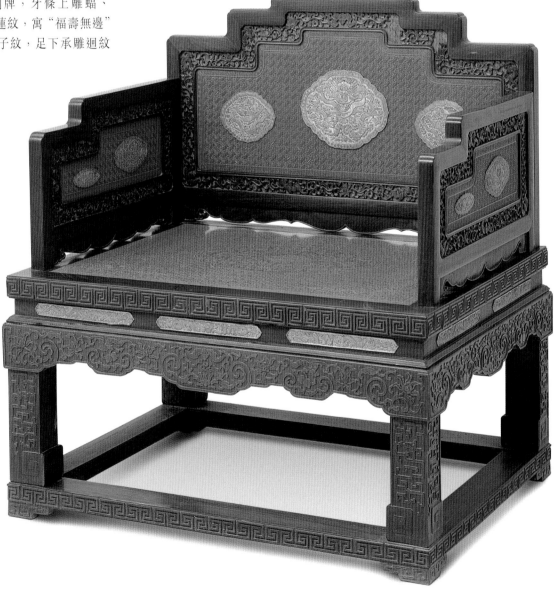

28

黑漆描金海屋添籌圖寶座
清
高107厘米　長138.5厘米　寬104厘米
清宮舊藏

Black lacquered throne, decorated with gold tracery Hai Wu Tian Chou[5] pictures
Qing Dynasty
Height: 107cm　Length: 138.5cm
Width: 104cm
Qing Court collection

五屏風式座圍靠背正中飾描金《海屋
添籌圖》，寓長壽之意，兩側飾《山水
樓閣圖》。座面飾描金花草紋，外沿
飾描金迴紋。束腰平直，曲形牙條與
三彎腿飾描金山水、花草圖紋，外翻
雲紋足。

"海屋添籌"寓"添壽"之意。傳說海
中有一樓，樓內有一瓶，瓶內儲有世
間人們的壽數，如能將一籌添入瓶
中，便可多活百年。

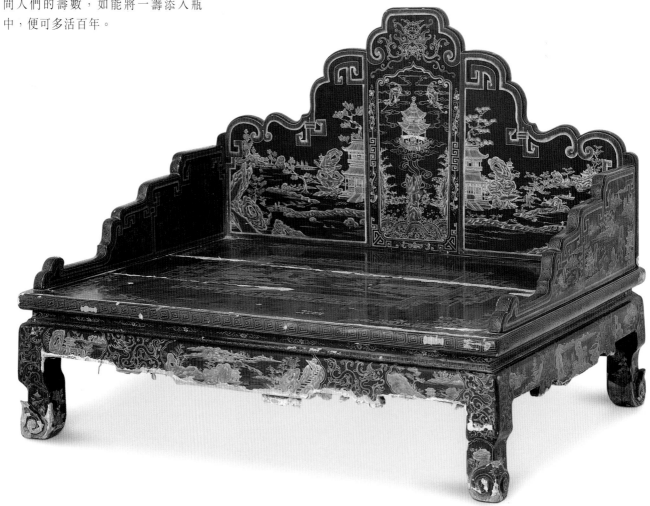

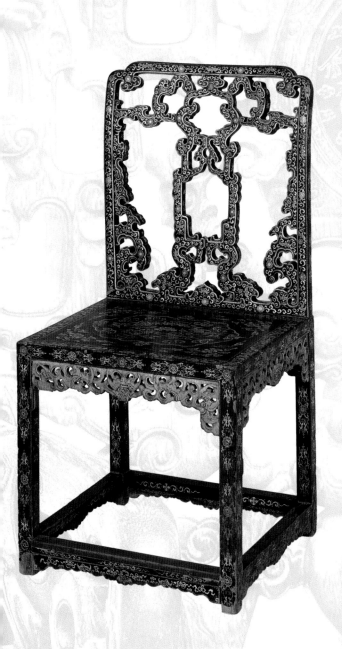

椅凳墩

Chairs and Stools

黑漆髹金雲龍紋交椅
清早期
高105.5厘米　長52.5厘米　寬41厘米
清宮舊藏

Black, lacquered folding chair, decorated with dragon and cloud patterns in gold lacquer
Early Qing Dynasty
Height: 105.5cm　Length: 52.5cm
Width: 41cm
Qing Court collection

五稜形椅圈與扶手前部龍首相連，整體形成兩條蜿蜒的龍形。靠背板正面髹金漆雕"蒼龍教子"，背面雕《五嶽真形圖》，襯以雲水紋，道教認為此圖象徵華夏五大名山，佩帶可以逢凶化吉。椅圈、背板及扶手間飾雲紋，均髹金漆。席心座面，面前梁兩端雕螭首，面下腿間透雕夔鳳紋牙子。足下承托泥，前附腳踏。

交椅別稱"胡牀"，即前後腿相交為軸、座面能摺疊的椅子，源於匈奴，便於游牧民族使用，後逐漸發展為皇帝出行儀仗（鹵簿）中所用之物，多以韌性較好的楠木或楸木為骨架，外髹金漆。

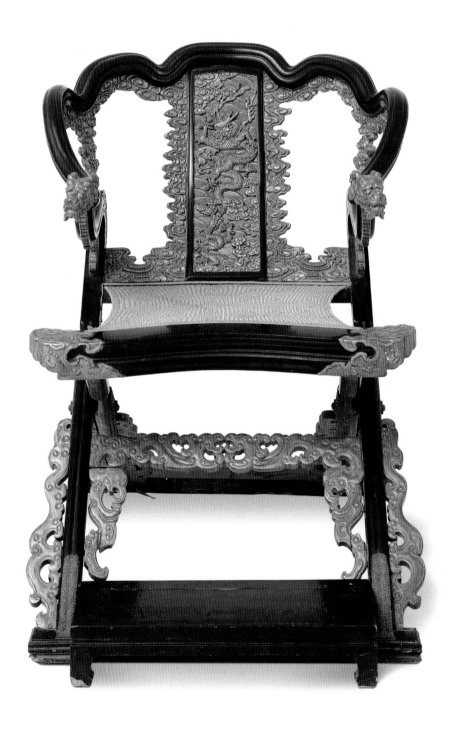

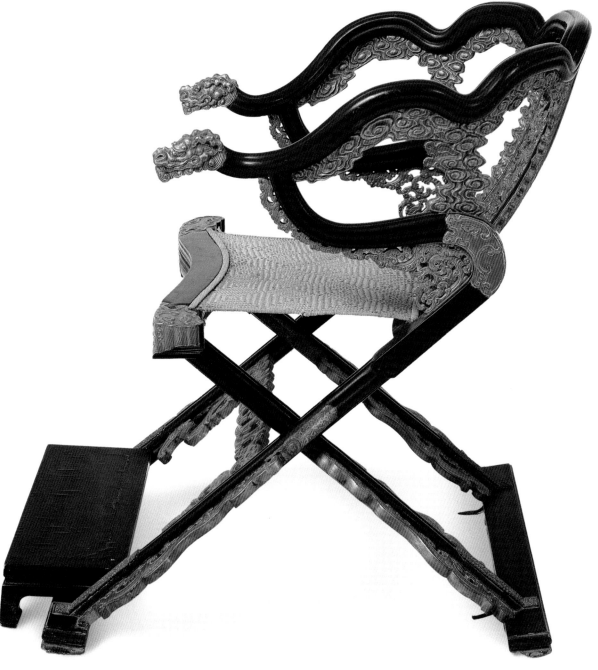

30

紅漆髹金雲龍紋大交椅
清早期
高121厘米　長107.5厘米　寬104厘米
清宮舊藏

Large, red lacquered folding chair,
decorated with dragon and cloud
patterns in gold lacquer
Early Qing Dynasty
Height: 121cm　Length: 107.5cm
Width: 104cm
Qing Court collection

五稜形椅圈與扶手處圓雕螭首相連，
頗似兩條蜿蜒曲折的螭龍。背板髹金
漆雕"蒼龍教子"，雙龍一上一下，大
龍在雲間叫海中小龍升天。席心座
面，面下牙條上浮雕雲龍紋，腿間透
雕夔鳳紋牙子。足下承托泥，前附腳
踏。

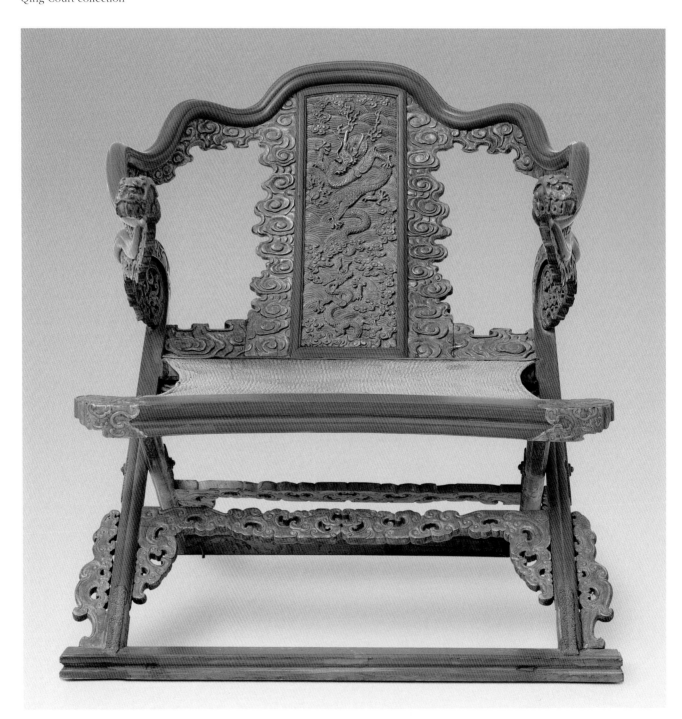

31

金漆龍紋交椅
清早期
高100厘米 長70厘米 寬65厘米
清宮舊藏

Gold lacquered folding chair, decorated with dragon patterns
Early Qing Dynasty
Height: 100cm　Length: 70cm
Width: 65cm
Qing Court collection

椅圈自搭腦中部向兩側扶手一順而下，弧度婉延流暢，扶手出頭處雕捲草紋。靠背板中間加橫棖，分段嵌裝縧環板，將背板分成上下兩部分，上段開光內雕正龍、海水江崖及祥雲紋，下段雕捲草紋，透出雲紋亮腳，靠背板與椅圈相交處及兩側扶手的下端均安有雲紋角牙。座面為軟屜，面

下的前後腿相交處有銅鍍金飾件連接固定。圓腿直足，下承長方形足托。

此椅製作精緻，紋飾尊貴，是皇帝大駕鹵簿和法駕鹵簿中必備之物。

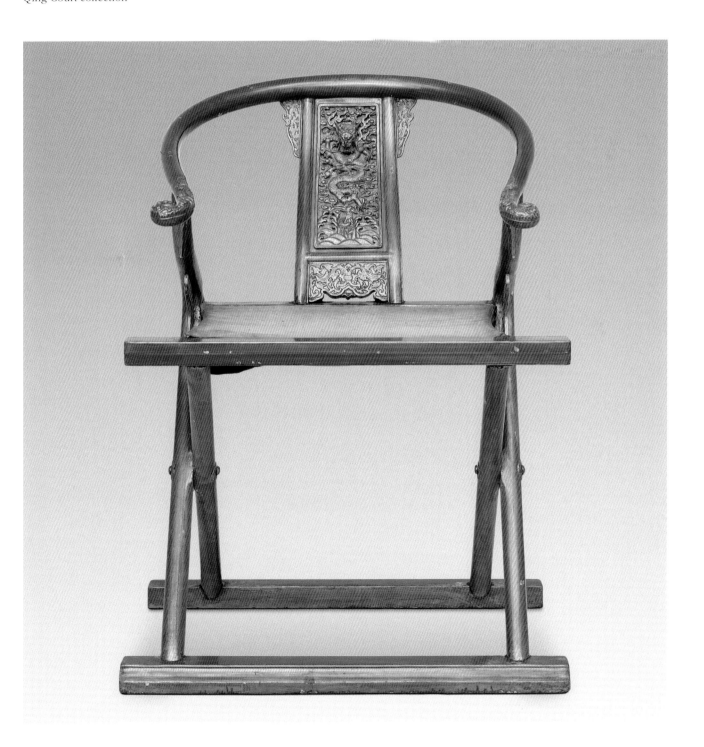

32

黃花梨直後背交椅
清
高105.5厘米　長55厘米　寬36.5厘米
清宮舊藏

Huanghuali[6] wooden folding chair with straight back
Qing Dynasty
Height: 105.5cm　Length: 55cm
Width: 36.5cm
Qing Court collection

捲書式搭腦，三屏風式直靠背，框內安透雕拐子紋的縧環板繫壁花牙。絲編座面。方腿直足，下承長方形足托。

直後背交椅在清代極為流行，其靠背兩側外框多與椅子的腿足一木連做。此椅靠背另安，藉銅箍與椅橫材連結。

33

榆木捲葉紋扶手椅
清早期
高98厘米　長58厘米　寬43厘米
清宮舊藏

Elm armchair, decorated with scrolled leaf patterns
Early Qing Dynasty
Height: 98cm　Length: 58cm
Width: 43cm
Qing Court collection

背板雕束帶捲葉紋，扶手煙袋鍋式，鐮刀把式聯幫棍。座面光素。椅盤下三面壼門式券口，圓腿直足，腿間安有步步高管腳棖。

此椅原為清宮軍機處值房所用。榆木等柴木家具在清代使用範圍最廣。

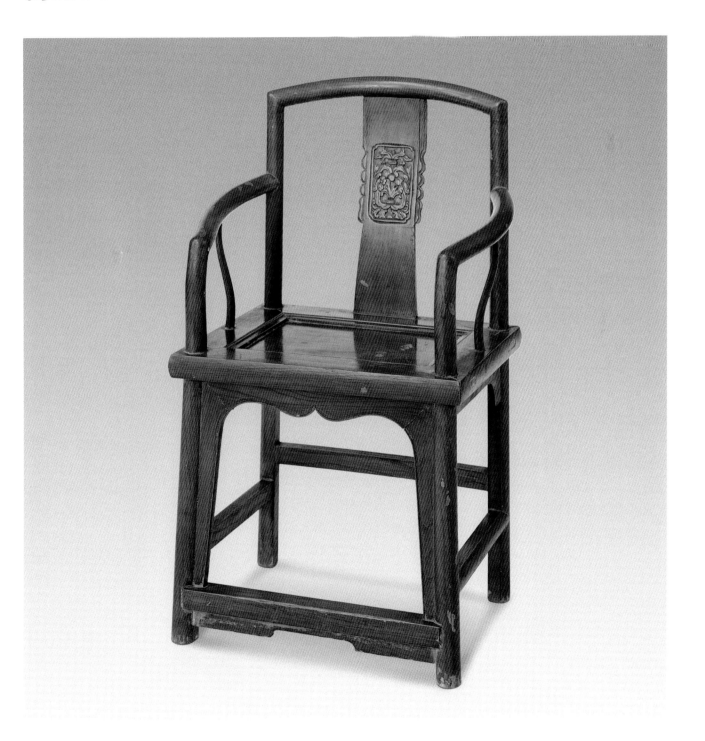

34

紫檀描金萬福紋扶手椅
清雍正至乾隆
高104厘米　長67厘米　寬57厘米
清宮舊藏

Red sandalwood armchair, decorated
with gold tracery swastika and bat
patterns
Yongzheng-Qianlong Period, Qing Dynasty
Height: 104cm　Length: 67cm
Width: 57cm
Qing Court collection

靠背、扶手皆用小料做成拐子紋。靠
背中心為卍字紋，邊框上滿繪蝙蝠、
纏枝花紋，寓意"萬福"。座面貼草
蓆。面下束腰浮雕縧環板，上飾花卉
紋，下有托腮。牙條正中垂帶透孔窪
堂肚。拱肩下浮雕雲紋，展腿拐角處
安捲雲紋角牙。雕迴紋內翻馬蹄。

清式扶手椅重裝飾和雕刻，但忽略了
家具的科學性，大多靠背垂直，沒有
側腳收分。坐靠並不舒適。

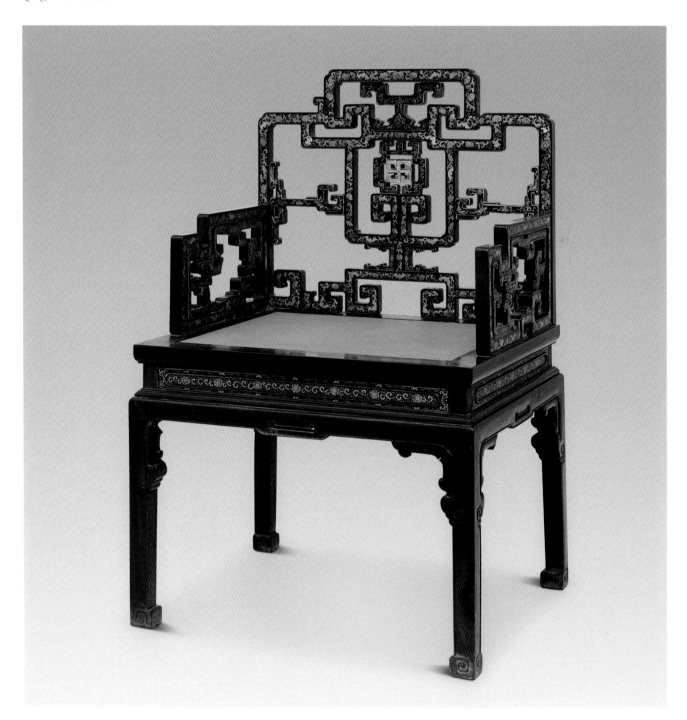

35

紫檀雕福慶紋藤心扶手椅
清乾隆
高85.5厘米　長53.5厘米　寬42厘米
清宮舊藏

Red sandalwood armchair with rattan
seat, decorated with a carving of a bat
holding a stone in its mouth[8]
Qianlong Period, Qing Dynasty
Height: 85.5cm　Length: 53.5cm
Width: 42cm
Qing Court collection

如意雲頭形搭腦與靠背板正中透雕蝙
蝠啣磬，以諧音寓"福壽吉慶"之意，
兩側飾拐子紋。藤心座面，面下束腰
裝托腮，拱肩直腿。內翻捲雲紋足踩
圓珠，下承橢圓形托泥。

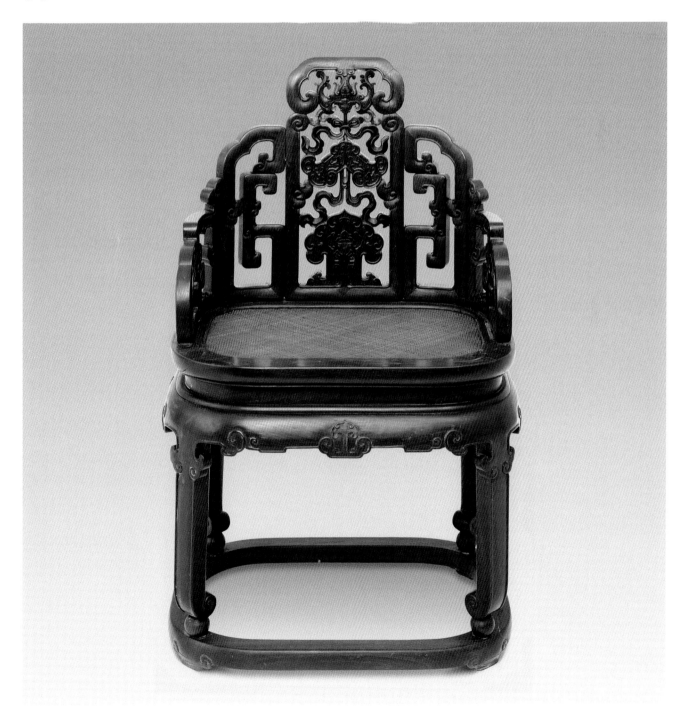

36

紫檀嵌玉花卉紋扶手椅
清乾隆
高89.5厘米　長60厘米　寬42.5厘米
清宮舊藏

Red sandalwood armchair, decorated with a floral picture made with inlaid jade

Qianlong Period, Qing Dynasty
Height: 89.5cm　Length: 60cm
Width: 42.5cm
Qing Court collection

如意雲頭形搭腦與靠背、扶手的雲頭紋勾捲相連，靠背板正中嵌玉製花卉紋，下端鎪出雲頭形亮腳。座面方中帶圓，面下束腰雕連環雲頭紋，下有托腮。披肩式窪堂肚牙子雕魚水紋。外翻如意形四足，下承委角方形托泥，帶雲頭紋龜腳。

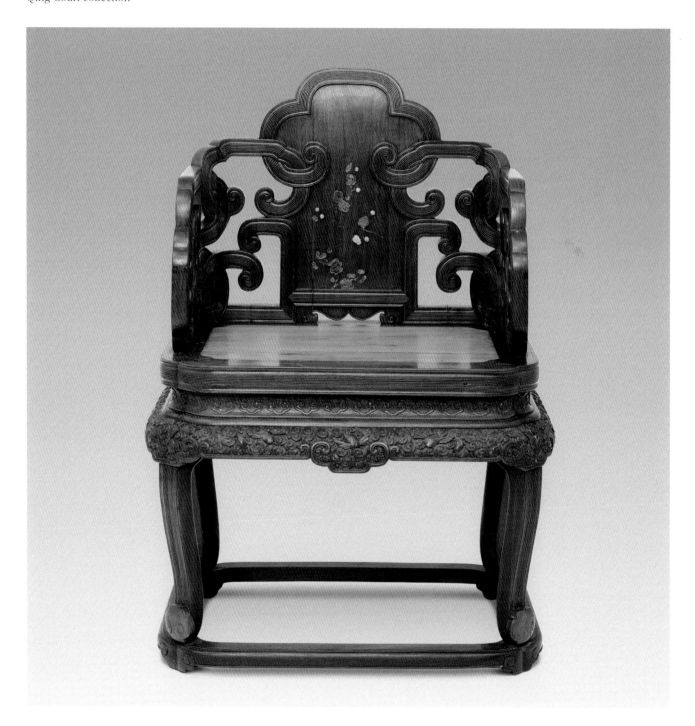

37

紫檀福慶紋扶手椅
清乾隆
高106.5厘米　長63.5厘米　寬48厘米
清宮舊藏

**Red sandalwood armchair, decorated
with carvings of a bat holding a stone in
its mouth**[8]
Qianlong Period, Qing Dynasty
Height: 106.5cm　Length: 63.5cm
Width: 48cm
Qing Court collection

靠背板上雕蝠磬紋，寓"福慶"之意。
搭腦、立柱透雕捲雲紋，與背板相
連，背板與立柱的內邊均透雕拐子
紋，兩側扶手婉轉而下，成捲雲狀。
扶手中間透雕立瓶式拐子紋。座面下
束腰並透雕拐子紋角牙。腿間安有四
面平管腳棖。

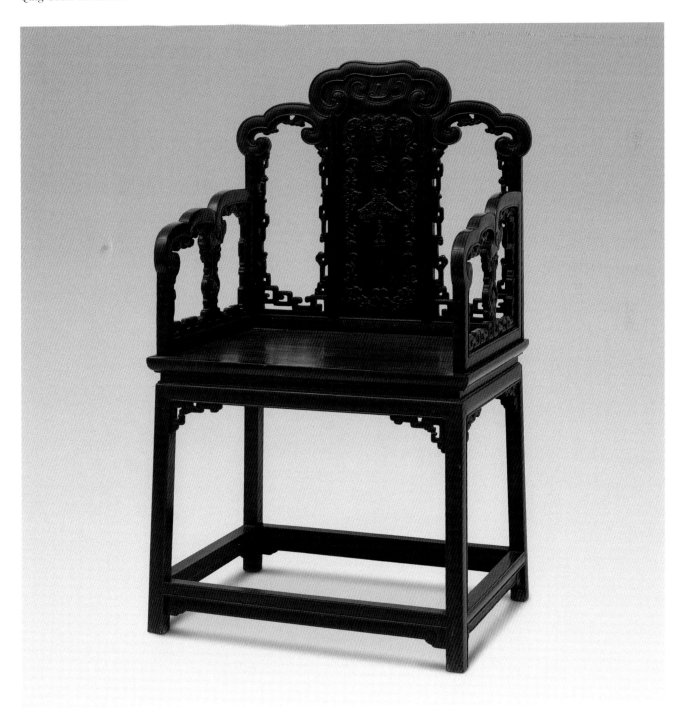

38

雞翅木嵌烏木龜背紋扶手椅
清乾隆
高83厘米　長54厘米　寬42厘米
清宮舊藏

**Jichimu[9] wooden armchair, decorated
with ebony inlays and tortoiseshell-
patterned carvings**
Qianlong Period, Qing Dynasty
Height: 83cm　Length: 54cm
Width: 42cm
Qing Court collection

靠背以兩捲雲紋相抵作框架，正中鑲
板，透雕龜背錦紋為地。其上浮雕珪
形框，兩側為圓形開光透洞，扶手亦
取同樣作法。座面下打窪高束腰，透
雕龜背錦紋。鼓腿彭牙，大挖馬蹄下
承托泥。

此椅表面打槽鑲嵌隨形烏木細絲，呈
現不同色彩和質感。

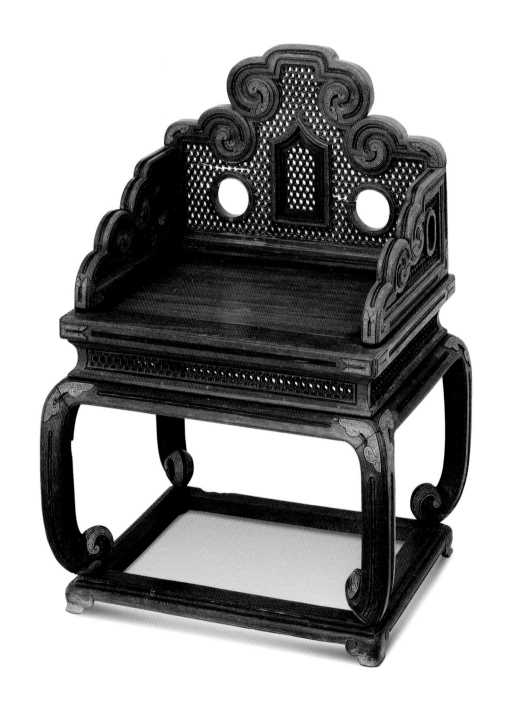

39

紫檀西洋花紋扶手椅
清乾隆
高117.5厘米　長66厘米　寬51.5厘米
清宮舊藏

**Red sandalwood armchair, decorated
with Western style carvings**
Qianlong Period, Qing Dynasty
Height: 117.5cm　Length: 66cm
Width: 51.5cm
Qing Court collection

靠背板作瓶形，雕西洋花紋。靠背邊框
及扶手亦西洋式與巴洛克式搭腦相連，
座面下束腰雕捲雲紋。曲邊牙條上雕西
化了的玉寶珠紋。三彎腿，上部雕西洋
花紋。鷹爪抓珠式足，下承帶龜腳托
泥。

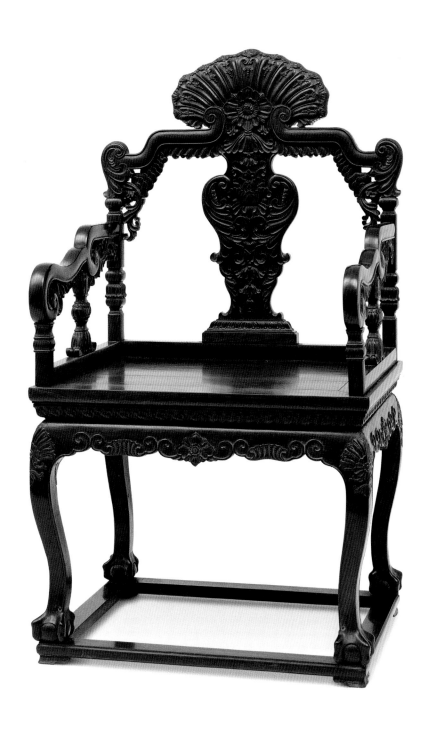

40

紫檀福壽紋扶手椅
清乾隆
高108.5厘米　長65.5厘米
寬51.5厘米
清宮舊藏

Red sandalwood armchair, decorated with carvings of bats[4] and the character "Shou" (longevity)
Qianlong Period, Qing Dynasty
Height: 108.5cm　Length: 65.5cm
Width: 51.5cm
Qing Court collection

靠背正中搭腦凸起，靠背板雕"壽"字
和蝙蝠，扶手為四迴紋形，整體造型
寓意"福壽無邊"。座面下束腰平直。
方腿直足，各上角皆飾托角牙，四面
平底棖。

此椅係乾隆年間萬壽慶典所用之物。

41

紫檀嵌黃楊木蝠螭紋扶手椅
清乾隆
高99厘米　長66厘米　寬51厘米
清宮舊藏

Red sandalwood armchair, decorated
with bat[4] and hornless dragon patterns
made with inlaid boxwood
Qianlong Period, Qing Dynasty
Height: 99cm　Length: 66cm
Width: 51cm
Qing Court collection

靠背板雕成瓶式，上嵌蝙蝠及雙螭
紋，曲綫形搭腦雕雲紋與扶手上沿係
一木鎪成。座面側沿混面，束腰上下
托腮，牙條透雕拐子紋。方腿內側起
單邊綫，四面平底棖起雙邊綫，與
腿、牙綫腳交圈。

42

紫檀竹節紋扶手椅
清乾隆至嘉慶
高93厘米　長58厘米　寬49厘米
清宮舊藏

**Red sandalwood armchair, carved to
resemble jointed bamboo**
Qianlong-Jiaqing Period, Qing Dynasty
Height: 93cm　Length: 58cm
Width: 49cm
Qing Court collection

搭腦、靠背及扶手均仿竹節，靠背板
自上而下由三段攢成，形成長方形圈
口，扶手用攢拐子作。座面鑲硬屜
板，座邊沿亦雕竹節紋，座面之下安
有弓背牙子，圓材直腿，四面平式管
腳棖。牙子、腿、足及棖上皆雕成竹
節狀。

43

紫檀夔鳳紋扶手椅
清
高81厘米　長53厘米　寬42厘米
清宮舊藏

**Red sandalwood armchair, decorated
with Kui[1]-phoenix patterns**
Qing Dynasty
Height: 81cm　Length: 53cm
Width: 42cm
Qing Court collection

捲書式搭腦，開夔鳳唧尾紋透孔。靠
背板分兩段攢成，上段開長方形亮
洞，下段鎪出雲頭形亮腳，靠背板與
邊框之間以拐子紋攢成。兩側扶手與
靠背活榫相接。座面裝硬板，面下束
腰。腿間安四面平底棖，內翻馬蹄。

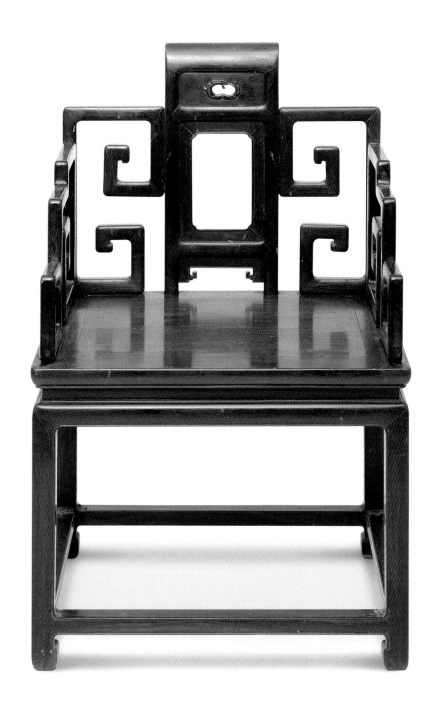

44

紅漆描金夔龍福壽紋扶手椅
清
高94厘米　長62厘米　寬48厘米
清宮舊藏

Red lacquered armchair, decorated with gold tracery pictures of Kui[1]-dragons, bats[4] and the character "Shou" (longevity)
Qing Dynasty
Height: 94cm　Length: 62cm
Width: 48cm
Qing Court collection

捲書式搭腦與靠背板連為一體，繪雙夔龍蝠壽紋，下端透雕雲紋亮腳。扶手框、靠背框亦花牙式相接。座面理溝餞金五蝠捧壽紋，前伸彎轉下垂至地面，形成魚肚圈口，圈口沿飾雙龍及纏枝花卉紋。方腿，三面橫棖，兩側橫棖攢拐子紋。

此椅前兩腿與座面實為一體，其造型在同類椅中頗為獨特。

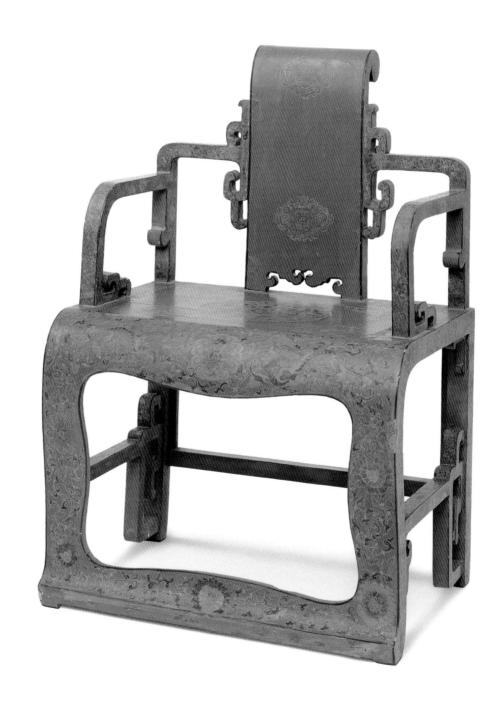

45

棕竹嵌玉三羊開泰紋扶手椅

清
高93.5厘米 長65厘米 寬51.5厘米
清宮舊藏

Black bamboo armchair, decorated with a pattern of three rams made with inlaid jade

Qing Dynasty
Height: 93.5cm Length: 65cm
Width: 51.5cm
Qing Court collection

靠背板髹黑漆，上部為描金雙夔龍紋；正中嵌青玉片，上為菱形，鏤雕夔龍玉璧紋；下為長方形，雕《三羊開泰圖》。搭腦略後捲。靠背兩側與扶手呈拐子紋。坐面及側沿飾描金漆捲草及拐子紋。四腿及根子或四劈料，或二劈料攢成。牙條、根子下部及扶手、靠背的空當處，均以湘妃竹攢成拐子紋鑲嵌花牙，棕竹和湘妃竹外露的斷面都以象牙片封堵。

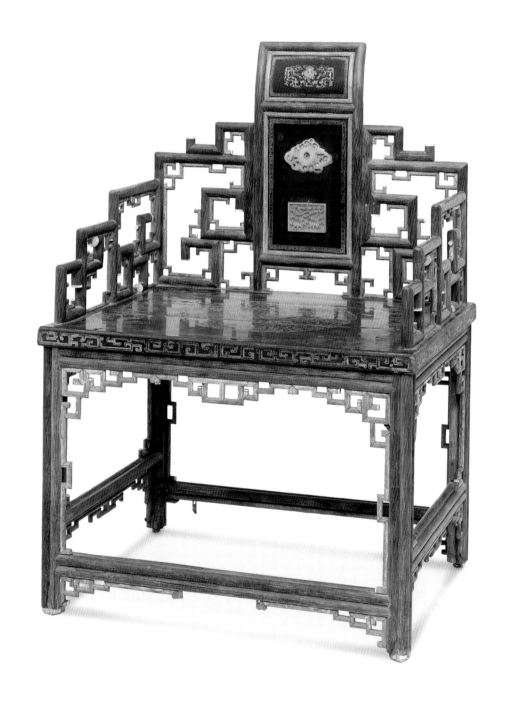

46

紫檀雲蝠紋扶手椅
清
高91厘米　長66厘米　寬51厘米
清宮舊藏

Red sandalwood armchair, decorated with bat[4] and cloud patterned carvings
Qing Dynasty
Height: 91cm　Length: 66cm
Width: 51cm
Qing Court collection

靠背板分三段攢成，上段與中段均為
落堂踩鼓做，上段"凸"字形開光內雕
雲蝠紋，中段長方形開光，內雕雲蝠
紋，下段雕蝠紋為亮腳，靠背立柱與
扶手為攢拐子做。座面下束腰雕捲草
紋。直腿上端安羅鍋棖，下接管腳
棖，內翻迴紋馬蹄。

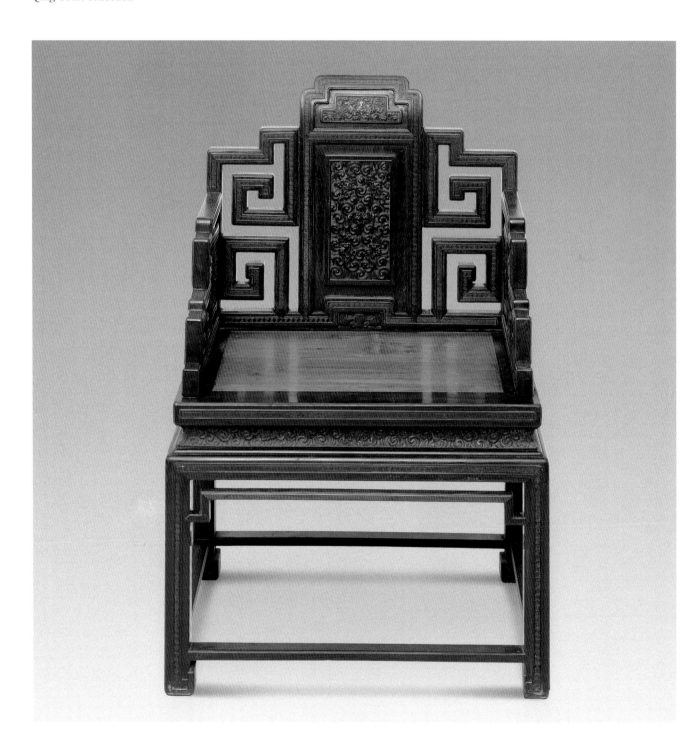

47

紫檀拐子紋扶手椅

清

高92.5厘米　長58厘米　寬47厘米

清宮舊藏

Red sandalwood armchair, decorated with Kui[1] patterns

Qing Dynasty

Height: 92.5cm　Length: 58cm

Width: 47cm

Qing Court collection

靠背板鏤空拐子紋。框式扶手，鑲拐子紋立柱。座面四角攢邊框鑲板心。面下有迴紋式牙條，腿內側起陽綫，與座面邊框棕角榫相連，四面平管腳棖下連羅鍋棖。

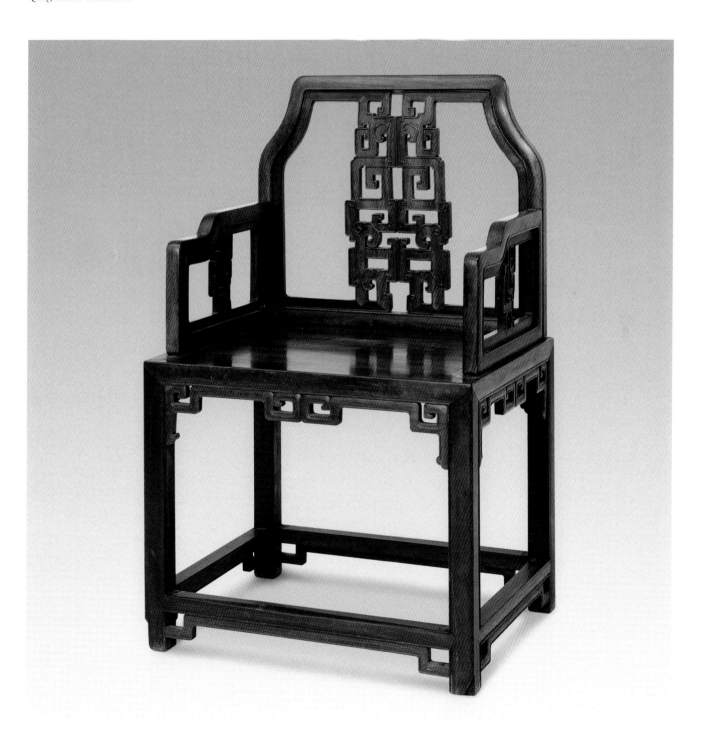

48

雞翅木嵌正龍紋扶手椅
清
高108.5厘米　長66.5厘米　寬50.5厘米
清宮舊藏

Jichimu[9] wooden armchair, decorated
with a dragon pattern on inlaid jade
Qing Dynasty
Height: 108.5cm　Length: 66.5cm
Width: 50.5cm
Qing Court collection

靠背板及扶手雕螭紋，靠背中心嵌墨
玉，其上陰刻描金正龍紋。座面下束
腰，有透雕螭紋角牙。方腿內側邊緣
起陽綫，四面平式管腳根，內翻迴紋
馬蹄。

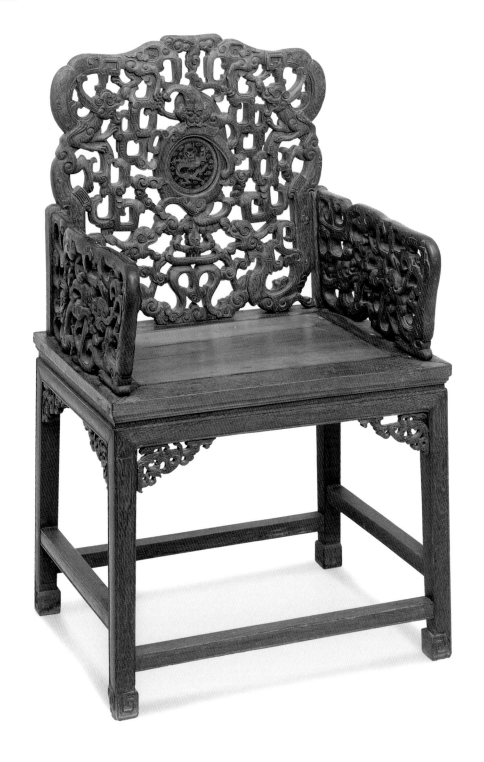

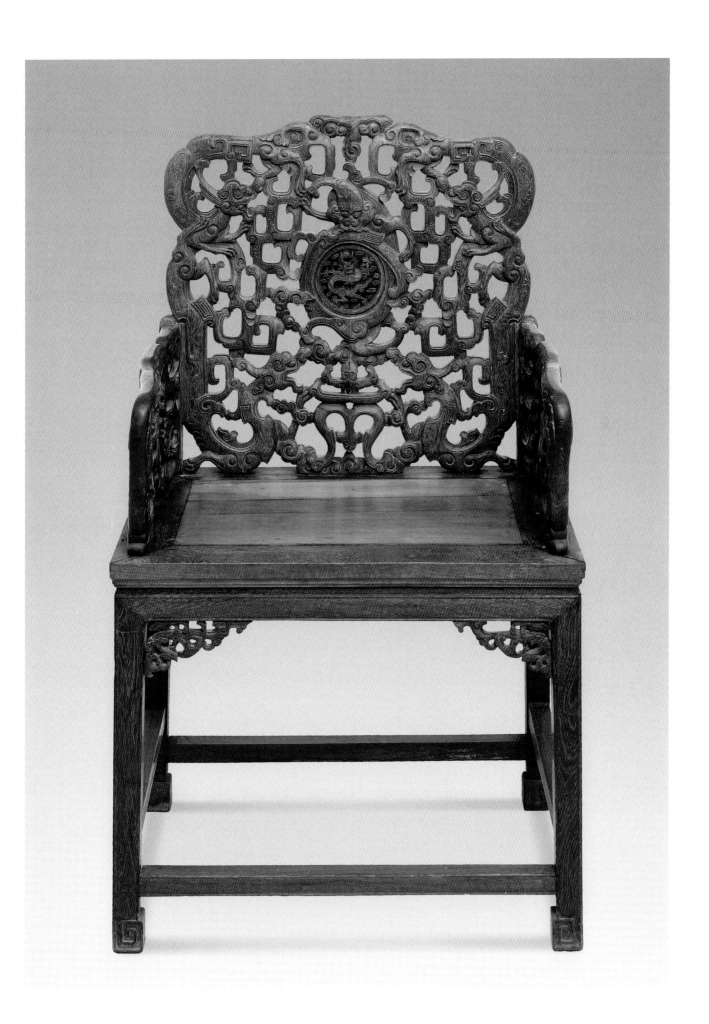

49

黑漆描金西洋花草紋扶手椅
清
高102.5厘米　長57厘米　寬47厘米
清宮舊藏

Black lacquered armchair, decorated with Western styled, gold tracery flower and grass patterns
Qing Dynasty
Height: 102.5cm　Length: 57cm
Width: 47cm
Qing Court collection

靠背板飾描金西洋式團花及捲草紋，下有拱券形開光，開光兩側及扶手雕成迴紋形狀。座面鑲裝板心，面下正面為壺門式券口牙條，上雕雲龍紋。四腿帶叉，上收下張，飾描金花草紋。步步高管腳根雕龍首。

此椅扶手和搭腦兩端均不出頭，此式樣又名"南官帽式椅"。

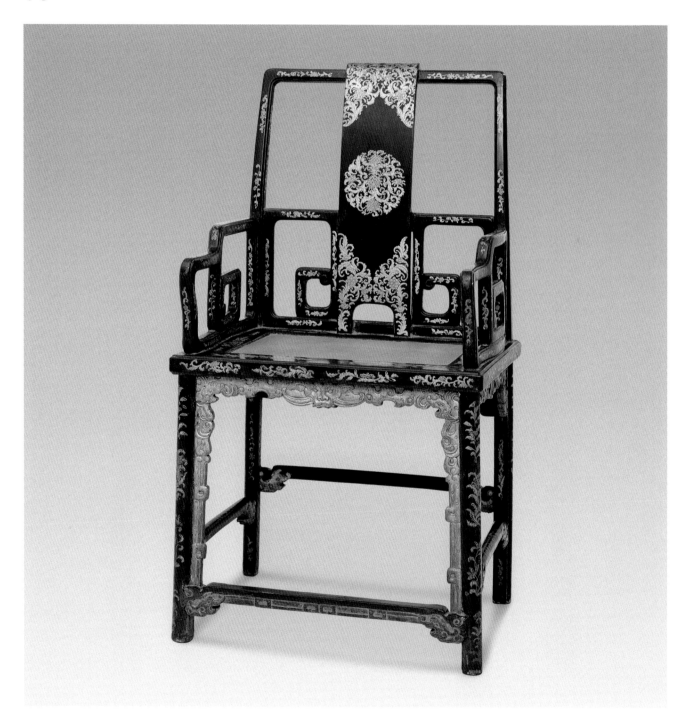

50

榆木異獸紋扶手椅
清晚期
高104厘米　面徑56厘米
清宮舊藏

**Elm armchair, decorated with patterns
made up of rare animals**
Late Qing Dynasty
Height: 104cm　Diameter of top: 56cm
Qing Court collection

靠背四抹攢框鑲板，邊框雕拐子紋，板心上部雕鳳，下部雕麒麟，中間一塊雕《魚龍變化圖》，兩側為博古紋。四角留四透孔，鑲透雕拐子紋花牙。扶手由三條纏繞蜿蜒的虯龍組成，空隙處鑲透雕花牙。座面下呈香几形，

束腰浮雕捲草紋，牙條浮雕夔龍及捲雲紋。三彎腿，圓雕龍首形足，下承圓形托泥。

此椅一反清代扶手椅的造型，將座面下設計成香几形，優美獨特。

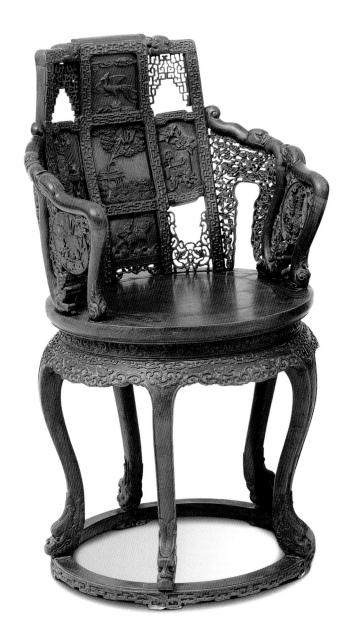
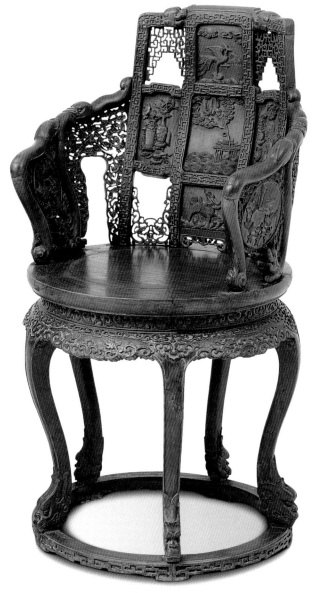

51

黃花梨福壽紋矮坐椅
清早期
高74厘米　長78厘米　寬58厘米
清宮舊藏

Low, Huanghuali[6] wooden armchair,
decorated with a pattern consisting of
Kui[1]-dragons, bats[4] and a circular "Shou"
(longevity) character
Early Qing Dynasty
Height: 74cm　Length: 78cm
Width: 58cm
Qing Court collection

捲書式搭腦，靠背板攢框鑲心，正中
雕雙夔龍及蝙蝠、團壽字紋，寓"雙
龍捧壽"和"福壽"之意，兩側以攢拐
子紋與背板連接，扶手亦取同樣作
法。藤心座面，下有束腰，牙條下裝
鏤空拐子形花牙。方腿，內翻馬蹄，
下承托泥。

此椅又寬又大，靠背卻比較矮小，不
合常規尺寸，據史料可知是船上所
用，其寬大的體積可以增強穩定性。

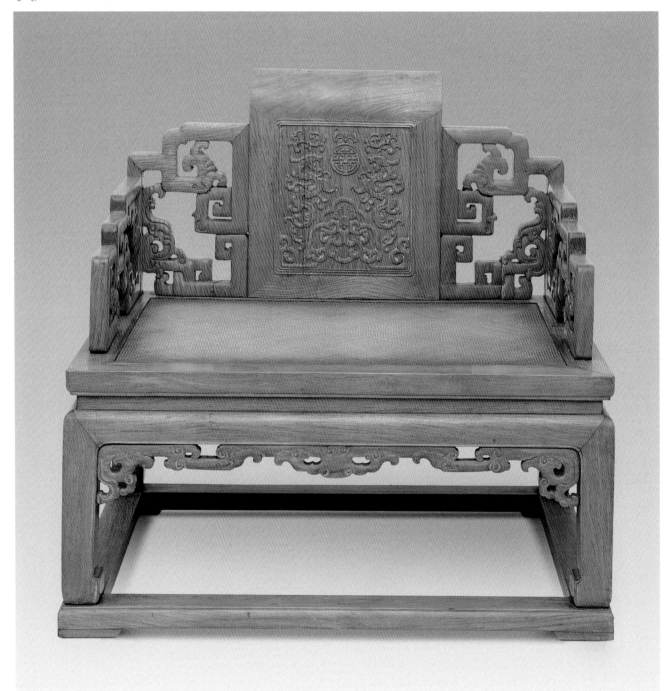

紫檀嵌粉彩四季花鳥圖瓷片椅
清雍正
高88.5厘米　長55.5厘米　寬44.5厘米
清宮舊藏

Red, sandalwood chair, decorated with
inlaid porcelain panels with pictures of
birds and flowers made from famille
rose[10]
Yongzheng Period, Qing Dynasty
Height: 88.5cm　Length: 55.5cm
Width: 44.5cm
Qing Court collection

七屏風式椅圍和捲書式搭腦，皆紫檀
木邊框鑲癭木心，嵌寓意吉祥的粉彩
四季花鳥圖瓷片，座面下束腰嵌癭
木，下有托腮，牙條正中垂迴紋窪堂
肚。腿間安有四面平管腳棖，迴紋馬
蹄。

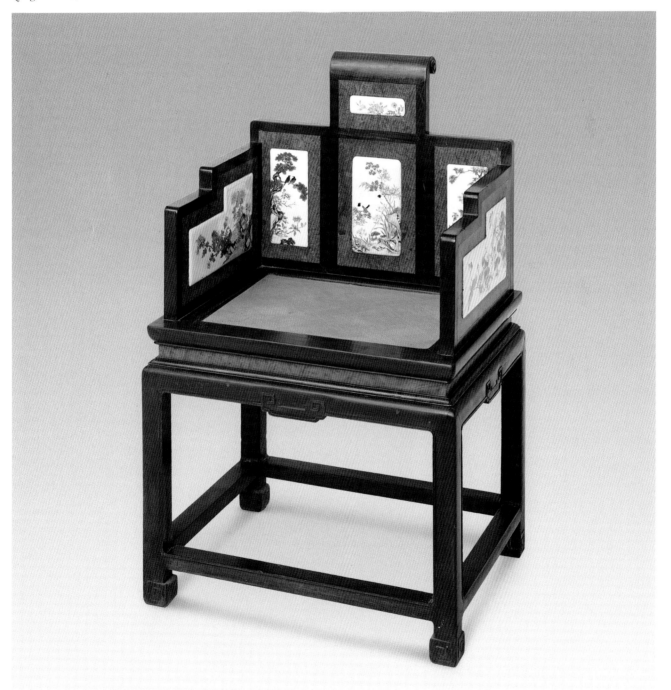

53

紫檀嵌樺木夔鳳紋椅
清雍正至乾隆
高92.5厘米 長85.5厘米 寬44厘米
清宮舊藏

**Red sandalwood chair, decorated with
inlaid birch wood and carvings of Kui[1]-
phoenixes**
Yongzheng-Qianglong Period, Qing
Dynasty
Height: 92.5cm Length: 85.5cm
Width: 44cm
Qing Court collection

三屏風式椅圍，皆紫檀木內鑲樺樹癭
木心，浮雕迴紋及拐子紋，正中雕夔
鳳紋。搭腦正中後捲，靠背及扶手均
為直角活榫組合，可以拆裝。席心座
面，直束腰，下裝托腮。牙條正中垂
窪堂肚，腿間安有四面平底棖，雲頭
紋足。

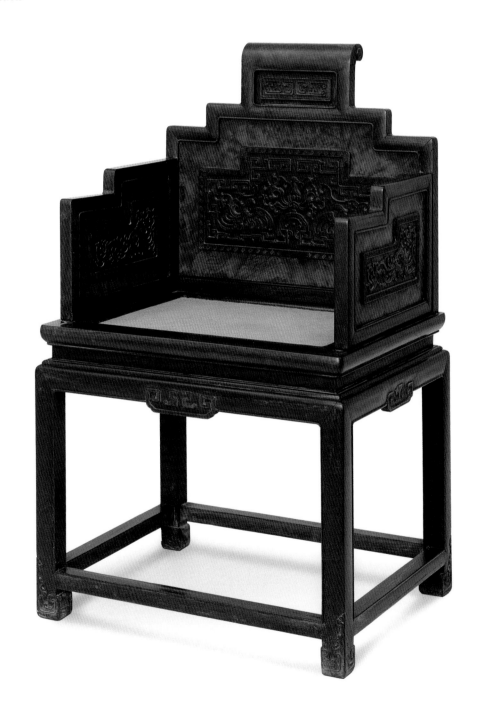

54

紫檀嵌樺木竹節紋椅
清乾隆
高107厘米　長64厘米　寬49.5厘米
清宮舊藏

**Red sandalwood chair, decorated with
inlaid birch wood and jointed bamboo
patterns carved in relief**
Qianlong Period, Qing Dynasty
Height: 107cm　Length: 64cm
Width: 49.5cm
Qing Court collection

靠背及扶手邊框雕竹節形，內鑲樺木
心。樺木心被紫檀框分成如意和迴紋
狀。座面下束腰，牙條、腿、足及四
面平式管腳棖均雕竹節紋。

55

紫檀西番蓮紋椅
清
高110厘米　長56厘米　寬52厘米
清宮舊藏

Red sandalwood chair, decorated with dahlia patterns
Qing Dynasty
Height: 110cm　Length: 56cm
Width: 52cm
Qing Court collection

如意形搭腦，靠背板和扶手板上滿雕西番蓮紋。座面下束腰，壺門式牙條滿雕西番蓮紋。三彎腿，捲葉紋馬蹄，下承托泥。

56

紫檀福慶如意紋椅
清
高108厘米　長66厘米　寬51.5厘米
清宮舊藏

Red sandalwood chair, decorated with bat[4] and ruyi[11] patterns
Qing Dynasty
Height: 108cm　Length: 66cm
Width: 51.5cm
Qing Court collection

捲書式搭腦，靠背板正中雕蝠磬紋及
如意雲頭紋，寓意"福慶如意"，靠背
板兩側及扶手雕拐子紋。束腰平直，
下雕拐子紋花牙。腿內側起陽綫，安
四面平管腳棖。

57

紫漆描金捲草紋靠背椅
清雍正至乾隆
高90厘米　長51厘米　寬41.5厘米
清宮舊藏

**Purple lacquered wooden chair,
decorated with gold tracery scrolled
grass patterns**
Yongzheng-Qianlong Period, Qing Dynasty
Height: 90cm　Length: 51cm
Width: 41.5cm
Qing Court collection

捲雲形搭腦、方瓶式背板、座沿與束
腰均飾捲草紋。牙條飾描金夔紋間雜
寶紋，兩端透雕雲紋，披在腿外，成
展腿式，腿間有步步高管腳棖，腿和
棖亦飾捲草紋。

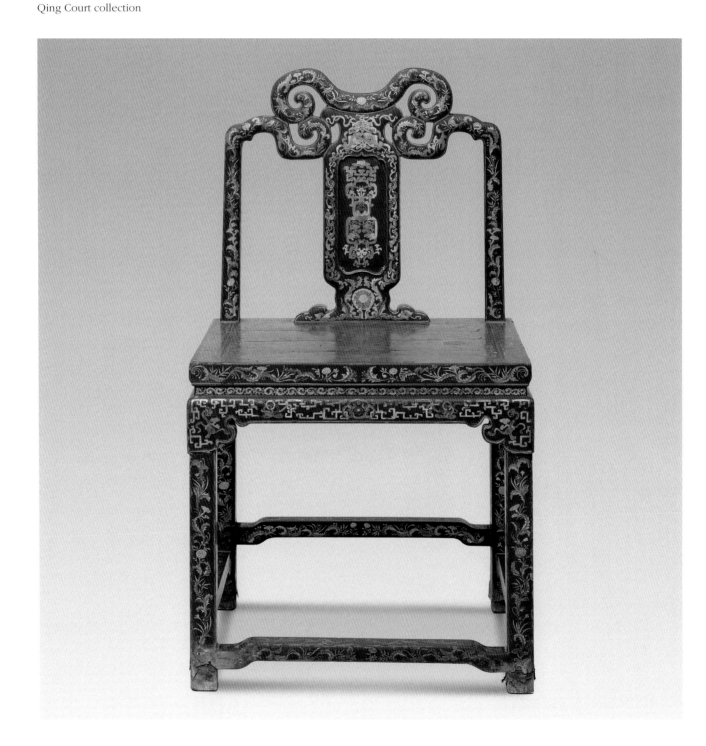

58

黃花梨拐子紋靠背椅
清乾隆
高121厘米　長56厘米　寬44厘米

Huanghuali[6] wooden chair, decorated with Kui[1] patterns
Qianlong Period, Qing Dynasty
Height: 121cm　Length: 56cm
Width: 44cm

捲雲紋搭腦兩端出頭，靠背板與立柱均做彎曲狀，背板浮雕拐子紋，背板下端安角牙，立柱與搭腦相接處有倒掛牙，立柱與座面相交處有坐角牙。落堂式座面下為捲雲紋牙子。方腿直足，步步高管腳根。

靠背椅搭腦兩端出頭者，稱"燈掛式"。

59

竹框黑漆描金菊蝶紋靠背椅
清乾隆
高101厘米　長48厘米　寬39厘米
清宮舊藏

**Bamboo framed, black lacquered chair,
decorated with gold tracery chrysanthe-
mum and butterfly patterns**
Qianlong Period, Qing Dynasty
Height: 101cm　Length: 48cm
Width: 39cm
Qing Court collection

靠背板湘妃竹攢邊，板心上部為描金
蝠磬紋，並在圓形開光內嵌湘妃竹團
壽字，寓意"福壽吉慶"；下部飾描金
菊花、蝴蝶圖。座面下有湘妃竹攢拐
子紋花牙。四劈料式腿及管腳棖。

60

紫漆描金福壽紋靠背椅
清
高102.5厘米　長48.5厘米　寬39.5厘米
清宮舊藏

Purple lacquered chair, decorated with gold tracery patterns consisting of bats[4] and the character "Shou" (longevity)
Qing Dynasty
Height: 102.5cm　Length: 48.5cm
Width: 39.5cm
Qing Court collection

靠背板描金繪蝙蝠、"壽"字、捲草紋，寓意"福壽"。外側呈雙交繩式邊框，邊框內角有透雕捲草紋描金花牙。座面下束腰。腿間安橫棖，正面牙條與橫棖下有描金牙子。側面二橫棖皆鑲透雕捲雲紋描金花牙。

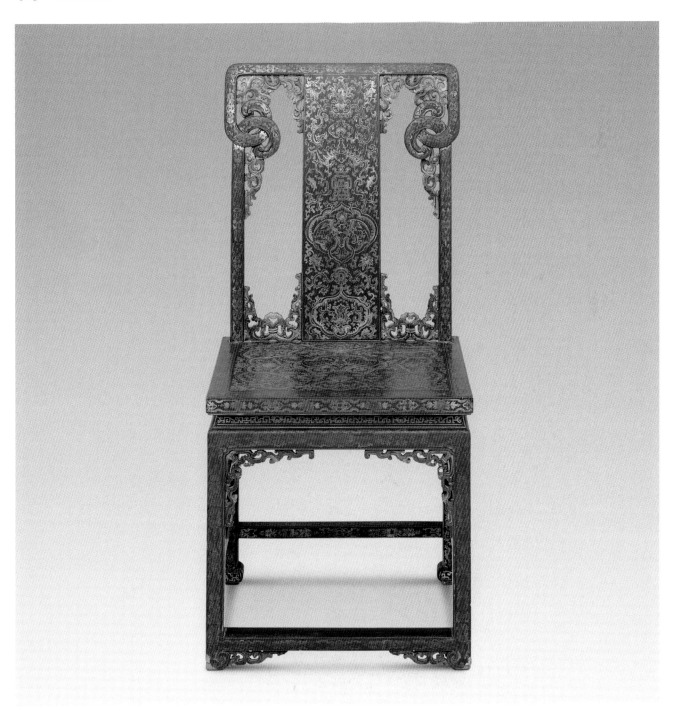

61

黑漆描金福壽紋靠背椅
清
高103厘米　長51.5厘米　寬43.5厘米
清宮舊藏

Black lacquered chair, decorated with gold
tracery patterns consisting of bats[4] and a
circular "Shou" (longevity) character
Qing Dynasty
Height: 103cm　Length: 51.5cm
Width: 43.5cm
Qing Court collection

靠背板透雕捲雲紋，滿飾描金蝙蝠、團壽字、雜寶、番蓮紋。座面正中勾蓮紋開光內外皆飾描金花卉，座面兩側及前緣牙條透雕雲蝠紋，腿部亦飾描金花卉紋，四面平底棖飾捲草紋，下裝牙條，飾捲雲、蝠磬、方勝紋，寓意"福慶吉祥"。

此椅背板垂直，搭腦兩端不出頭，又稱"一統碑式椅"，為典型的清式家具。

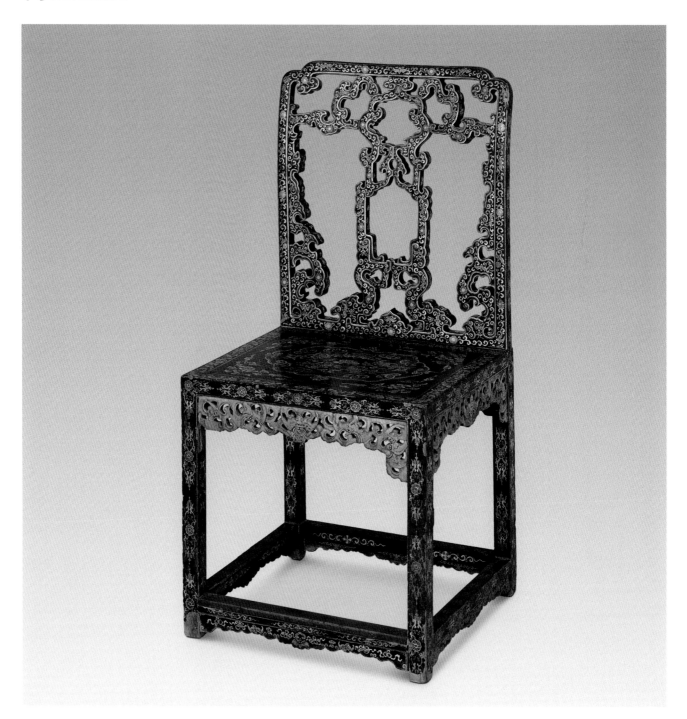

62

黑漆描金花草紋雙人椅

清
高96厘米　長96厘米　寬42厘米
清宮舊藏

**Black lacquered double chair, decorated
with gold tracery flower and grass
patterns**

Qing Dynasty
Height: 96cm　Length: 96cm
Width: 42cm
Qing Court collection

雙靠背的內側邊框、座面和內側前後兩腿均連為一體，靠背板分三段攢成，上段飾描金捲浪紋，雕圓形旋渦紋；中段為長方形開光，飾描金花草紋；下層鏤出雲頭形亮腳，其上亦為描金花紋。靠背板下方安橫棖，鑲壺門券口。座面下束腰，束腰下為描金螭紋券口牙子。外側四足為內翻馬蹄，中間二足為雙翻馬蹄。

此椅可供雙人同時坐，古時亦稱"春椅"，其特點是似兩椅整體相連，有雙靠背和六腿足，此種做法既節省了材料，又顯示出整體造型的協調一致，頗見匠心。

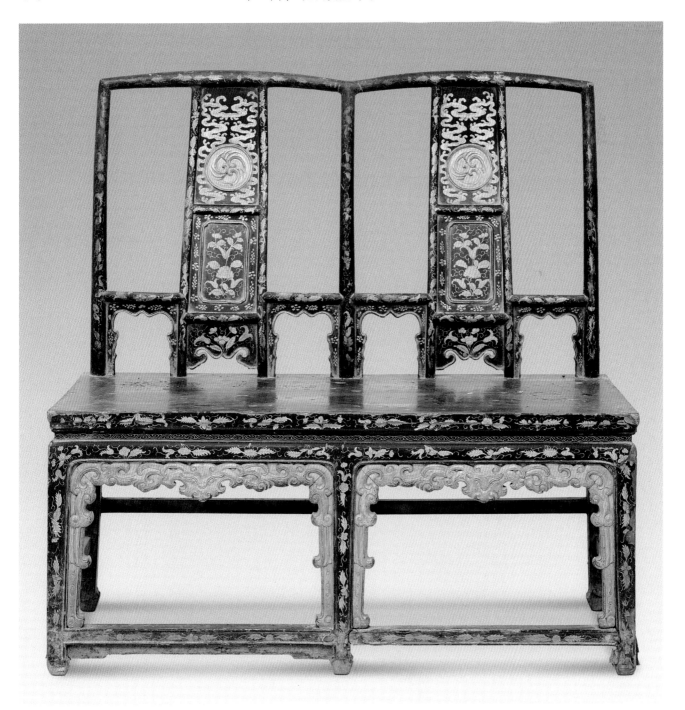

63

黃花梨玉璧紋圓凳
清乾隆
高45厘米　面徑36厘米
清宮舊藏

Round Huanghuali[6] wooden stool,
decorated with "Bi" (a round flat piece
of jade with a hole in its centre) patterns
Qianlong Period, Qing Dynasty
Height: 45cm　Diameter of top: 36cm
Qing Court collection

圓凳高束腰，雕六個長方形捲珠紋開
光，束腰下有托腮，鼓腿彭牙，牙條
浮雕海棠式珠花。腿上下兩端雕勾雲
紋玉璧，璧中心雕花朵紋，腿中間浮
雕海棠式珠花。下承須彌式底座。

清代凳和墩的體積較小，且四面均有
紋飾，使用和擺放比較隨意。

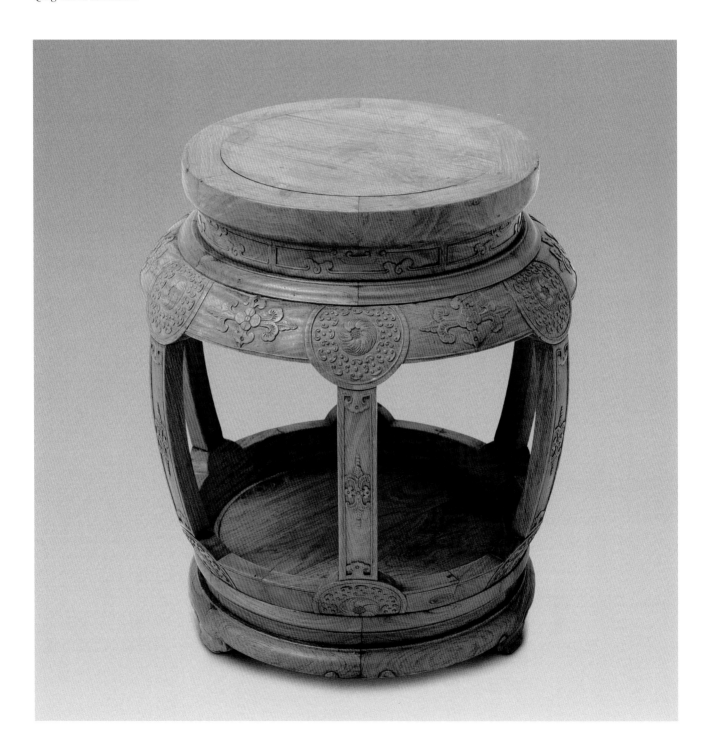

64

剔黑彩繪梅花式凳
清乾隆
高50厘米　面徑30厘米
清宮舊藏

Carved, black lacquered stool, with a plum blossom shaped top
Qianlong Period, Qing Dynasty
Height: 50cm　Diameter of top: 30cm
Qing Court collection

凳面梅花形，以彩繪冰紋及黃色海水紋錦為地，飾白色梅花，邊沿雕迴紋，側沿飾迴紋和蕉葉紋。面下有蕉葉紋束腰，上下迴紋托腮，牙條雕迴紋和變形蕉葉紋。腿上滿佈六方剔花錦紋，起迴紋中綫，腿間安有雙環繩紋棖，內翻馬蹄，下承卍字錦紋梅花形托泥。

65

紫檀小方凳
清乾隆
高41.5厘米　面徑37厘米
清宮舊藏

Small, square, red sandalwood stool
Qianlong Period, Qing Dynasty
Height: 41.5cm　Diameter of top: 37cm
Qing Court collection

凳面邊沿雕玉寶珠紋，面下束腰起長
方形陽綫，牙條、凳腿、上下橫棖均
起槽鑲銅綫，方腿直足，下踩圓珠。

66

紫檀嵌琺瑯漆面團花紋方凳
清乾隆
高43厘米　面徑38厘米
清宮舊藏

Square, red sandalwood stool with
lacquered seat, decorated with flower
posy patterns made with inlaid enamel
Qianlong Period, Qing Dynasty
Height: 43cm　Diameter of top: 38cm
Qing Court collectiona

凳面飾黑漆描金蝙蝠勾蓮團花紋，四
周飾描金螭紋，邊緣雕迴紋錦，四角
嵌琺瑯片，下承嵌琺瑯瓶式柱，牙條
雕蟠螭紋，與凳腿上皆鑲嵌銅胎琺瑯
螭紋。迴紋足，下承托泥。

67

紫檀嵌竹冰梅紋梅花式凳
清乾隆
高46厘米　面徑34厘米
清宮舊藏

Red sandalwood, plum blossom shaped
stool, decorated with ice crackle and
plum blossom patterns made from inlaid
bamboo strips and carvings
Qianlong Period, Qing Dynasty
Height: 46cm　Diameter of top: 34cm
Qing Court collection

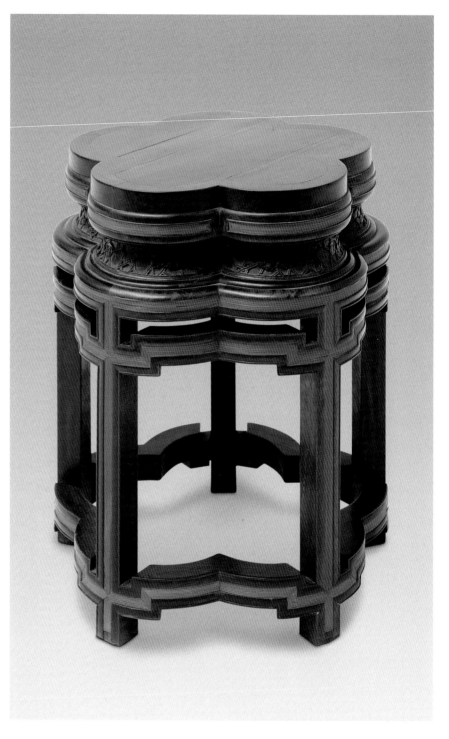

凳面側沿起槽以竹絲隨形鑲嵌合匝。
面下高束腰，打窪綫條，浮雕冰梅
紋。束腰下有托腮，牙條及上下兩道
硬角羅鍋棖俱隨凳面為梅花形，中心
鑲嵌竹絲。凳腿中心亦鑲嵌竹絲。

此凳造型構思巧妙，竹絲與紫檀色彩
搭配明顯，裝飾效果獨到。

68

紫檀雲龍紋海棠式凳
清乾隆
高52.5厘米　長35厘米　寬28厘米
清宮舊藏

Red sandalwood stool with a begonia-
shaped seat, decorated with dragon and
cloud patterned carvings
Qianlong Period, Qing Dynasty
Height: 52.5cm　Length: 35cm
Width: 28cm
Qing Court collection

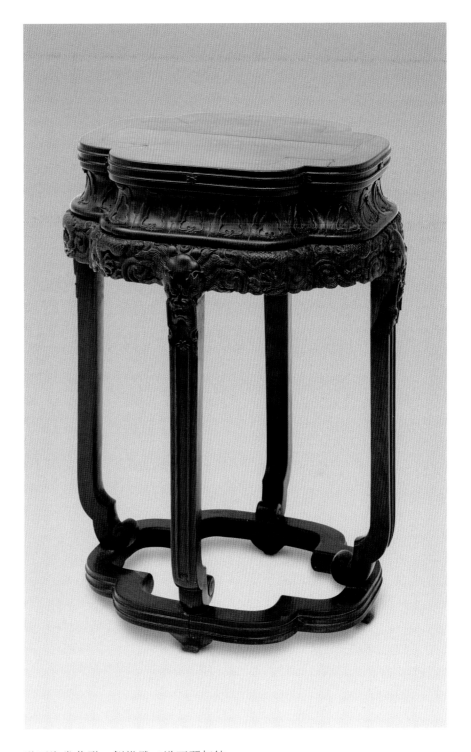

凳面海棠花形，側沿雕二道兩頭打結
的細繩紋，面下打窪束腰，上雕蕉葉
紋，牙條及腿上部雕雲龍紋，腿正面
亦雕二道細繩紋。捲雲形足，下承海
棠式托泥，帶龜腳。

69

方形抹角文竹凳
清中期
高46厘米　面徑34.5厘米
清宮舊藏

Square bamboo stool with beveled edges
Middle Qing Dynasty
Height: 46cm　Diameter of top: 34.5cm
Qing Court collection

凳木胎，通體文竹包鑲。方形抹角凳
面，面下束腰的四面有矩形開光，束
腰上下裝有托腮，鼓腿彭牙，迴紋式
牙條。內翻馬蹄，下承托泥，托泥亦
隨凳面為方形抹角，上下呼應。

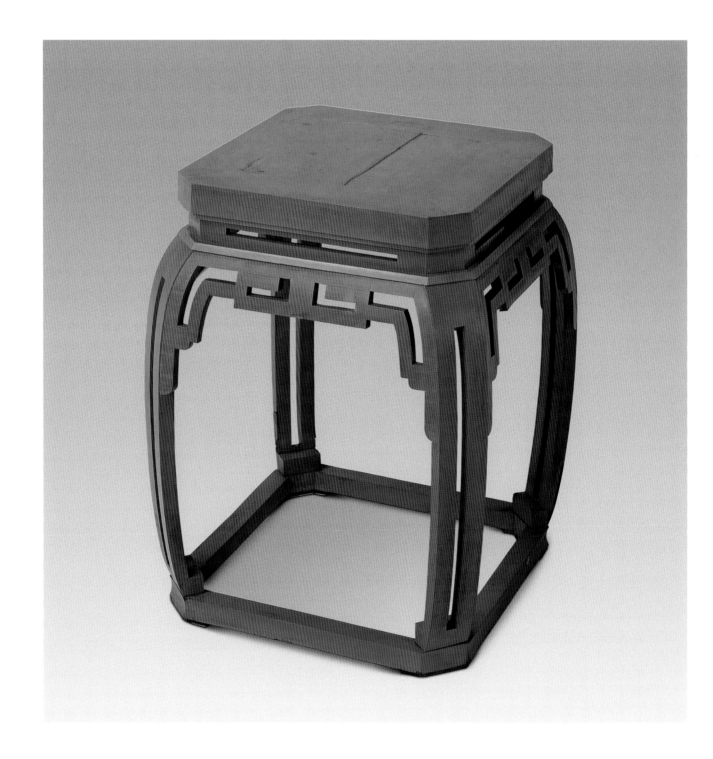

70

紫檀如意紋方凳
清中期
高50.5厘米　長41.5厘米　寬35厘米
清宮舊藏

Square red sandalwood stool, decorated with a Ruyi[11] pattern
Middle Qing Dynasty
Height: 50.5cm　Length: 41.5cm
Width: 35cm
Qing Court collection

凳面四角攢框鑲板，面下打窪束腰，上下托腮。牙條與管腳根連接凳腿，形成券門，券內鑲鱳環板，雕迴紋錦及如意雲頭紋。四腿外角作劈料狀，足下承托泥，帶龜腳。

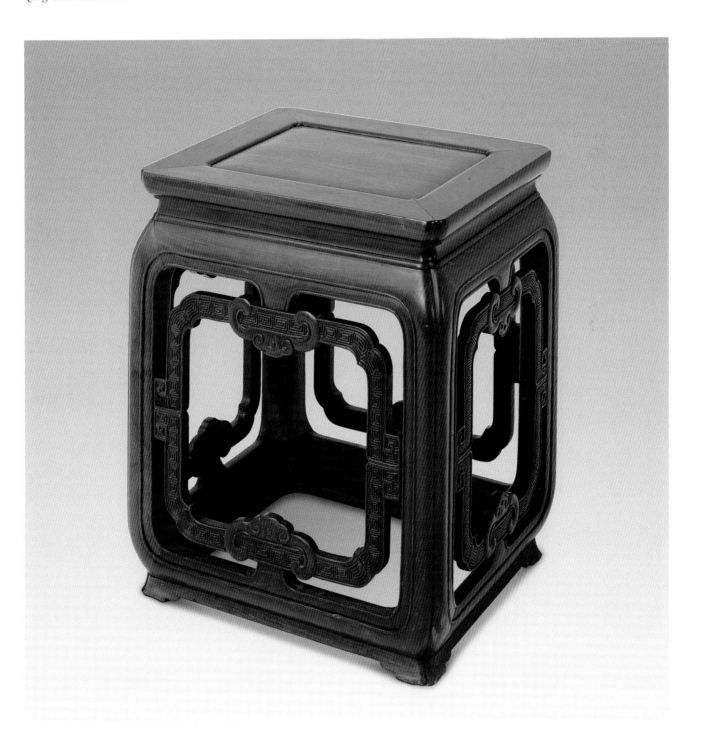

紫檀雙龍戲珠紋六方凳
清中期
高50厘米　面徑36厘米
清宮舊藏

Hexagonal, red sandalwood stool,
decorated with carvings of twin dragons
playing with a pearl
Middle Qing Dynasty
Height: 50cm　Diameter of top: 36cm
Qing Court collection

凳面六角形，側沿呈弧形，俗稱泥鰍
背。面下平直束腰，上下托腮，腿內
側起陽角綫，鑲嵌透雕雙龍戲珠紋的
縧環板，縧環板開光邊沿雕繩紋，管
腳棖式托泥，帶龜腳。

72

紫檀嵌玉團花紋六方凳

清
高47厘米　面徑35.5厘米
清宮舊藏

**Hexagonal red sandalwood stool,
decorated with flower posy patterns
made with inlaid jade**

Qing Dynasty
Height: 47cm　Diamete of top: 35.5cm
Qing Court collection

凳面中間鑲嵌由紫檀木條拼成的卍字
錦紋，側沿平直。打窪束腰，鑲嵌十
二片綠地捲草紋掐絲琺瑯，上下托腮
雕蓮瓣紋。鼓腿彭牙，下垂窪堂肚。
腿、牙鑲嵌白玉雕蝙蝠、團花及草龍
紋飾。內翻馬蹄，下承托泥，帶龜
腳。

73

紫檀靈芝紋方凳
清
高47.5厘米　面徑33.5厘米

Square, red sandalwood stool, decorated with carvings of lingzhi[12] (magical fungus)
Qing Dynasty
Height: 47.5cm
Diameter of top: 33.5cm

凳面下有束腰，鼓腿彭牙，正面牙條中央雕一下垂靈芝，腿間四根相連，兩側橫根上則雕向上靈芝，與牙條相呼應。

此凳結構簡單，卻有飽滿、敦實之感，自面沿以下滿飾靈芝紋，卻不顯繁縟，充分展示工藝的和諧美感。

74

紫檀如意雲頭紋方凳
清
高43厘米　面徑37厘米
清宮舊藏

**Square, red sandalwood stool, decorated
with ruyi[11] patterned lappets[13]**
Qing Dynasty
Height: 43cm　Diameter of top: 37cm
Qing Court collection

凳面下高束腰，裝縧環板，開炮仗洞
透光，束腰下有托腮，接鏤空連續如
意雲頭形花牙，三彎展腿，外翻雲頭
形足，下承托泥，帶龜腳。

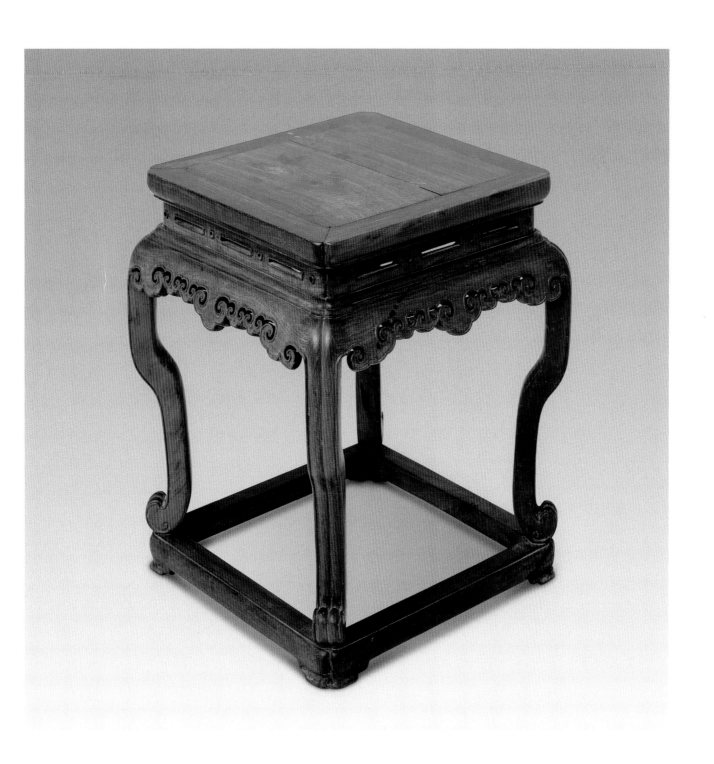

75

紫檀西洋花紋方凳
清
高51.5厘米　面徑52厘米
清宮舊藏

Square, red sandalwood stool, decorated with Western style patterns
Qing Dynasty
Height: 51.5cm　Diameter of top: 52cm
Qing Court collection

凳面下有極窄的束腰，束腰上有炮仗洞開光，牙條雕西洋式捲草花葉紋，腿肩部雕成捲鼻勾牙的象首，外翻捲草形足，下承托泥。

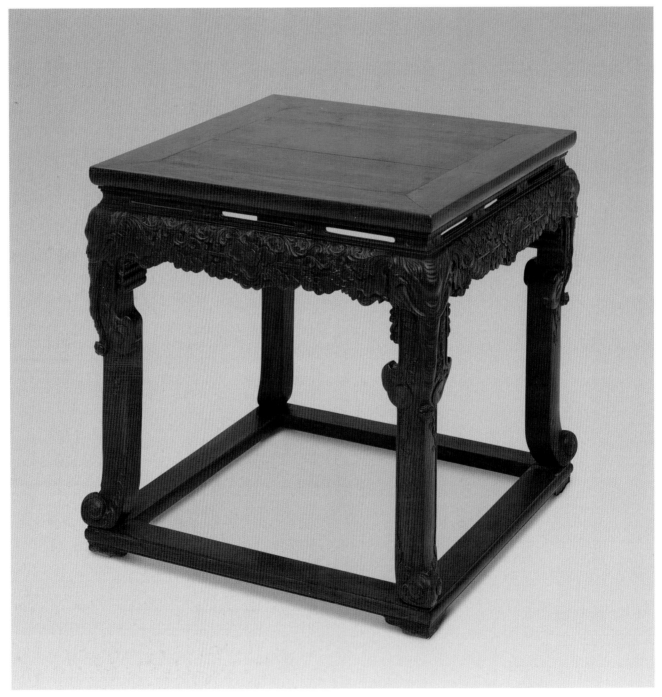

76

黑漆描金折枝花紋春凳
清
高50厘米　長158.5厘米　寬59.7厘米
清宮舊藏

Black lacquered couples' stool, decorated with gold tracery floral patterns
Qing Dynasty
Height: 50cm　Length: 158.5cm
Width: 59.7cm
Qing Court collection

凳面長方形，上開光繪折枝四季花
卉，面下束腰，飾描金迴紋。牙條及
腿部均飾描金纏枝連紋，內翻馬蹄。

春凳亦稱"二人凳"，因便於二人同坐
而得名。

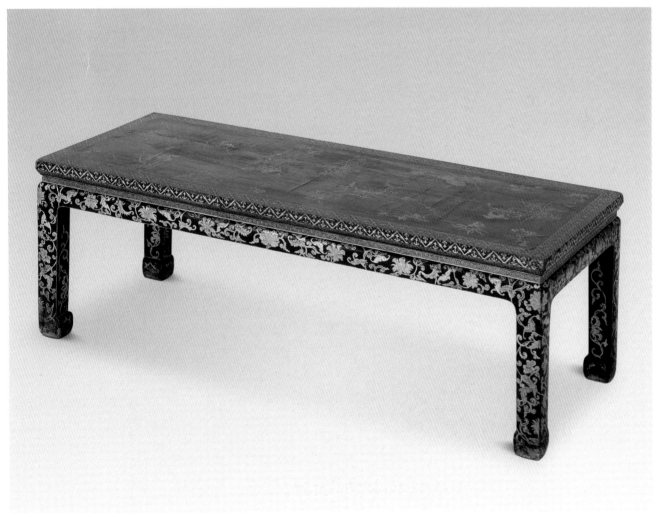

77

紫檀纏枝蓮紋四開光坐墩
清早期
高53厘米　面徑26厘米
清宮舊藏

Red sandalwood seat block with four begonia-shaped openings, decorated with an intertwining lotus pattern
Early Qing Dynasty
Height: 53cm　Diameter of top: 26cm
Qing Court collection

圓形墩面與底座的側面各飾鼓釘紋一匝並弦紋一道，在弦紋之間的墩壁凸雕兩道纏枝蓮紋，墩壁中間為四個海棠式開光洞。

此墩造型挺拔俊秀，紋飾簡潔，是典型的清式家具。

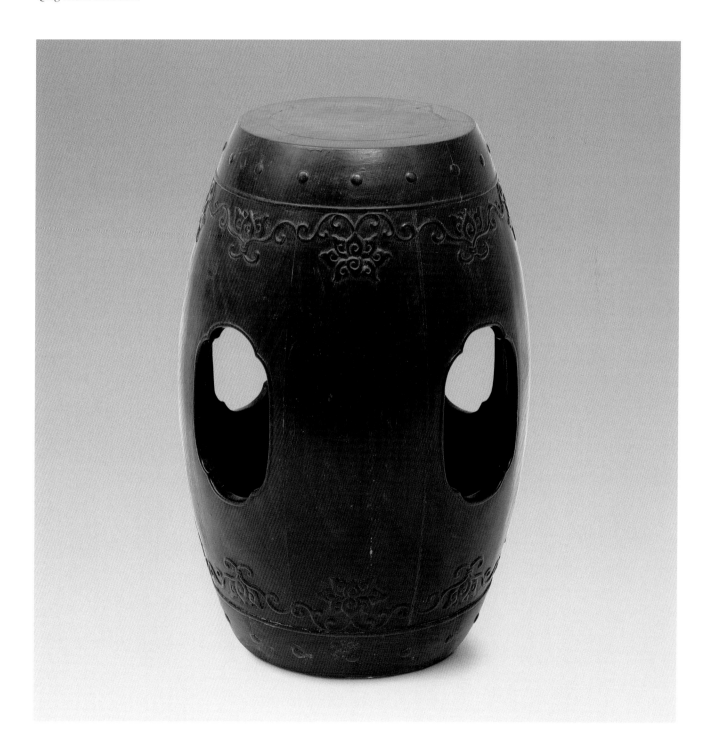

78

紫檀雲頭紋五開光坐墩
清乾隆
高52厘米　面徑28厘米
清宮舊藏

Red sandalwood seat block with five side openings, decorated with carved cloud patterns
Qianlong Period, Qing Dynasty
Height: 52cm　Diameter of top: 28cm
Qing Court collection

墩面與底座的側面各飾鼓釘紋一匝並弦紋二道，墩壁上滿飾如意雲頭紋，並五個海棠形開光，每個開光中各透雕一個海棠形繩紋璧，並以繩紋與上下兩端的如意雲頭相接。

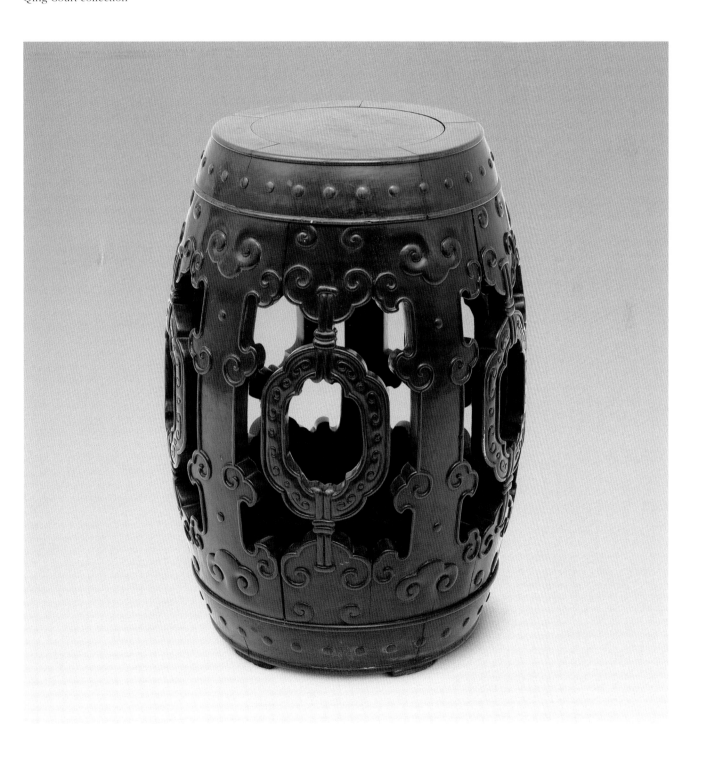

79

紫檀夔鳳紋四開光坐墩
清乾隆
高49.5厘米　面徑35厘米
清宮舊藏

Red sandalwood seat block, decorated with carved Kui¹-phoenixs within the four side openings
Qianlong Period, Qing Dynasty
Height: 49.5cm　Diameter of top: 35cm
Qing Court collection

墩面下打窪束腰，拱肩處雕蟬紋一圈，並鏤空如意雲頭形。墩壁鼓肚四開光，開光內透雕雙夔鳳纏繞圓環紋，開光之間的墩壁上下各雕雙虬紋，中間透雕花葉紋。

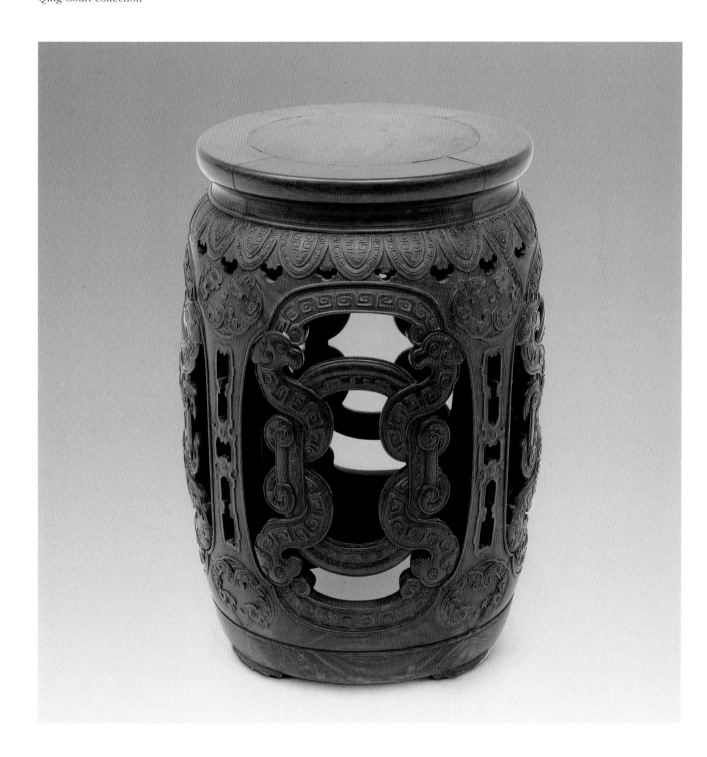

80

紫檀獸面唧環紋八方坐墩
清乾隆
高52厘米　面徑37×31厘米
清宮舊藏

Octagonal, red sandalwood seat block,
decorated with muzzle and ring pat-
terned carvings
Qianlong Period, Qing Dynasty
Height: 52cm
Diameter of top: 37×31cm
Qing Court collection

八角形墩面下束腰，束腰下有與墩面
對應的八面墩壁，邊框內分別透雕捲
葉紋、如意紋、迴紋、菱花紋並雕獸
面唧環紋。底部帶八個小龜腳。

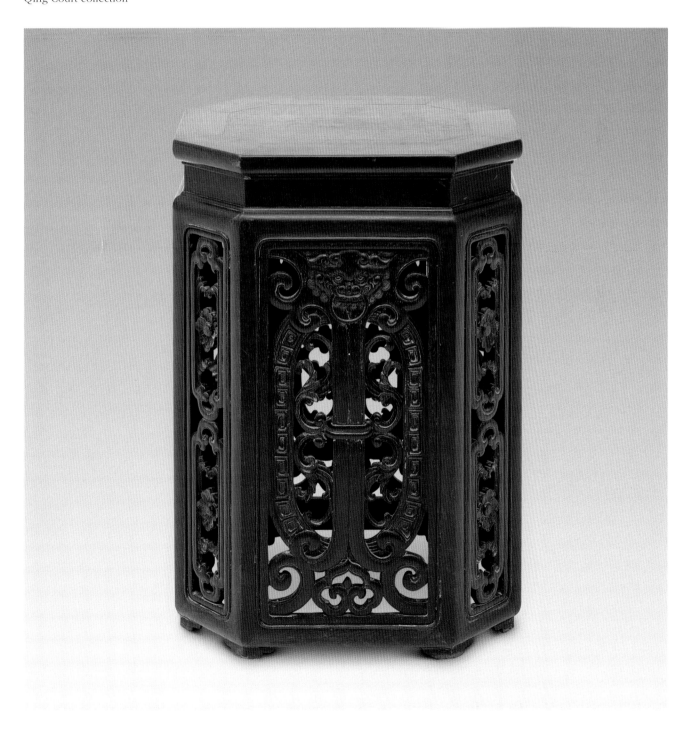

81

紫檀龍鳳盤腸紋六方坐墩
清乾隆
高50厘米　面徑34厘米
清宮舊藏

Hexagonal, red sandalwood seat block,
decorated with carvings of Kui¹-dragons,
Kui¹-phoenixes and their entrails
Qianlong Period, Qing Dynasty
Height: 50cm　Diameter of top: 34cm
Qing Court collection

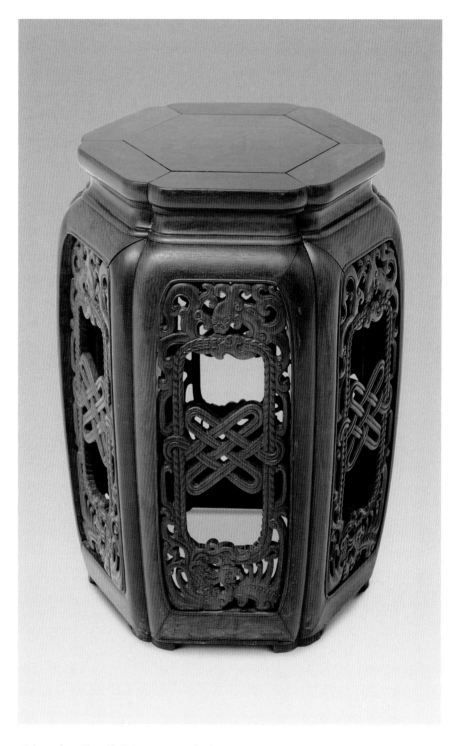

委角六邊形墩面鑲裝板心，面下打窪
束腰，上下托腮。束腰下六面墩壁皆
透雕夔龍、夔鳳及盤腸紋，寓 "江山
永固，地久天長" 之意。

此墩做工精良，造型新穎獨特，紋飾
精美，寓意吉祥，為典型的清乾隆年
間家具。

紫檀多子長壽圖六方坐墩
清乾隆
高52厘米　面徑34厘米
清宮舊藏

Hexagonal, red sandalwood seat block,
decorated with carved motifs represent-
ing long life and many male offspring
Qianlong Period, Qing Dynasty
Height: 52cm　Diameter of top: 34cm
Qing Court collection

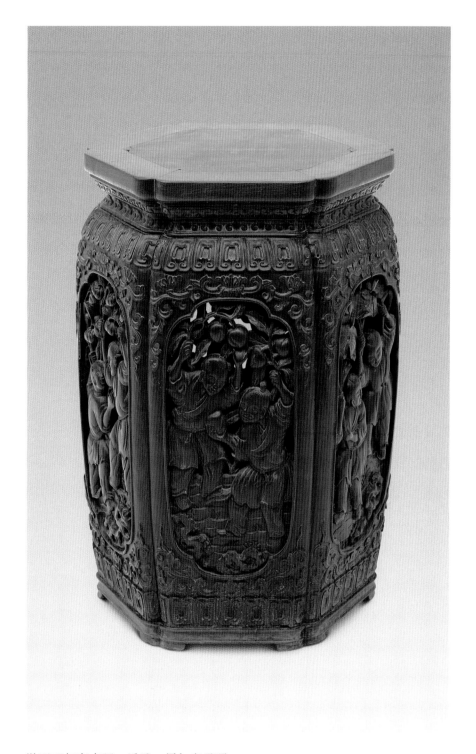

墩面下打窪束腰，浮雕一周如意雲頭
紋，束腰上部裝雕祥雲紋托腮，墩壁
上下兩端雕蓮瓣紋，中間為海棠形開
光，開光內分別透雕童子摘桃、持
蓮、捧石榴、拿荔枝等圖紋，寓“多
子多壽”之意。

83

黑漆描金勾雲紋交泰式坐墩
清中期
高49厘米　面徑36.5厘米
清宮舊藏

Black lacquered seat block, decorated with gold tracery cloud cluster patterns
Middle Qing Dynasty
Height: 49cm　Diameter of top: 36.5cm
Qing Court collection

墩面彩漆繪寶相花紋，邊沿飾描金棗花錦紋，側沿飾描金雲紋，墩壁上沿外翻，下飾棗花錦紋，中間鏤空描金花卉並勾雲紋，邊沿鏤成勾雲紋，上下凸凹相對，呈交泰式。底座下帶四龜腳。

此墩與眾不同之處在於，墩內正中有一立柱連接墩面與墩底，以此承重。

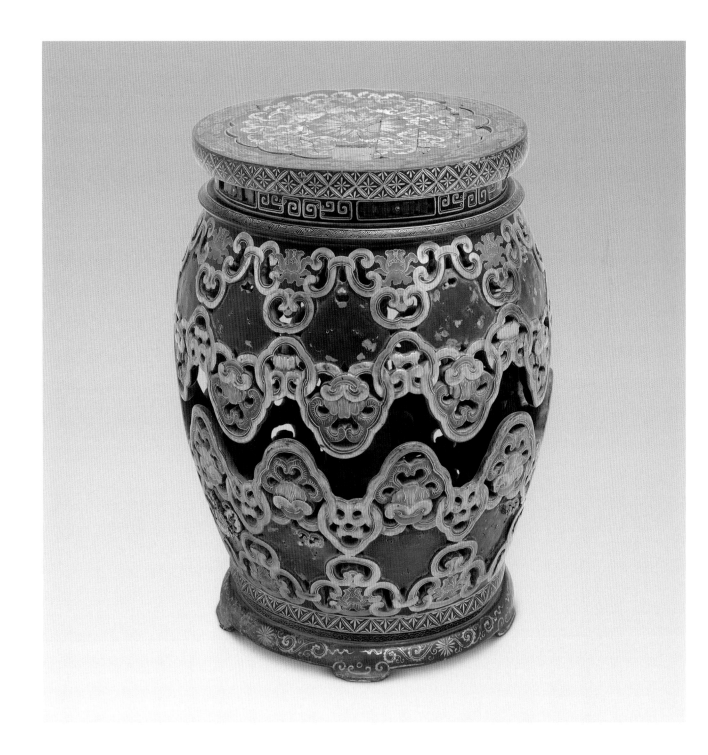

84

剔紅夔龍紋方坐墩
清
高45.5厘米　面徑28厘米
清宮舊藏

**Square, carved, red lacquered seat block,
decorated with Kui[1]-dragon patterns**
Qing Dynasty
Height: 45.5cm　Diameter of top: 28cm
Qing Court Colleciton

方形墩面上沿及底邊雕迴紋兩道，其
間卍字錦紋地上雕鼓釘紋。墩壁上下
雕如意雲頭紋，在轉角處相接，雲頭
紋上雕番蓮花紋。墩壁中部龜背紋地
上雕夔龍在海浪中翻騰。墩底四角下
承卍字錦紋鑲銅龜腳。

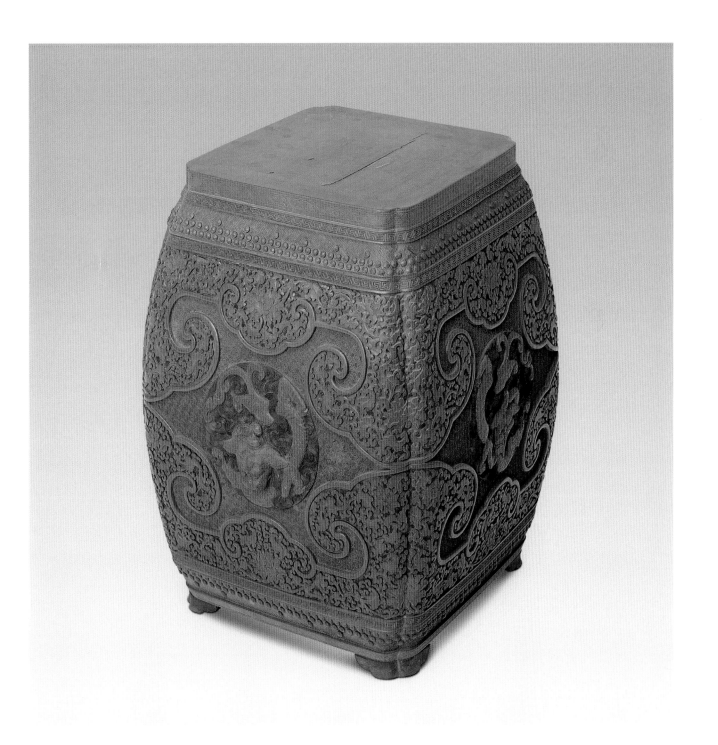

85

黑漆描金龍鳳紋坐墩
清
高43厘米　面徑35.5厘米
清宮舊藏

**Black lacquered seat block, decorated
with gold tracery dragon and phoenix
patterns**
Qing Dynasty
Height: 43cm　Diameter of top: 35.5cm
Qing Court collection

墩面飾描金龍鳳紋，寓意"龍鳳呈
祥"，墩面與墩底側沿均飾描金如
意、方勝、雲紋及磬等雜寶紋飾，束
腰上飾描金迴紋，墩壁透雕夔龍紋，
描金勾邊。

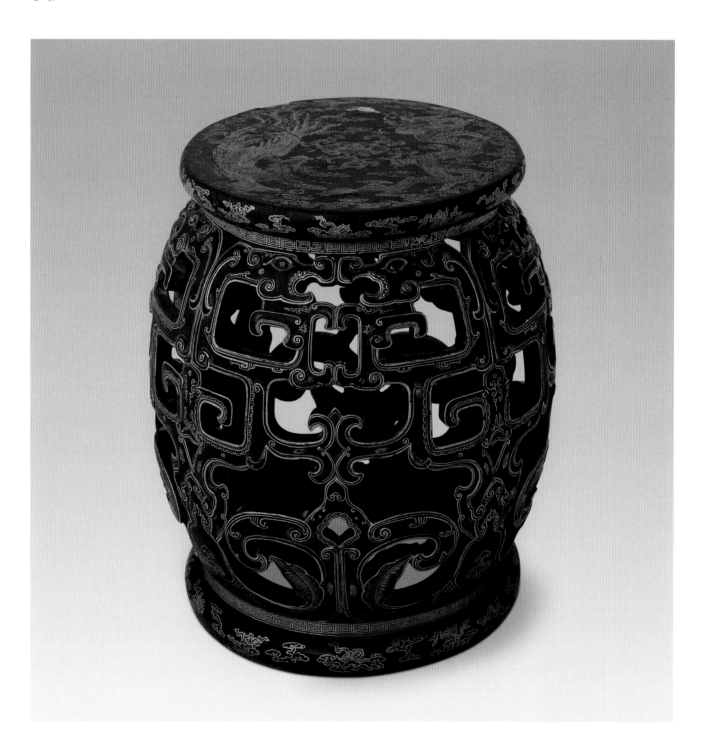

桌案几

Tables

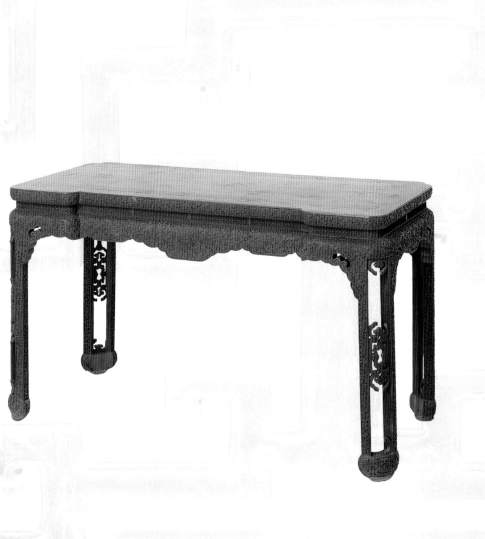

黃花梨雲龍壽字紋方桌

清乾隆
高86.5厘米　長95厘米　寬95厘米
清宮舊藏

Square, Huanghuali[6] wooden table, decorated with patterns consisting of dragons, clouds and a circular "Shou" (longevity) character
Qianlong Period, Qing Dynasty
Height: 86.5cm　Length: 95cm
Width: 95cm
Qing Court collection

桌面下束腰，牙條雕拐子、雲朵、夔龍、團壽字紋，寓"長壽吉祥"之意。腿間安羅鍋棖，腿內側及羅鍋棖邊沿起陽綫。迴紋馬蹄。

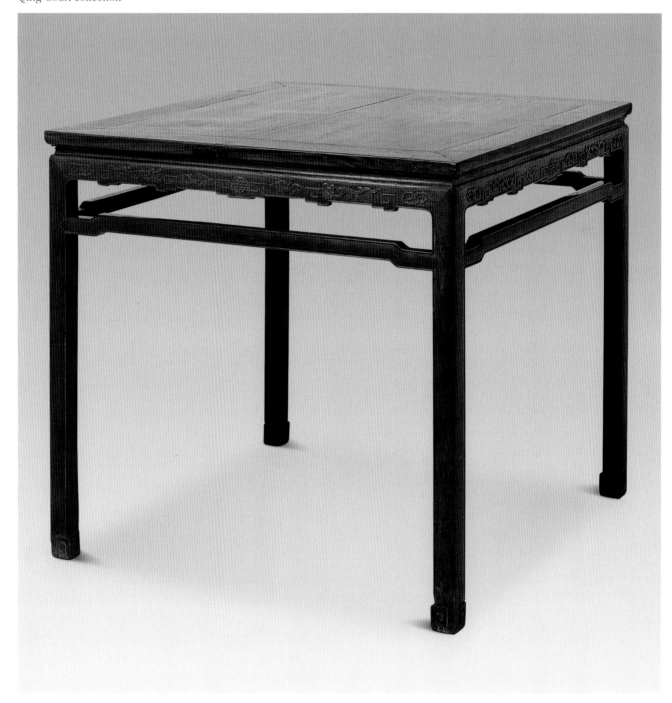

87

榆木捲雲紋方桌
清
高83厘米　面徑88.5厘米
清宮舊藏

Square elm table, decorated with cirrus cloud patterns
Qing Dynasty
Height: 83cm　Diameter of top: 88.5cm
Qing Court collection

束腰雕三個細長的橫條，下有托腮，
牙條中部陰刻變形捲雲紋，捲雲紋中
心有太極紋。方腿內沿起凹綫，腿間
安有羅鍋根，內翻馬蹄。

88

湘妃竹漆面長桌
清雍正
高83厘米 長92厘米 寬38厘米
清宮舊藏

Long, bamboo table with lacquered top
Yongzheng Period, Qing Dynasty
Height: 83cm Length: 92cm
Width: 38cm
Qing Court collection

桌面下以湘妃竹攢成兩道牙條。牙條下另安拐子紋花牙，兩端垂牙頭，與腿連接，四腿用四根竹棍拼成，竹節斷面處均用象牙封堵。

89

黑漆描金芍藥花紋長桌
清雍正
高84.5厘米　長110厘米　寬38厘米
清宮舊藏

Long, black lacquered table, decorated with gold tracery peony patterns
Yongzheng Period, Qing Dynasty
Height: 84.5cm　Length: 110cm
Width: 38cm
Qing Court collection

桌面飾描金芍藥、靈芝、山石等圖紋，兩側邊泥鰍背小翹。側沿飾描金雲蝠紋，束腰以描金捲草界出數格，開炮仗洞透孔，下承托腮。牙條飾描金番蓮紋，下雕拐子紋及西洋捲草紋牙子，兩端沿腿下垂，形成護腿牙，並以金漆勾邊。內翻迴紋方馬蹄。

紫檀漆面嵌琺瑯西番蓮紋長桌

清乾隆
高84.5厘米　長144.5厘米　寬64厘米
清宮舊藏

**Red sandalwood table with lacquered
top, decorated with dahlia patterns made
with inlaid enamel**

Qianlong Period, Qing Dynasty
Height: 84.5cm　Length: 144.5cm
Width: 64cm
Qing Court collection

桌面以紫檀木四邊攢框，漆面心，面
沿雕迴紋，四角用西番蓮紋琺瑯片包
角，與桌腿之間用一個琺瑯瓶支撐。
透空迴紋角牙及方腿上嵌西番蓮紋琺
瑯片。內翻迴紋馬蹄。

此桌原為符望閣所用之物。符望閣位
於寧壽宮花園內。寧壽宮是乾隆皇帝
為自己興建的養老之所。

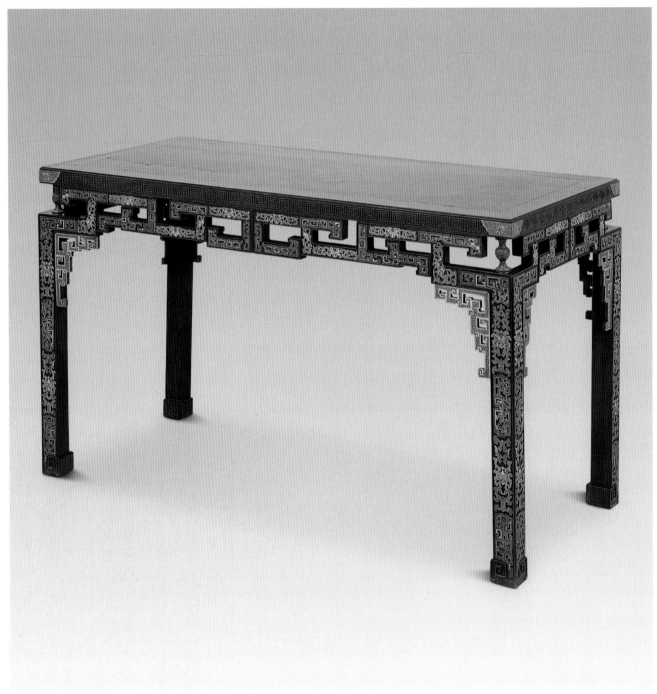

91

紫檀勾蓮紋長桌
清乾隆
高105.5厘米　長102厘米　寬64厘米
清宮舊藏

**Rectangular, red sandalwood table,
decorated with intertwining lotus
patterns**
Qianlong Period, Qing Dynasty
Height: 105.5cm　Length: 102cm
Width: 64cm
Qing Court collection

高束腰浮雕縧環板，縧環板內浮雕梭
子紋。束腰上下裝托腮，牙條較寬，
下垂浮雕勾蓮紋窪堂肚。展腿式，牙
條與腿拐角處裝透雕拐子紋角牙，外
翻迴紋馬蹄，下承托泥，有龜腳。

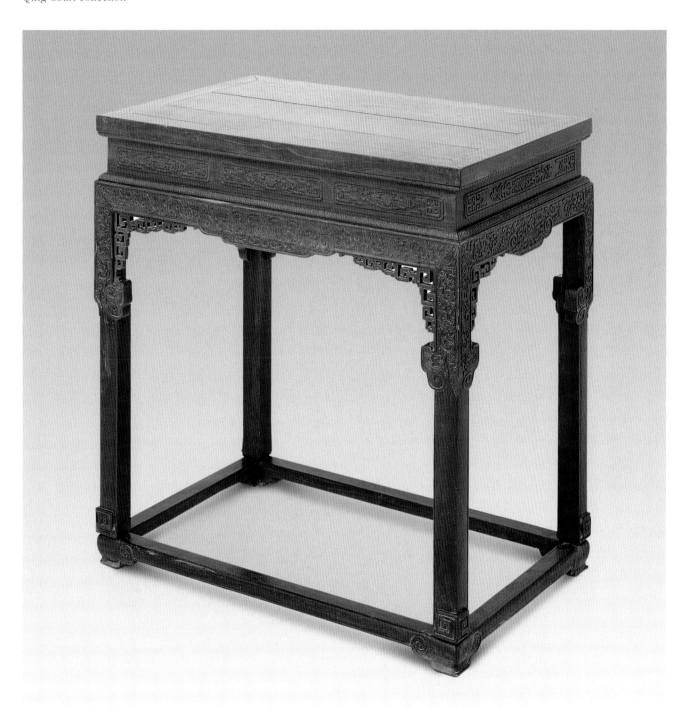

紫檀長桌
清乾隆
高86厘米　長143.5厘米　寬48厘米
清宮舊藏

Long, narrow, red sandalwood table
Qianlong Period, Qing Dynasty
Height: 86cm　Length: 143.5cm
Width: 48cm
Qing Court collection

高束腰嵌繩紋繫璧形卡子花，牙條雕
玉寶珠紋。拱肩展腿，內翻捲雲紋馬
蹄。

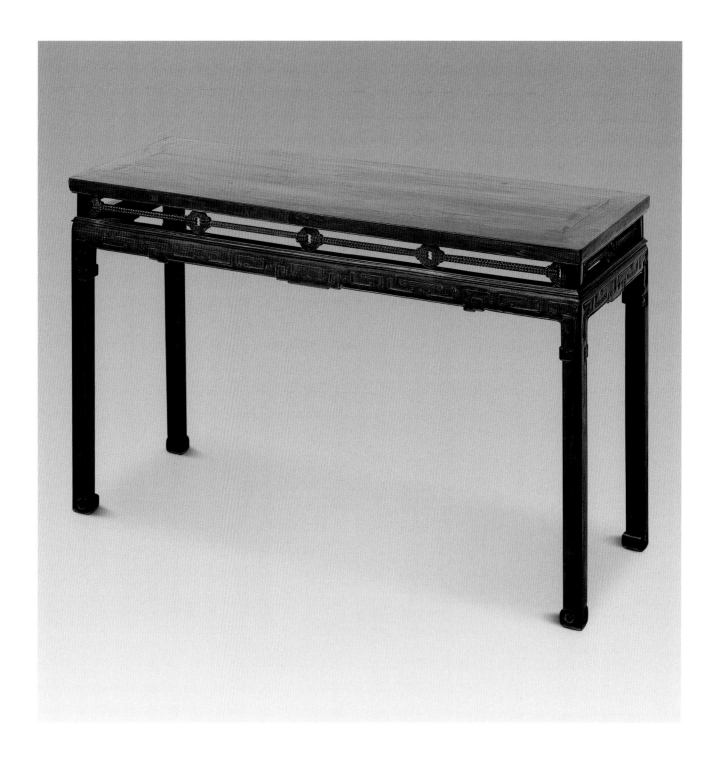

93

紫檀拐子紋長桌
清乾隆
高81厘米　長116厘米　寬39厘米
清宮舊藏

**Long, narrow, red sandalwood table,
decorated with Kui[1] patterns**
Qianlong Period, Qing Dynasty
Height: 81cm　Length: 116cm
Width: 39cm
Qing Court collection

束腰上開炮仗洞，束腰下有托腮，攢
框透雕拐子紋牙條，四腿及牙條裏口
起綫，內翻迴紋馬蹄。

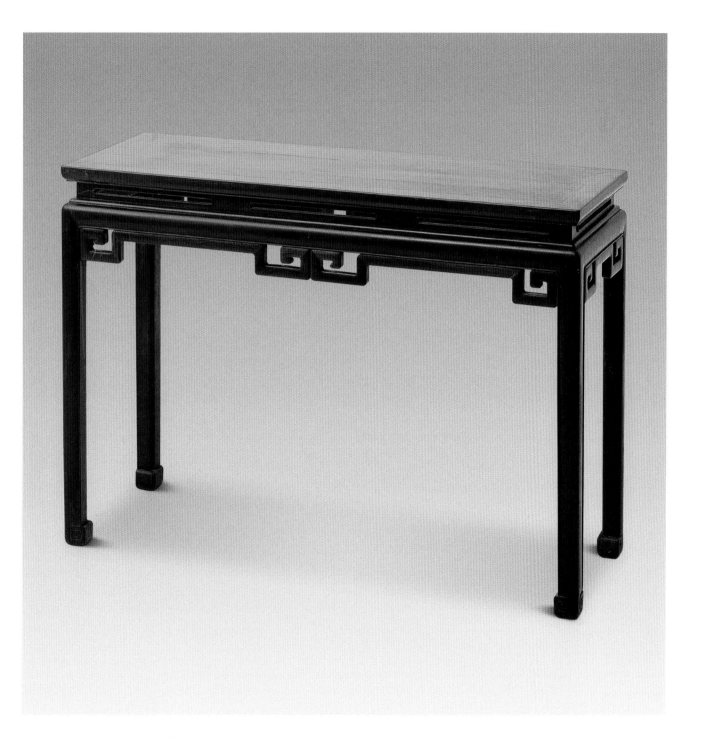

94

填漆戧金卍字勾蓮花紋長桌
清乾隆
高84厘米　長139.5厘米　寬48.5厘米
清宮舊藏

Long, narrow table, decorated with
swastika and intertwining lotus patterns
made from inlaid lacquer and gold
Qianlong Period, Qing Dynasty
Height: 84cm　Length: 139.5cm
Width: 48.5cm
Qing Court collection

桌面邊起冰盤沿，飾卍字紋。面下束
腰四周開炮仗洞，洞四周飾勾蓮紋，
束腰下有托腮，雕拐子紋角牙。方
腿，牙與腿內側起陽綫，外側飾卍字
紋，側面兩腿間安有橫棖，下雕拐子
紋角牙。內翻馬蹄。

填漆是將漆堆刻後填彩，再磨出花紋
的髹飾技法。戧金則是先在漆器表面
刻畫出纖細的紋樣，再在紋樣中上漆
金膠，最後填以泥金或金箔的工藝。

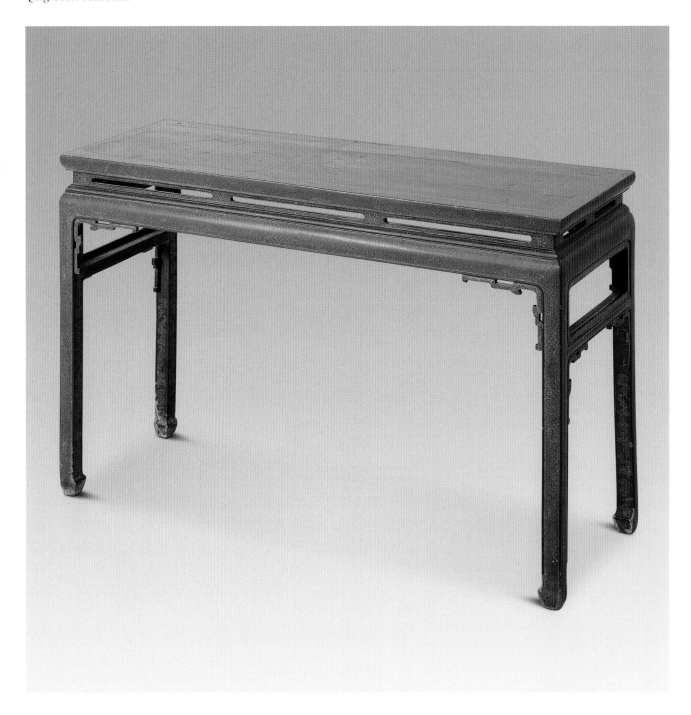

剔紅雲龍紋委角長桌
清乾隆
高83.5厘米　長155厘米　寬67厘米
清宮舊藏

Rectangular, carved, red lacquered table,
decorated with dragon and cloud
patterns
Qianlong Period, Qing Dynasty
Height: 83.5cm　Length: 155cm
Width: 67cm
Qing Court collection

桌面正面邊沿中間呈"凹"形縮進，面
下有浮雕錦紋的束腰，牙條正中為垂
雲形窪堂肚，雕雲龍紋。四腿為挖缺
做，每條腿中間開出長方形透光，中
間施以透雕如意雲頭紋卡子花，雲頭
形足，腿及足端雕雲蝠紋。

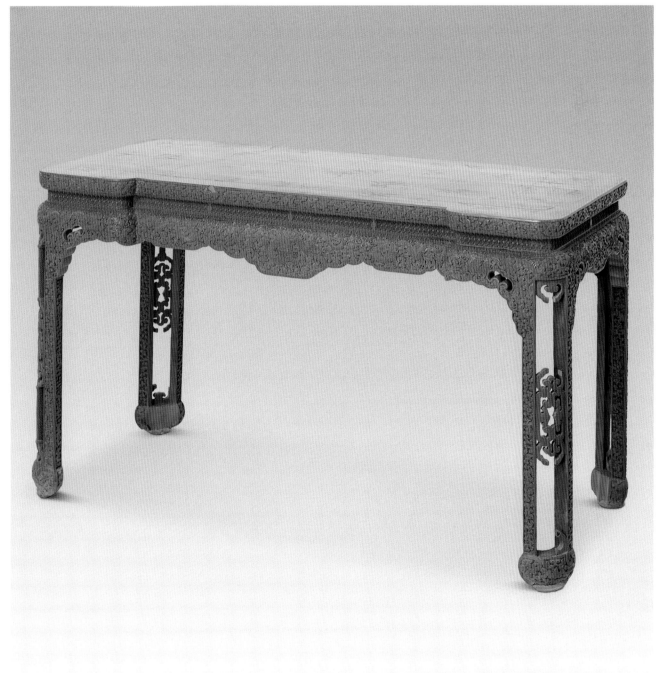

96

黑漆描金山水圖長桌
清乾隆
高86.5厘米　長194.5厘米　寬77.5厘米
清宮舊藏

**Long, black lacquered table, decorated
with gold tracery landscape patterns**
Qianlong Period, Qing Dynasty
Height: 86.5cm　Length: 194.5cm
Width: 77.5cm
Qing Court collection

通體髹黑漆描金紋飾。桌面描金彩繪
山水圖，畫面上山石聳峙，煙波浩
淼，樹木掩映，樓閣錯落。面側沿描
金菱花錦紋，束腰上鏤空菱花紋，下
有托腮。鏤空拐子紋花牙金漆勾邊，
牙條與腿拐角處安有矩形托角棖，牙
條、棖子及腿上散佈各式皮球花。內
翻馬蹄。

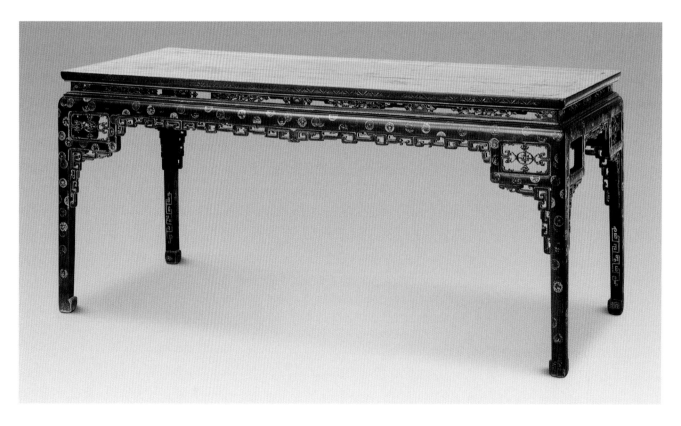

97

紫檀嵌樺木夔龍紋長桌
清乾隆
高86.5厘米　長145厘米　寬47.5厘米
清宮舊藏

**Long, red sandalwood table with inlaid
birch top, decorated with carvings of
Kui[1]-dragons**
Qianlong Period, Qing Dynasty
Height: 86.5cm　Length: 145cm
Width: 47.5cm
Qing Court collection

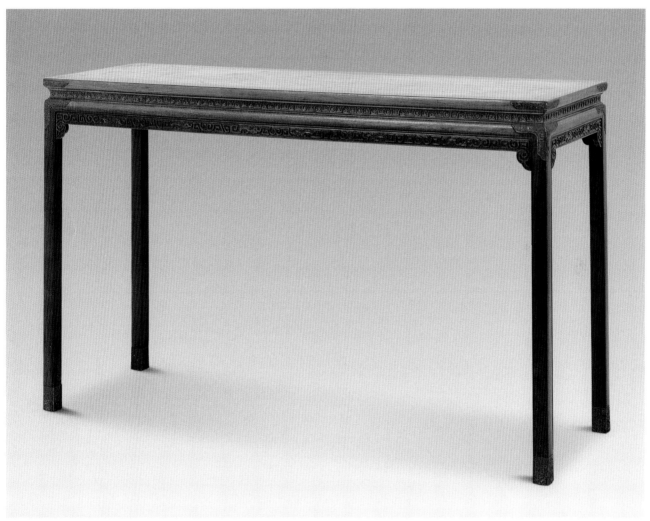

長桌紫檀木製。桌面平直，四邊攢
框，中間打槽鑲樺木板心，冰盤沿，
有銅包角，面下束腰雕水波紋，牙條
雕變形夔龍紋，雲紋牙頭。包銅套
足。

98

紫檀雕花長桌
清
高87厘米　長157.5厘米　寬56厘米
清宮舊藏

Long, red sandalwood table, decorated
with floral patterned carvings
Qing Dynasty
Height: 87cm　Length: 157.5cm
Width: 56cm
Qing Court collection

桌面鬆菠蘿漆，冰盤沿，面下束腰，
上雕結子花並開菱形透光，束腰下有
托腮，牙條透雕攢拐子紋，兩側腿間
安橫棖，橫棖上有透雕拐子紋擋板，
下鑲攢拐子紋圈口，羅鍋底棖，捲書
式足。

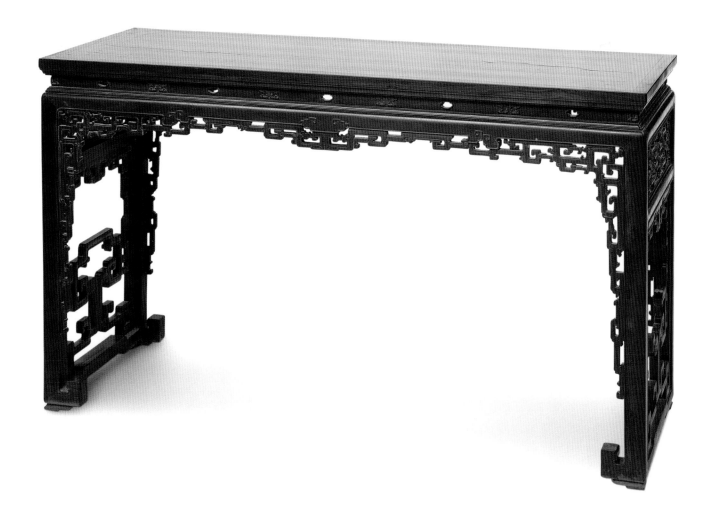

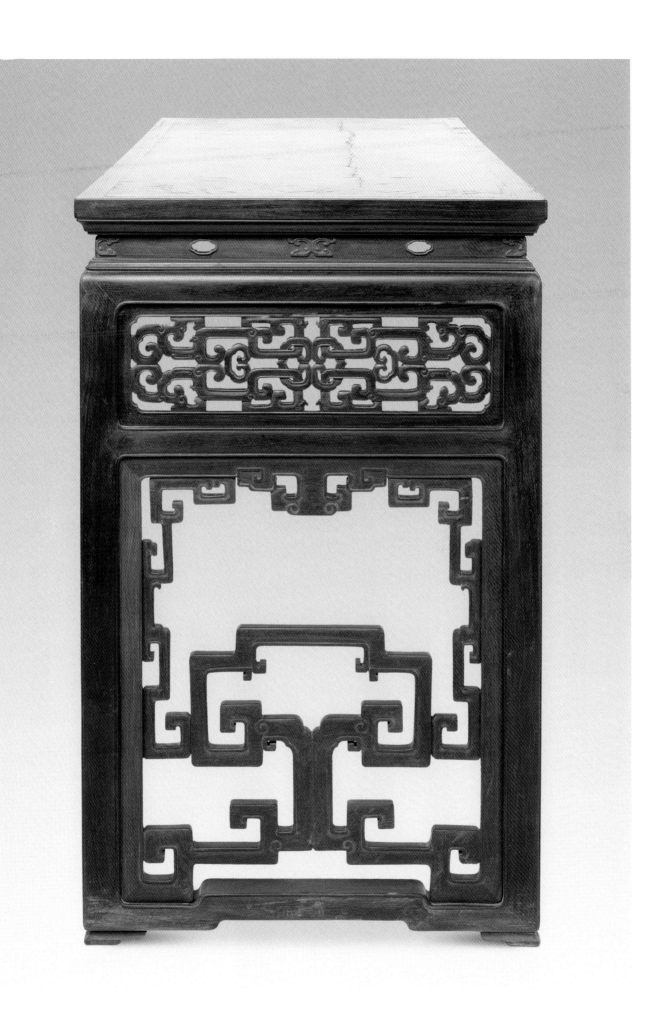

99

紅木雲紋長桌
清
高83厘米　長133厘米　寬47厘米
清宮舊藏

**Long mahogany table, decorated with
cloud patterns**
Qing Dynasty
Height: 83cm　Length: 133cm
Width: 47cm
Qing Court collection

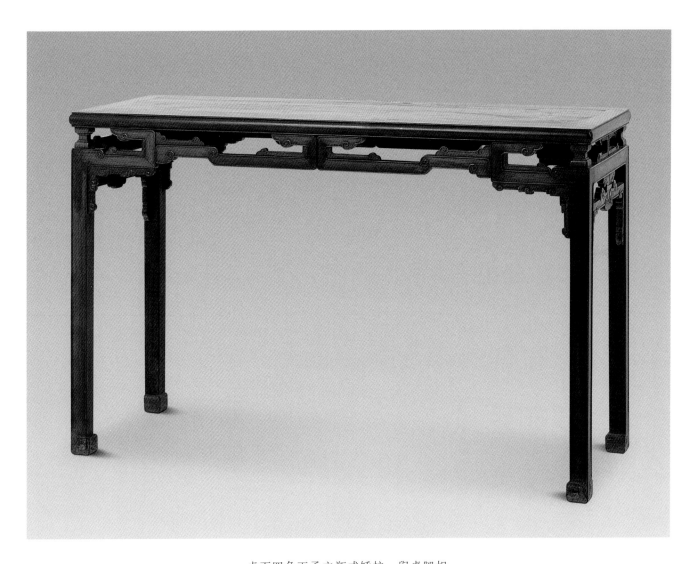

桌面四角下承立瓶式矮柱，與桌腿相
接，正面腿間拐子棖透雕攢雲紋，桌
面與腿、棖相交處安有垂雲紋牙頭。
兩側腿間安有捲雲紋橫棖，內翻迴紋
馬蹄。

100

紫檀靈芝紋長桌
清
高86厘米　長180厘米　寬70厘米

Long, red sandalwood table, decorated with carvings of lingzhi[12] (magical fungus)
Qing Dynasty
Height: 86cm　Length: 180cm
Width: 70cm

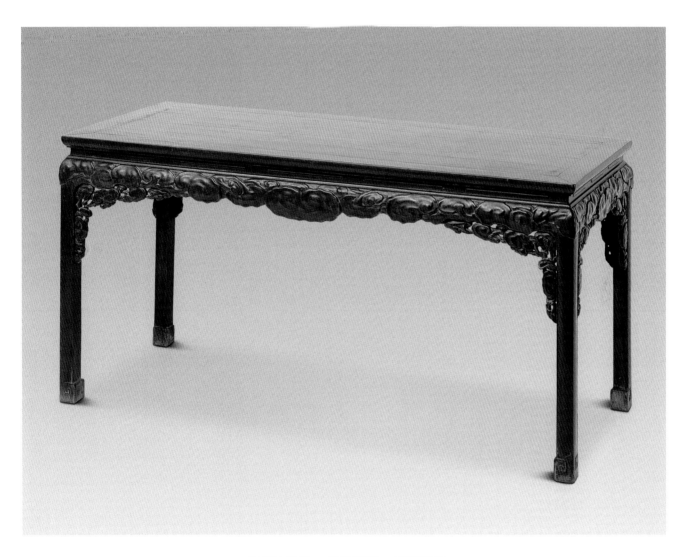

桌面冰盤沿，面下束腰，束腰下托
腮，牙條滿飾靈芝紋，兩側為透雕靈
芝紋托角牙。方腿拱肩部亦飾靈芝
紋，與牙條抱肩榫相交，內翻馬蹄。

紫檀蕉葉紋長桌
清
高85厘米 長185厘米 寬68.5厘米
清宮舊藏

**Long, red sandalwood table, decorated
with banana leaf patterned carvings**
Qing Dynasty
Height: 85cm　Length: 185cm
Width: 68.5cm
Qing Court Colleciton

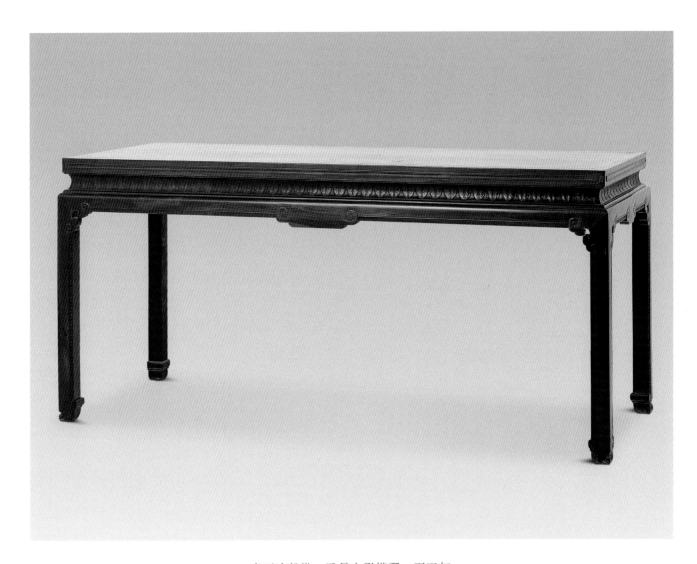

桌面冰盤沿，雕長方形縧環，面下打
窪束腰，雕蕉葉紋一周，束腰下有托
腮，牙條雕玉寶珠紋，如意雲頭紋牙
頭。內翻雲紋足。

102

紫檀嵌螺鈿花卉紋長桌
清
高87厘米　長167厘米　寬70厘米

**Long, red sandalwood table, decorated
with inlaid mother-of-pearl floral patterns**
Qing Dynasty
Height: 87cm　Length: 167cm
Width: 70cm

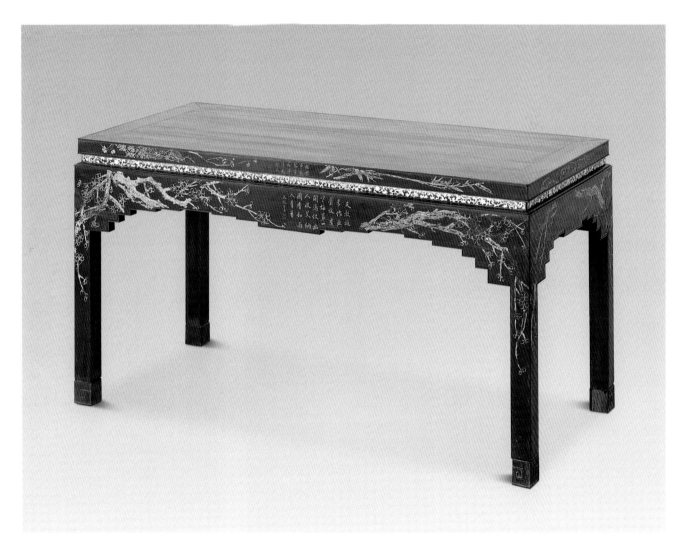

桌面下束腰，飾灑金嵌螺鈿蝠紋及纏
枝蓮紋，束腰下裝托腮。曲形牙條，
中央垂窪堂肚，方材直腿，面沿、牙
條及腿上均有張照描金繪靈芝、梅、
蘭、竹、菊等花卉紋飾，面沿及牙條
上並陰刻填金張照題詩及款識。迴紋
足。

張照（1691－1745）字得天，號涇
南，自號天瓶居士，江蘇人，清康熙
年間進士，歷仕康熙、雍正、乾隆三
朝，官至內閣學士、刑部尚書。擅書
畫，為＂館閣體＂代表書家，常為乾隆
代筆。

斜枝　淺水　隙得幽　谷得天　生意　浮天

張照奉勑題　女同如何　訣不須天　已空澄著　覺多結習　盡千林末　便清和看　一枝風物

經霜　爭艷　飈有　節浮　清風　張照

天瓶居士　入青苔　國香和雨　人收艾納　閑憑仗幽　空梅第一　臺故遺　李作典　天敕桃

117

103

紫檀嵌銅絲鼎式長桌
清
高86.5厘米　長115.5厘米　寬48厘米
清宮舊藏

Red sandalwood table in the shape of a
quadruped, decorated with patterns
made with inlaid copper-wire
Qing Dynasty
Height: 86.5cm　Length: 115.5cm
Width: 48cm
Qing Court collection

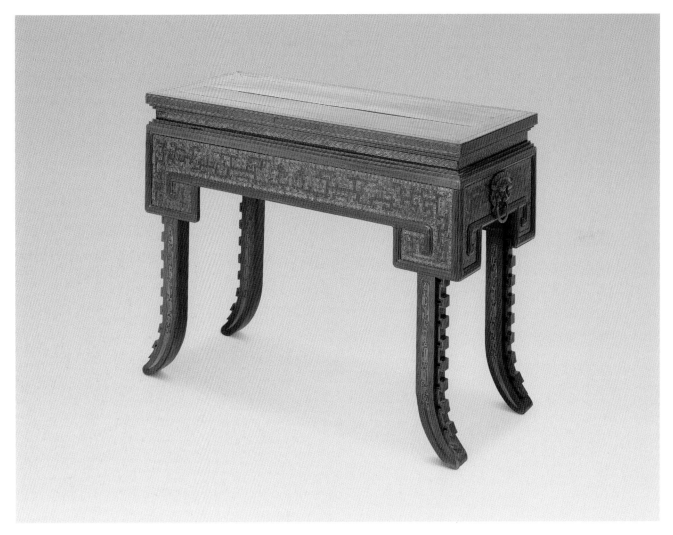

長桌仿青銅器鼎式，桌面邊沿嵌迴
紋，面下有嵌迴紋束腰，托腮上起
綫，桌牙與牙頭一木連做，邊沿凸
起，框上起綫，框內嵌迴紋錦地雕夔
龍紋，兩側牙條正中嵌獸面啣環耳。

四腿外撇，側沿起框，上嵌迴紋，框
內繪夔龍紋，側沿起脊。

此桌造型仿古，工藝複雜精湛，給人
典雅古樸之感。

104

黑漆描金山水圖長桌
清
高85厘米　長192.5厘米　寬73厘米
清宮舊藏

Rectangular, black lacquered table,
decorated with gold tracery landscape
patterns
Qing Dynasty
Height: 85cm　Length: 192.5cm
Width: 73cm
Qing Court collection

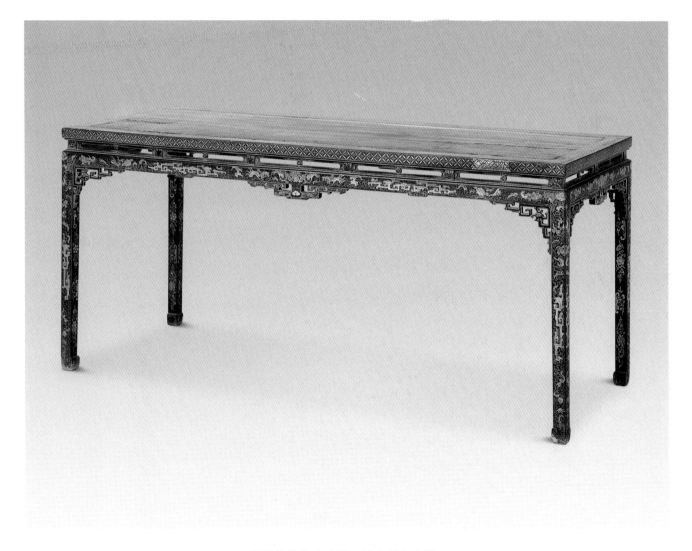

桌面飾描金山水圖，遠山近水之間，
樹木林立，數間屋舍掩映其間，頗具
意境。桌沿有菱形描金花卉紋，面下
束腰上開炮仗洞，嵌卡子花，牙上飾
描金夔龍及花葉紋，角牙透雕夔龍
紋。內翻馬蹄。

105

紫檀拐子紋條桌
清
高83.5厘米　長117.5厘米　寬38.5厘米
清宮舊藏

**Small, long, red sandalwood table,
decorated with Kui[1] patterns**
Qing Dynasty
Height: 83.5cm　Length: 117.5cm
Width: 38.5cm
Qing Court collection

桌面冰盤沿，下起陽綫，面下束腰分段開光，透雕拐子紋。牙條雕玉寶珠紋，角牙透雕拐子紋。方腿，起混面單邊綫，內翻迴紋馬蹄。

此桌原為太極殿所用之物。太極殿位於故宮內廷，是清代嬪妃居住的宮殿之一。

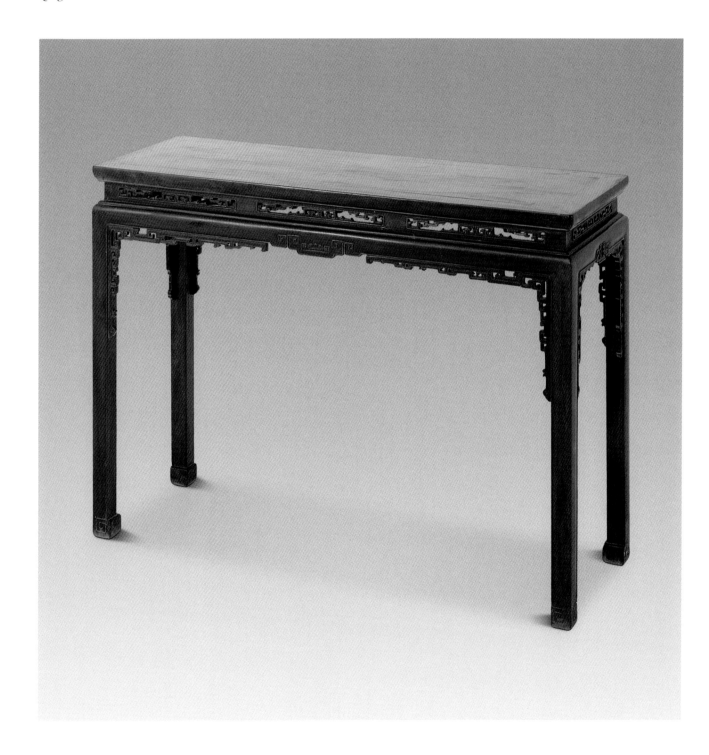

106

紫檀蕉葉紋條桌
清乾隆
高85厘米　長143厘米　寬37厘米
清宮舊藏

Long, red sandalwood table
Qianlong Period, Qing Dynasty
Height: 85cm　Length: 143cm
Width: 37cm
Qing Court collection

桌面平直，冰盤沿，面下打窪高束
腰，雕蕉葉紋。四腿直下，腿間安有
羅鍋根，與腿格肩榫相交。捲珠形
足。

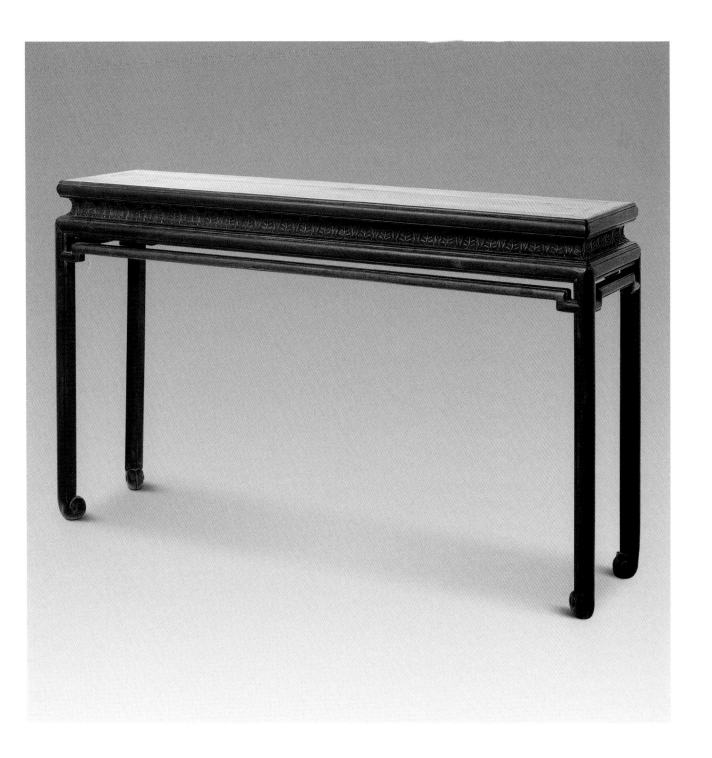

107

剔紅雲龍紋條桌
清乾隆
高86厘米　長161.5厘米　寬42厘米
清宮舊藏

**Long, carved, red lacquered table,
decorated with dragon and cloud
patterns**
Qianlong Period, Qing Dynasty
Height: 86cm　Length: 161.5cm
Width: 42cm
Qing Court collection

桌面邊沿剷地雕纏枝蓮紋，面下束腰
雕迴紋，上下有蓮紋托腮，牙條正中
垂窪堂肚，腿間安有直棖，與窪堂肚
相連，腿、牙子及直棖上均滿地雕龍
戲珠紋、魚紋、珊瑚紋等吉祥紋樣。
內翻馬蹄。

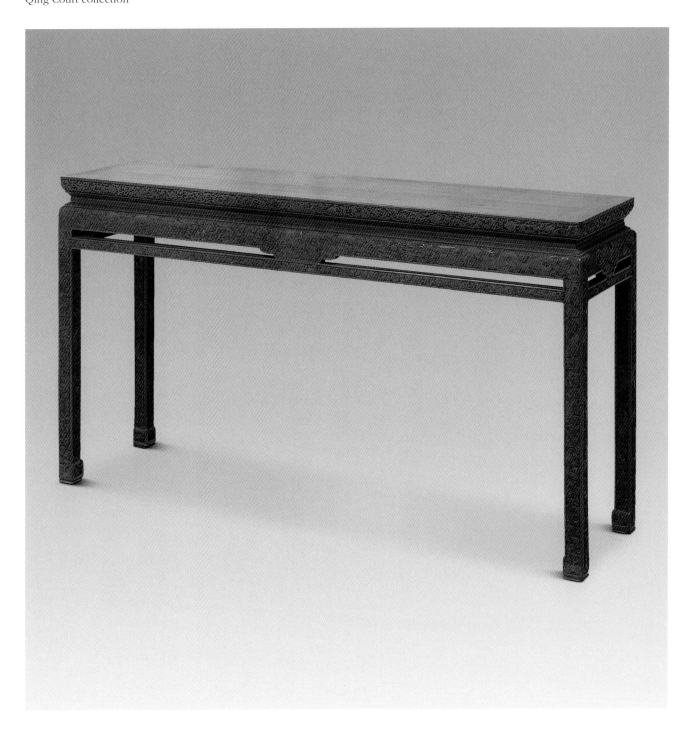

108

紫檀西番蓮紋銅包角條桌
清乾隆
高87.5厘米　長127.5厘米　寬32.5厘米
清宮舊藏

Long, red sandalwood table with copper
corner sheathings, decorated with
carvings of dahlias
Qianlong Period, Qing Dynasty
Height: 87.5cm　Length: 127.5cm
Width: 32.5cm
Qing Court collection

桌面冰盤沿，面下束腰，桌面及束腰
四角處均安有銅包角，牙條正中及兩
側牙頭浮雕西番蓮紋，四腿飾雙混面
單邊綫，鏨花鍍銅金套足。

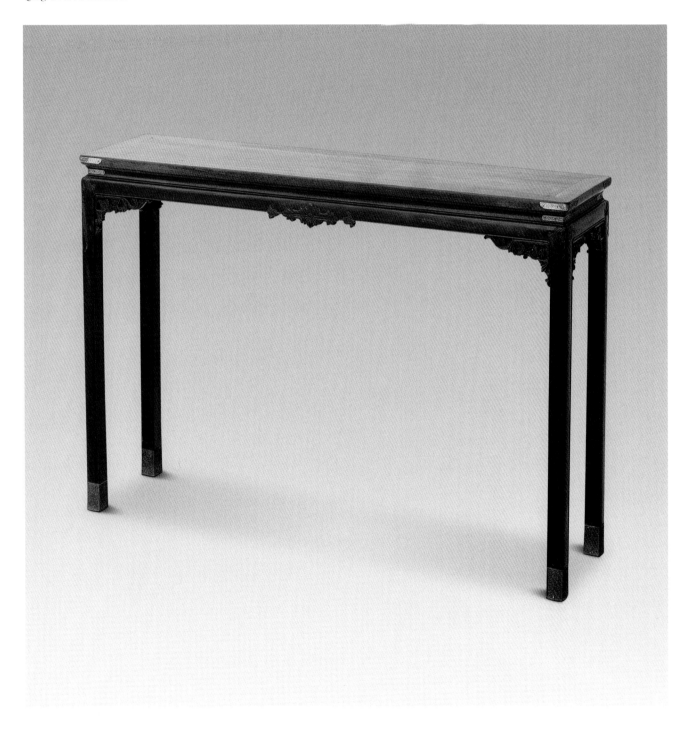

109

紫檀魚紋銅包角條桌
清乾隆
高87.5厘米　長138.5厘米　寬44.5厘米
清宮舊藏

Long, narrow, red sandalwood table with
copper-coated corners, decorated with
carvings of fish
Qianlong Period, Qing Dynasty
Height: 87.5cm　Length: 138.5cm
Width: 44.5cm
Qing Court collection

條桌紫檀木製。桌面攢邊鑲樺木心，
面下束腰，牙條雕水波紋，邊沿雕繩
紋一周，牙頭雕魚紋。桌角、束腰四
角及腿的拱肩處皆以銅飾件包裹，包
銅套足。

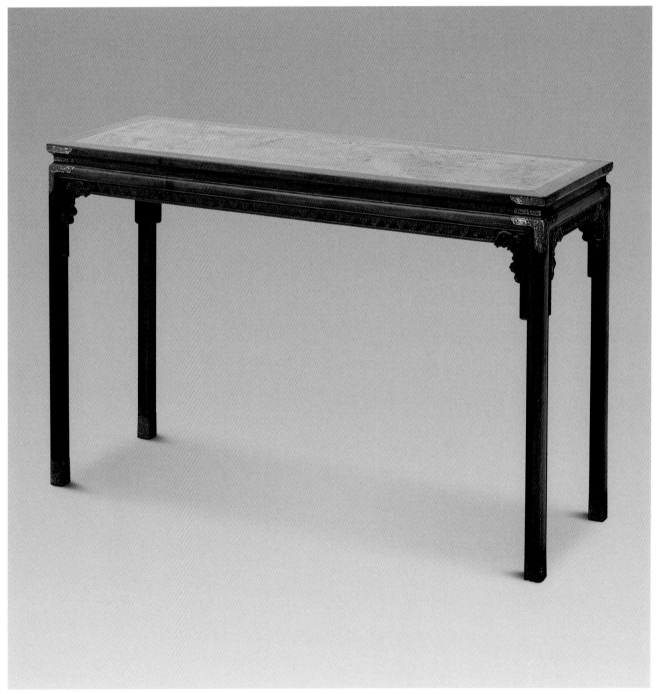

110

填漆戧金雲龍紋條桌
清乾隆
高84.5厘米　長186.5厘米　寬44.5厘米
清宮舊藏

Long, black lacquered table, decorated
with dragon patterns made with inlaid
colored lacquer and gold
Qianlong Period, Qing Dynasty
Height: 84.5cm　Length: 186.5cm
Width: 44.5cm
Qing Court collection

桌面飾雲龍紋，面邊沿為描金斜方格
棗花錦及捲雲紋。面下束腰，分段鑲
板，當中透雕炮仗洞。牙條正中垂雲
紋窪堂肚，拐角處鎪空成捲雲形。桌
牙及桌腿飾雲龍紋。內翻馬蹄。

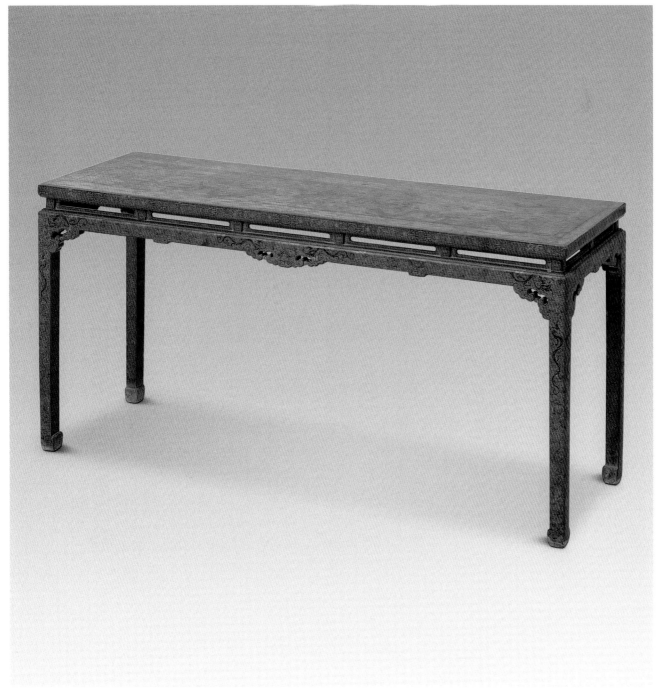

111

紫檀勾雲紋條桌
清乾隆
高90厘米　長192.5厘米　寬57厘米
清宮舊藏

Long, narrow, red sandalwood table,
decorated with cloud cluster patterned
carvings
Qianlong Period, Qing Dynasty
Height: 90cm　Length: 192.5cm
Width: 57cm
Qing Court collection

桌面四角銅鏨花包角，面下細束腰雕
幾何紋，拱肩部包鏨花銅包角，牙條
浮雕勾雲紋，與桌邊沿整體連貫，並
呈迴紋狀與桌腿相連，角牙浮雕勾雲
紋。桌腿內側起陽綫，銅鏨花套足。

112

紫檀捲草紋條桌
清乾隆
高87厘米　長191厘米　寬56.5厘米
清宮舊藏

**Long, red sandalwood table, decorated
with scrolled grass patterns**
Qianlong Period, Qing Dynasty
Height: 87cm　Length: 191cm
Width: 56.5cm
Qing Court collection

桌面為典型的四面平式。面側沿浮雕
捲草紋，面下有透雕捲草紋角牙，兩
腿之間榫接攢拐子紋羅鍋棖，以透雕
捲草紋卡子花與桌面相接，棖子及腿
均浮雕捲草紋，內翻迴紋馬蹄。

113

紫檀玉寶珠紋條桌
清乾隆
高85厘米　長160厘米　寬47厘米
清宮舊藏

Long, red sandalwood table, decorated
with small spiral patterns
Qianlong Period, Qing Dynasty
Height: 85cm　Length: 160cm
Width: 47cm
Qing Court collection

桌面四面平式。面下為雕玉寶珠紋牙
條，牙頭上雕迴紋拐子。四腿素混
面，內翻如意雲頭形足。

114

花梨木迴紋條桌
清乾隆
高85厘米　長144.5厘米　寬38.5厘米
清宮舊藏

Long rosewood table, decorated with key-fret patterns
Qianlong Period, Qing Dynasty
Height: 85cm　Length: 144.5cm
Width: 38.5cm
Qing Court collection

桌面攢框，四面平式。面側沿雕迴紋，桌腿與桌面粽角榫相交，腿間安有橫棖，棖兩端攢框透雕拐子紋，四腿及橫棖上均雕迴紋。

115

填漆戧金雲龍紋條桌
清中期
高85.5厘米　長185厘米　寬55.5厘米
清宮舊藏

Long wooden table, decorated with
dragon and cloud patterns made with
inlaid lacquer and gold
Middle Qing Dynasty
Height: 85.5cm　Length: 185cm
Width: 55.5cm
Qing Court collection

桌面飾雲龍紋。邊沿飾拐子紋，面下
有雲龍紋束腰，四角有立柱，下有雲
紋托腮，牙頭與牙條一木做成，透雕
夔龍紋。方腿上飾雲紋，中部起花
牙，內翻馬蹄。

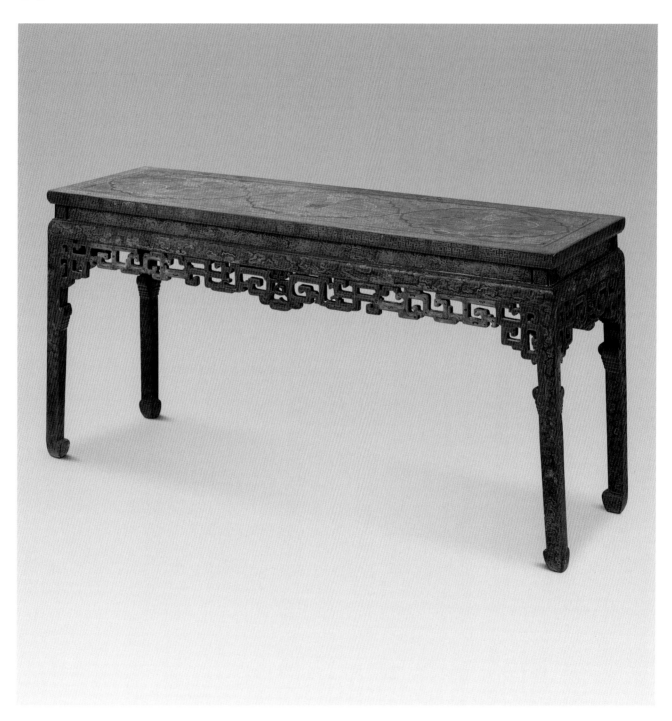

116

紫檀條桌
清
高88.5厘米　長174厘米　寬45厘米
清宮舊藏

Long, narrow, red sandalwood table
Qing Dynasty
Height: 88.5cm　Length: 174cm
Width: 45cm
Qing Court collection

桌面與腿直接用粽角榫連接，以攢欞
的手法做成橫棖和角牙，連接和固定
腿足。橫棖與桌面之間有四個矮老支
撐。方腿，內翻迴紋馬蹄。

此桌原為養心殿所用之物。養心殿位
於隆宗門內，清雍正以後成為皇帝起
居和處理日常政務的地方。

117

紫檀夔龍紋銅包角條桌
清
高86.5厘米　長144厘米　寬39厘米
清宮舊藏

**Long, red sandalwood table with copper
corner sheathings, decorated with Kui[1]-
dragon patterns**
Qing Dynasty
Height: 86.5cm　Length: 144cm
Width. 39cm
Qing Court collection

桌面邊抹冰盤沿綫角，面下打窪束
腰，桌面及束腰四角均包鑲銅飾件，
牙條透雕夔龍紋。腿肩部亦包鑲銅飾
件，內翻馬蹄。

118

紫漆花草紋條桌
清
高84厘米　長134厘米　寬42厘米
清宮舊藏

Long, purple lacquered table, decorated with flower and grass patterns
Qing Dynasty
Height: 84cm　Length: 134cm
Width: 42cm
Qing Court collection

桌面繪洞石、花草。冰盤沿，面下束腰，上有開海棠式透光，飾描金團花紋，束腰下托腮，透雕攢拐子結繩紋花牙，牙上及四腿繪紅蝙蝠。側面兩腿間安有橫棖，腿及棖上均鑲透雕拐子紋圈口，足下承托泥，托泥上安攢拐子紋圈口。

119

紫檀西洋捲草紋條桌
清
高88厘米　長174厘米　寬45厘米
清宮舊藏

**Long, red sandalwood table, decorated
with Western style scrolled grass
patterns**
Qing Dynasty
Height: 88cm　Length: 174cm
Width: 45cm
Qing Court collection

桌面下高束腰，下有蓮紋托腮和透雕
西洋捲草紋花牙。方材直腿，雕捲草
紋內翻馬蹄。

120

紫檀拐子紋包銅角炕桌
清乾隆
高42厘米　長103厘米　寬42厘米
清宮舊藏

**Small, red sandalwood kang[11] table, with
copper corner sheathings, decorated
with Kui[1] patterns**
Qianlong Period, Qing Dynasty
Height: 42cm　Length: 103cm
Width: 42cm
Qing Court collection

桌面攢框鑲板，邊角鑲銅鏨花包角。
面下有雕拐子紋束腰，束腰下為雕拐
子紋牙條，拐角處為剷地雕拐子紋角
牙。腿的拱肩部鑲銅鍍金鏨花包角，
內翻馬蹄。

炕桌的結構與其他桌相同，唯十分矮
小，主要用於炕上陳設。

121

黑漆嵌玉描金百壽字炕桌
清乾隆
高29.5厘米　長112厘米　寬81厘米
清宮舊藏

Black lacquered kang[14] table, decorated
with inlaid jade and gold tracery patterns
featuring the character "Shou" (longevity)
Qianlong Period, Qing Dynasty
Height: 29.5cm　Length: 112cm
Width: 81cm
Qing Court collection

桌面中間飾描金"壽"字一百二十個，
邊沿為雕填描金卍字錦紋地，嵌玉製
蝙蝠、壽桃及描金團壽紋，桌面側沿
為描金卍字錦紋並長圓形開光，開光
內嵌玉製蝙蝠、壽桃。迴紋束腰，下
為描金蓮瓣紋托腮，雲紋牙條。拱肩
直腿，腿、牙邊沿描金，並滿飾填彩
描金團壽字及玉製壽桃、蝙蝠。內翻
馬蹄。

此桌做工精湛，紋飾繁複且寓意吉
祥，為清代家具精品。

122

紅漆嵌螺鈿百壽字炕桌
清中期
高29厘米　長96.5厘米　寬63厘米
清宮舊藏

Red lacquered kang[14] table, decorated
with the character "Shou" (longevity)
made with inlaid mother-of-pearl
Middle Qing Dynasty
Height: 29cm　Length: 96.5cm
Width: 63cm
Qing Court collection

桌面中間嵌螺鈿"壽"字共一百二十
字，邊沿嵌螺鈿卍字錦紋地，寓意
"萬壽無疆"。桌面側沿嵌螺鈿連卍字
紋，面下束腰，嵌團壽及長壽字紋，
牙條及直腿嵌螺鈿蝙蝠、壽桃、團壽
及方壽紋，寓意"福壽雙全"。內翻馬
蹄。

此桌與前圖炕桌造型、工藝及紋飾相
同，唯髹漆顏色和嵌件材質略有差
異。

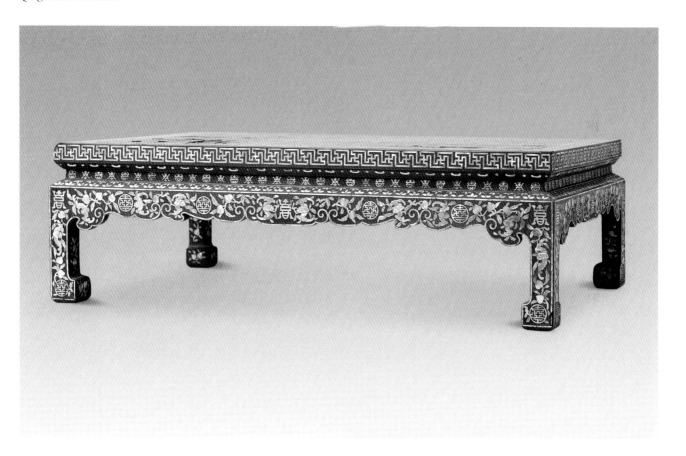

123

黑漆描金雲蝠紋炕桌
清
高33.5厘米　長85.5厘米　寬57.5厘米
清宮舊藏

**Small, black lacquered kang[14] table,
decorated with gold tracery bat[4] and
cloud patterns**
Qing Dynasty
Height: 33.5cm　Length: 85.5cm
Width: 57.5cm
Qing Court collection

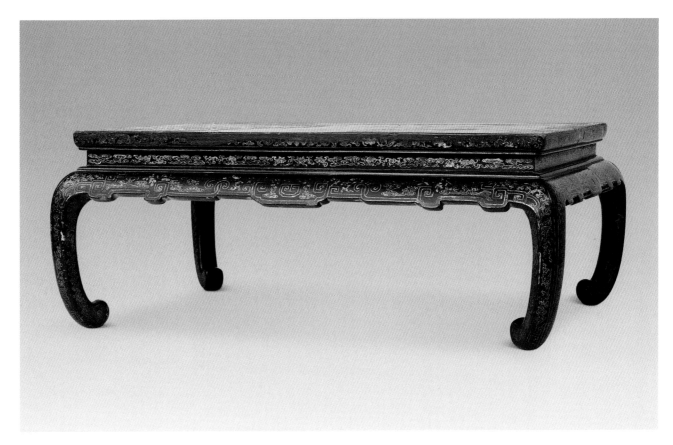

桌面冰盤沿飾描金雲蝠、花卉紋，面
下束腰飾描金西番蓮及捲雲紋，下承
托腮。鼓腿彭牙，牙條飾玉寶珠紋及
捲雲紋，桌腿飾描金雲紋，內翻馬
蹄。

此桌原為麗景軒所用之物。麗景軒為
儲秀宮後殿，晚清時期，慈禧曾經在
此居住。

124

紫檀方勝紋琴桌
清乾隆
高85厘米　長135厘米　寬39厘米
清宮舊藏

Red sandalwood Chinese lute table, decorated with an intersecting pattern
Qianlong Period, Qing Dynasty
Height: 85cm　Length: 135cm
Width: 39cm
Qing Court collection

琴桌棕角榫結構。桌面平直長條形，面下直棖，面、棖之間的正面和側面分別有三連和雙連方勝紋卡子花，雕緊帶紋棖，兩端雕如意雲頭紋牙頭與腿相交。方腿直足，下踩覆蓮頭。

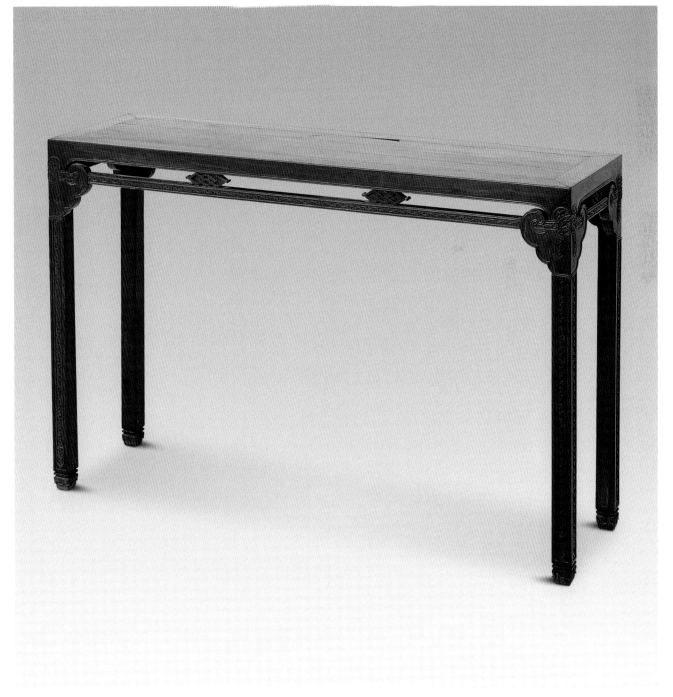

125

紫檀刻書畫八屜畫桌
清中期
高87.5厘米　長220厘米　寬89厘米

Red sandalwood, eight-drawer painting
table, decorated with carvings of the
Masters' calligraphy and paintings
Middle Qing Dynasty
Height: 87.5cm　Length: 220cm
Width: 89cm

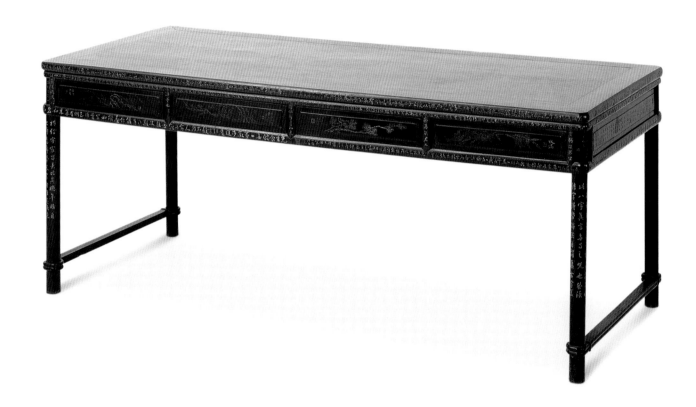

畫桌裏腿作。桌面長方形，劈料式
沿。雙面各四個抽屜，側面兩腿間安
有繩紋橫棖。四面滿刻錢維城、劉
墉、湯貽芬、南沙老人、金農、鄭
燮、蔣廷錫等名家題詞及繪畫。圓腿
直足。

此桌雖非清宮藏品，但其造型美觀，
做工圓潤，且有清代諸多名家的題記
和繪畫，是極為罕見的家具珍品。

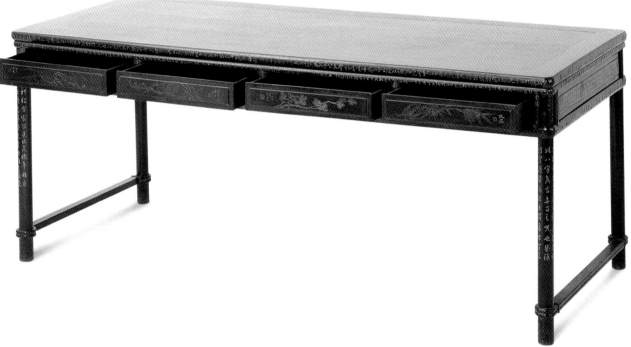

126

紫檀西番蓮紋大供桌
清乾隆
高97厘米　長236厘米　寬84厘米
清宮舊藏

**Large, red sandalwood altar table,
decorated with dahlia patterns**
Qianlong Period, Qing Dynasty
Height: 97cm　Length: 236cm
Width: 84cm
Qing Court collection

桌面長方形，冰盤沿雕卍字紋，高束
腰以矮柱分為數格，上嵌裝浮雕夔龍
紋的縧環板，束腰上下裝蓮瓣紋托
腮，牙條厚碩，為變體的玉寶珠形，
上剷地雕西番蓮紋。三彎腿上部起雲
翅，剷地雕西番蓮紋，外翻馬蹄，下
承托泥，帶龜腳。

127

紫檀西番蓮紋梯形桌
清乾隆
高90厘米　面徑112厘米
清宮舊藏

Trapezoidal, red sandalwood table,
decorated with dahlia patterns
Qianlong Period, Qing Dynasty
Height: 90cm
Diameter of tabletop: 112cm
Qing Court collection

桌面梯形，束腰雕如意紋並開菱形透孔，托腮雕一圈蓮紋，下裝透雕西番蓮紋花牙。四腿下部安底棖，棖內嵌裝透雕西番蓮紋的底盤，底棖下為雕玉寶珠紋牙條。外翻捲雲紋足。

此桌為一對，可以組合成一個六角形桌，亦可於室內對稱擺設。

128

紫漆描金花卉紋葵花式桌
清雍正
高89.5厘米　面徑124厘米
清宮舊藏

Purple lacquered, sunflower-shaped table, decorated with gold tracery floral patterns
Yongzheng Period, Qing Dynasty
Height: 89.5cm
Diameter of top: 124cm
Qing Court collection

桌面葵花形，上飾描金花卉，面側沿
有抽屜。面下透雕夔龍紋花牙一周，
正中為圓柱式描金花草紋獨腿，分兩
節，上節以六個描金花角牙支撐桌
面，下節以六個站牙抵住圓柱，下節
圓柱頂端有軸，上節圓柱下端有圓
孔，套在軸上，使桌面可左右轉動。
下承葵花式須彌座，座下為壼門式牙
子帶龜腳。

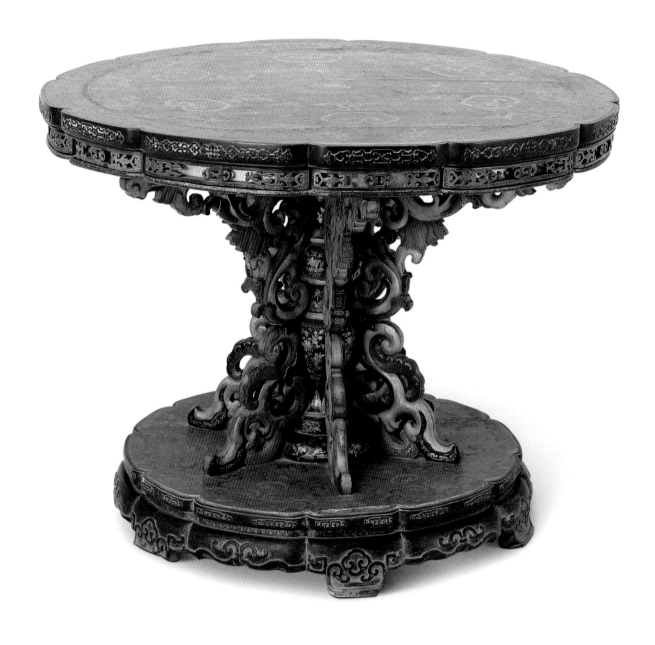

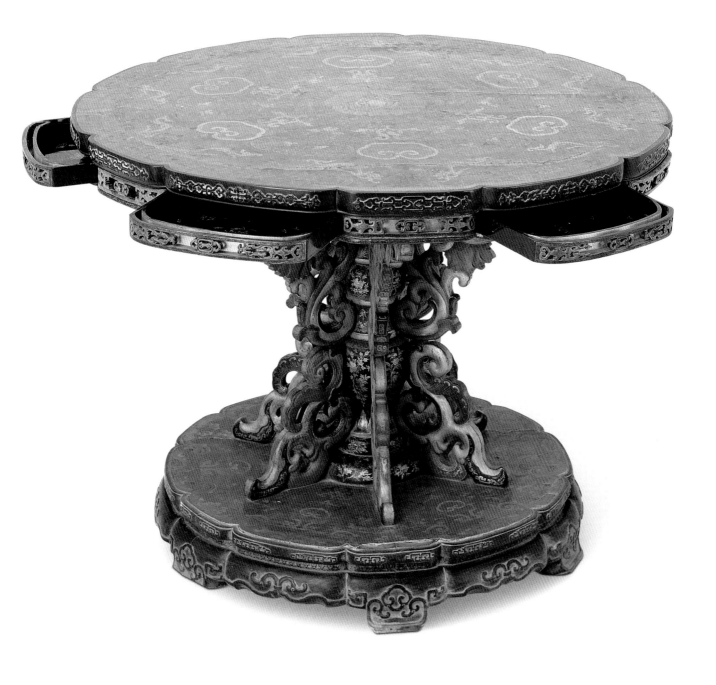

129

填漆福壽紋半圓桌

清雍正至乾隆
高80.5厘米　面徑64.5厘米
清宮舊藏

Matching pair of semi-circular, red
lacquered tables, decorated with bat[4]
and peach patterns made with colored
lacquer and gold inlays
Yongzheng-Qianlong Period, Qing
Dynasty
Height: 80.5cm
Diameter of top: 64.5cm
Qing Court collection

桌面半圓形，上理溝戧金花紋，側沿
飾蝙蝠、折枝壽桃，面下有雕拐子、
捲草紋束腰及迴紋托腮。牙條、牙頭
皆雕捲雲紋，四腿上飾蝙蝠、折枝壽
桃。下部裝透雕螭紋底盤，底盤下亦
安有牙條。

此桌成對為一組合，兩桌對拼恰可組
成一個圓桌。常用於廳堂兩側對稱陳
設。

130

紫檀西番蓮紋半圓桌
清
高86.5厘米　面徑110.5厘米
清宮舊藏

**Semi-circular red sandalwood table,
decorated with carvings of dahlias**
Qing Dynasty
Height: 86.5cm
Diameter of top: 110.5cm
Qing Court collection

桌面邊起冰盤沿，面下束腰凸雕六塊
夔龍紋縧環板，牙條雕西番蓮紋，止
中垂如意紋方形窪堂肚，兩邊透雕夔
龍紋牙條，桌腿上部雕西番蓮紋，兩
邊起陽綫，腿間安有底棖，鑲透雕夔
龍紋底盤，雙翻迴紋足。

131

黃花梨嵌螺鈿夔龍紋炕案

清早期
高28厘米　長91.5厘米　寬60.5厘米

Huanghuali[6] wood kang[14] table, decorated with inlaid mother-of-pearl
Early Qing Dynasty
Height: 28cm　Length: 91.5cm
Width: 60.5cm

案面平頭，長方形，上用紫檀木片鑲成珠花、岔角及開光，正中為嵌色石螺鈿螭龍、花朵紋，邊勾渦旋紋加紫色石圓珠。桌面邊沿、四角鑲紫檀開光，分別嵌飾螺鈿色石勾蓮和飛鶴、彩雲。面下雕螭紋花牙、沿板，直腿上嵌螺鈿螭龍紋，兩側腿間有鏤空螭紋沿板。四腿縮進安裝，雕雲頭形足。

案與桌的主要區別在於案的腿縮進安裝，而桌腿則與桌面四角垂直。

148

132

紫檀雕迴紋炕案

清乾隆
高32厘米　長91厘米　寬35厘米
清宮舊藏

**Red sandalwood kang[14] table, decorated
with key-fret patterns**

Qianlong Period, Qing Dynasty
Height: 32cm　Length: 91cm
Width: 35cm
Qing Court collection

案面攢框鑲板，冰盤沿浮雕飾迴紋縧
環板，面下直牙條，上雕迴紋，牙頭
鏤成如意雲頭形，腿面亦雕飾迴紋縧
環板，側面兩腿間安有橫棖，鑲長方
圈口，圈口兩面起凸綫一圈，內外浮
雕迴紋一匝。下承須彌式托座，帶龜
腳。

133

剔黑填漆六方紋炕案

清乾隆
高35厘米　長88厘米　寬33厘米
清宮舊藏

Carved black lacquered kang[14] table,
decorated with hexagonal patterns made
with inlaid colored lacquer
Qianlong Period, Qing Dynasty
Height: 35cm　Length: 88cm
Width: 33cm
Qing Court collection

除案面外，通體剔黑飾六方紋錦。案面髹豆綠色漆，飾理溝填漆六方紋錦，迴紋邊。面下長牙條貫通兩腿，牙條與腿的拐角處飾雙雲紋護腿牙，側面兩腿間鑲方式圈口。雲頭形足，下承捲書式托泥。

此案小巧精緻，現僅存二件，此為其一，十分珍貴。

134

剔紅纏枝花紋炕案
清乾隆
高36厘米　長83厘米　寬37厘米
清宮舊藏

**Carved, red lacquered kang[14] table,
decorated with floral spray patterns**
Qianlong Period, Qing Dynasty
Height: 36cm　Length: 83cm
Width: 37cm
Qing Court collection

炕案通體剔紅。案面邊沿雕纏枝蓮紋
及拐子紋，面下束腰的迴形框內雕蝠
紋，迴紋托腮，牙條雕纏枝牡丹紋，
角牙雕拐子紋，案腿滿飾花草紋。兩
側腿間有開光，開光內鏤成如意雲頭
形，上雕蝠磬紋、纏枝蓮紋。平底捲
雲形足。

此案原為養心殿所用之物。

135

紫檀雲蝠紋畫案
清乾隆
高89厘米　長191.5厘米　寬69厘米
清宮舊藏

Large, red sandalwood painting table,
decorated with bat[4] and cloud patterns
Qianlong Period, Qing Dynasty
Height: 89cm　Length: 191.5cm
Width: 69cm
Qing Court collection

畫案四角與案腿以粽角榫相交，為典
型的四面平做法。案面與四腿之間以
浮雕雲蝠紋牙條鑲成圈口。腿間以橫
棖連接，雕內翻長拐子紋四足。

此案的製作一反案類家具的一般形
製，別具一格，雖稱畫案，但主要用
於陳設。

136

竹簧畫案
清乾隆
高86.5厘米　長194.2厘米　寬82厘米
清宮舊藏

Wooden painting table with fir-covered
surface
Qianlong Period, Qing Dynasty
Height: 86.5cm　Length: 194.2cm
Width: 82cm
Qing Court collection

畫案杉木胎，通體包鑲竹簧。案面下
為迴紋透空攢牙子，四腿上端與案面
連接，支撐着牙條的下部。兩側腿間
安羅鍋棖，雲頭形足。

此案採用竹簧包鑲，在大型桌案中極
為少見，堪稱清代家具珍品。

137

黑漆描金山水圖書案
清雍正
高85厘米　長200厘米　寬78厘米
清宮舊藏

Black lacquered writing table, decorated
with gold tracery landscape patterns
Yongzheng Period, Qing Dynasty
Height: 85cm　Length: 200cm
Width: 78cm
Qing Court collection

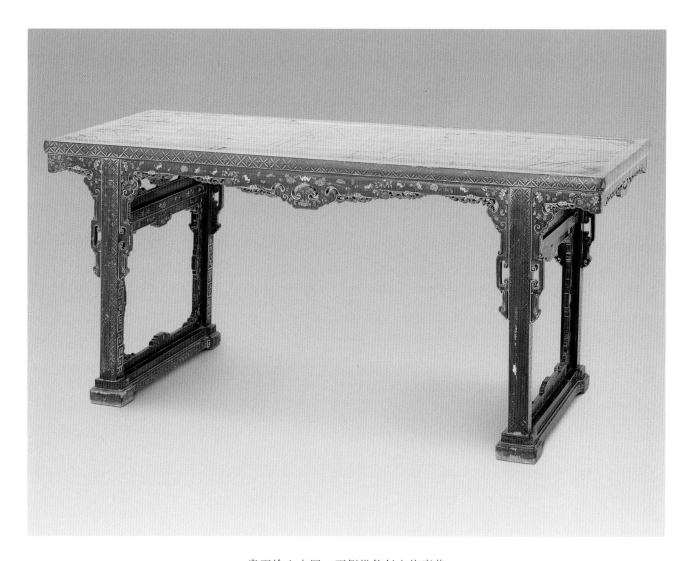

案面繪山水圖，面側沿飾斜方格棗花
錦。四面牙條鏤作雲紋，正中垂窪堂
肚，飾蝙蝠及折枝花卉紋。護腿牙上
部雕雲紋，下部演化為拐子紋。腿面
飾描金斜方格棗花錦，側面兩腿間鑲
帶窪堂肚的圈口。四腿外撇，側腳收
分，足下承托泥。

138

紫檀勾雲紋案
清中期
高81厘米　長144.5厘米　寬39.5厘米

**Long, red sandalwood table, decorated
with scrolled cloud patterns**
Middle Qing Dynasty
Height: 81cm　Length: 144.5cm
Width: 39.5cm

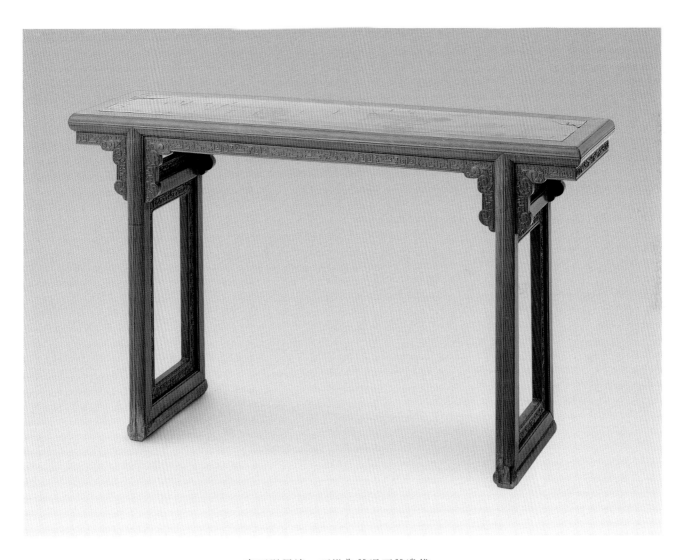

案面髹黑漆，面沿為雙混面雙邊綫。
面下牙條雕迴紋及勾雲紋，托角牙連
接牙堵，腿正面雕雙混面雙邊綫，與
面沿綫條吻合。兩側面腿間有管腳根
相連，腿內側鑲雕迴紋圈口，側面足
下承托泥。

139

花梨捲雲紋案
清
高87厘米　長144厘米　寬47厘米
清宮舊藏

Long, rosewood table, decorated with
cirrus cloud patterns
Qing Dynasty
Height: 87cm　Length: 144cm
Width: 47cm
Qing Court collection

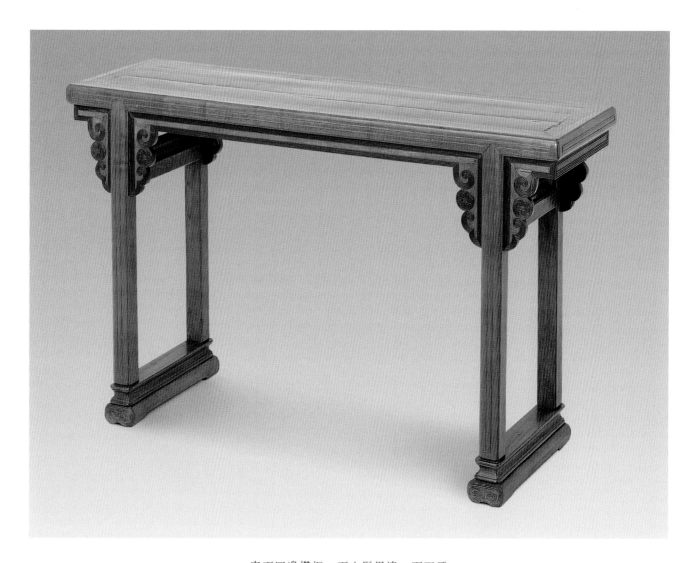

案面四邊攢框，面心鬃黑漆，面下牙
頭雕捲雲紋，格肩榫結構，直腿外側
中心起雙陽綫，側面兩腿間安有橫
棖，平底足，下承雕捲雲紋須彌座式
托泥。

140

紅漆描金團花紋大翹頭案
清
高92厘米　長407厘米　寬69.5厘米
清宮舊藏

Large, long, red lacquered table with up-
turned ends, decorated with gold tracery
floral patterns
Qing Dynasty
Height: 92cm　Length: 407cm
Width: 69.5cm
Qing Court collection

案面兩側高翹頭，面上飾描金丹鳳
紋、福壽紋等吉祥紋樣。面下牙條飾
描金纏枝花卉紋，牙頭透雕卍字紋。
直腿上亦飾描金纏枝花卉紋，側面腿
間鑲透雕罩金纏枝蓮紋擋板，平足。

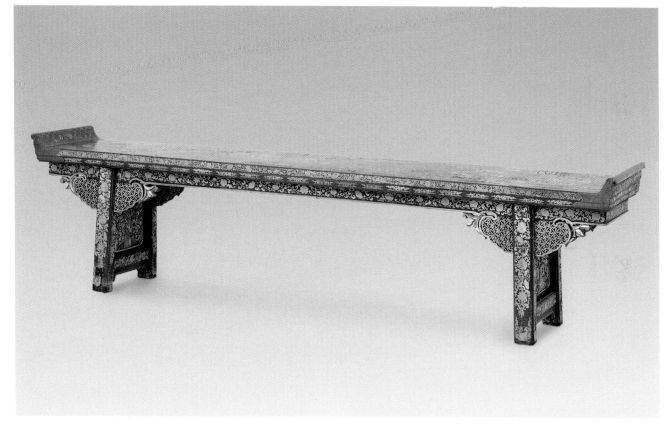

141

紫檀雲蝠紋邊架几案
清
高95厘米　長385.5厘米　寬52厘米
清宮舊藏

Red sandalwood trestle table, decorated
with bat⁴ and cloud patterned carvings
Qing Dynasty
Height: 95cm　Length: 385.5cm
Width: 52cm
Qing Court collection

案面側沿雕雲蝠紋，面下有兩個架
几，架几有束腰，透雕雲蝠紋，几壁
有勾雲形開光，開光外透雕蝙蝠、壽
桃、及蝙蝠啣卍字紋，有「福壽無
邊」、「萬壽無疆」的寓意。

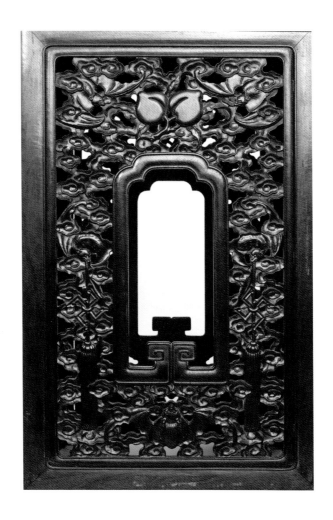

紅木雲蝠紋翹頭案

清
高100厘米　長367.5厘米　寬71厘米
清宮舊藏

Long, mahogany table with up-turned
ends, decorated with bat[4] and cloud
patterned carvings
Qing Dynasty
Height: 100cm　Length: 367.5cm
Width: 71cm
Qing Court collection

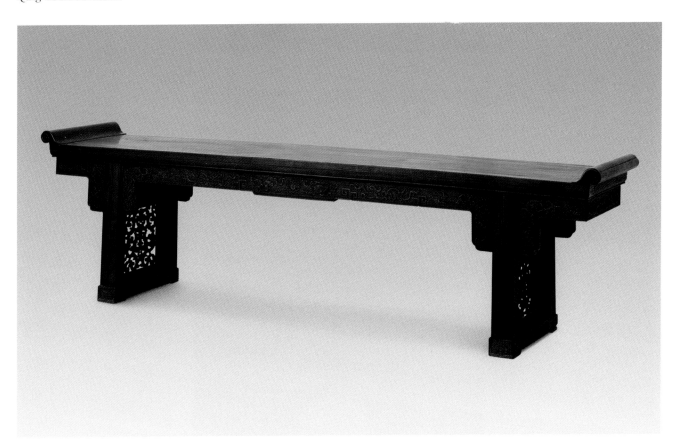

案面夾頭榫帶托子捲頭，兩側捲雲頭係用其他木料製作。案下牙頭、牙條雕雲蝠和夔龍紋，案腿中心雕二柱香，邊緣亦起綫，合成雙混面雙邊綫，側面腿間擋板透雕夔龍紋，足下承雕迴紋托泥。

此案原為故宮翊坤宮所用之物。翊坤宮屬於故宮西六宮，與儲秀宮、體和殿組成一個院落，是清代后妃的居住之所。

143

黑漆描金山水樓閣圖炕几
清雍正
高37厘米　長124厘米　寬47.5厘米
清宮舊藏

**Black lacquered kang[14] table, decorated
with gold tracery landscape patterns**
Yongzheng Period, Qing Dynasty
Height: 37cm　Length: 124cm
Width: 47.5cm
Qing Court collection

几面上描金繪《山水樓閣圖》，山水之
間樹木掩映，亭台樓榭錯落，　菜小
舟行於水面，意境深遠。面下束腰雕
菱形透空開光，周圍飾描金行龍紋，
直牙條，欟格牙頭，牙條及腿面均飾
描金圓形皮球花。內翻馬蹄，下踩圓
珠。

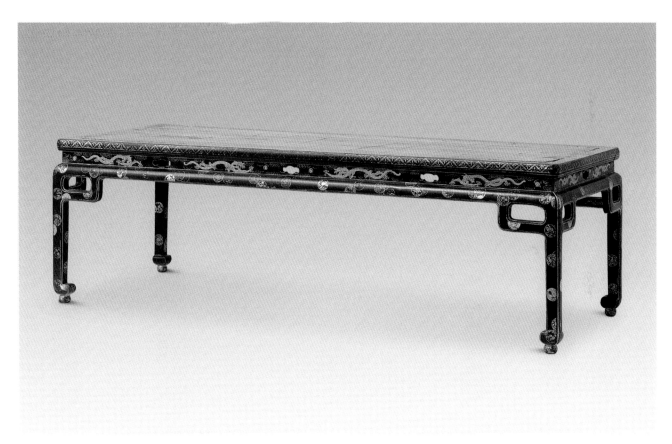

144

紫檀銅繩繫紋炕几
清乾隆
高36.5厘米　長82.5厘米　寬42.5厘米
清宮舊藏

**Red sandalwood kang[14] table, decorated
with a copper cord arrangement**
Qianlong Period, Qing Dynasty
Height: 36.5cm　Length: 82.5cm
Width: 42.5cm
Qing Court collection

几面側沿銅包角，面下有罩金漆銅製
雙條繩繫紋羅鍋棖，几腿四角起陽
綫，銅鏨花套足。

此几原為慈寧宮所用之物。慈寧宮位
於故宮內廷，是清代皇太后居住的宮
殿。

145

剔紅福壽紋炕几
清乾隆
高34.5厘米　長94.5厘米　寬25.5厘米
清宮舊藏

**Carved, red lacquered kang[14] table,
decorated with bat[4] and peach patterns**
Qianlong Period, Qing Dynasty
Height: 34.5cm　Length: 94.5cm
Width: 25.5cm
Qing Court collection

炕几通體剔紅。面心浮雕拐子紋及西
洋捲草紋，上點綴蝙蝠及鯰魚紋，迴
紋邊。面側沿雕蝙蝠、壽桃及卍字
紋、拐子紋，紋樣延續至腿面，寓意
"福壽"。面下鏤空拐子紋托角牙。側
面兩腿間開光，飾上翻如意雲頭，足
下承海水紋托泥。几面內裏正中陰刻
描金"大清乾隆年製"楷書款。

清代家具有款識的極少，此几對研究
乾隆年間家具工藝有重要參考價值。

146

紫檀小炕几
清乾隆
高40厘米　長95厘米　寬40厘米
清宮舊藏

Small, red sandalwood kang[14] table
Qianlong Period, Qing Dynasty
Height: 40cm　Length: 95cm
Width: 40cm
Qing Court collection

小炕几為三塊紫檀木整板雕刻組合而
成。几面與腿板以悶榫結構格角相
接，接角處打成軟圓角。兩側面腿板
落堂踩鼓做，中間透雕捲雲紋開光，
內翻捲書式足。

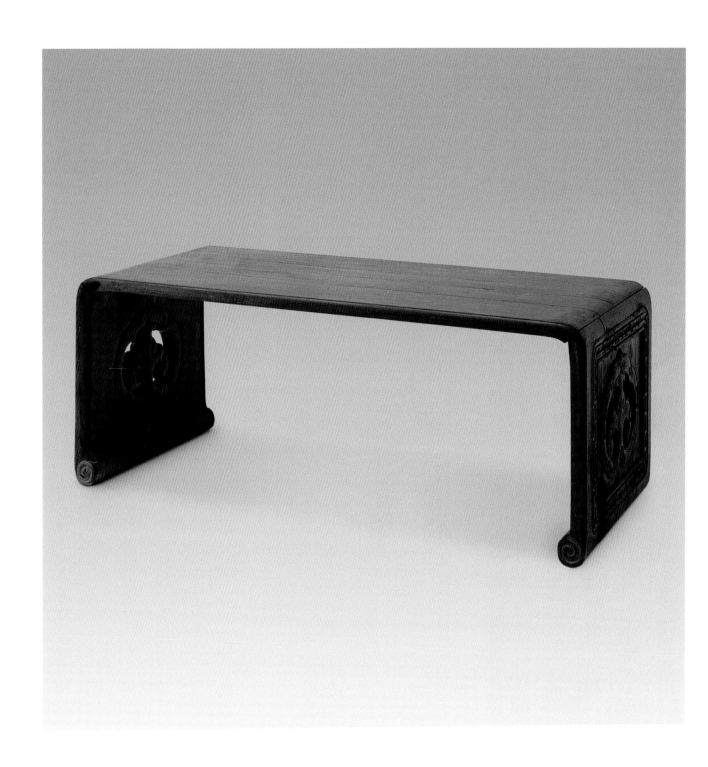

147

紅地填彩漆山水圖炕几
清
高40.5厘米　長87厘米　寬38厘米
清宮舊藏

Red lacquered kang[14] table, decorated with a landscape pattern made with inlaid colored lacquer
Qing Dynasty
Height: 40.5cm　Length: 87cm
Width: 38cm
Qing Court collection

几面填彩山水、樹石、雲霧，面側沿為菱形紋。面下繪捲草紋束腰，下有夔龍紋托腮。四腿挖缺作，牙條與腿均透雕券口，以纏枝花的形式把牙條與腿連在一起。內翻馬蹄。

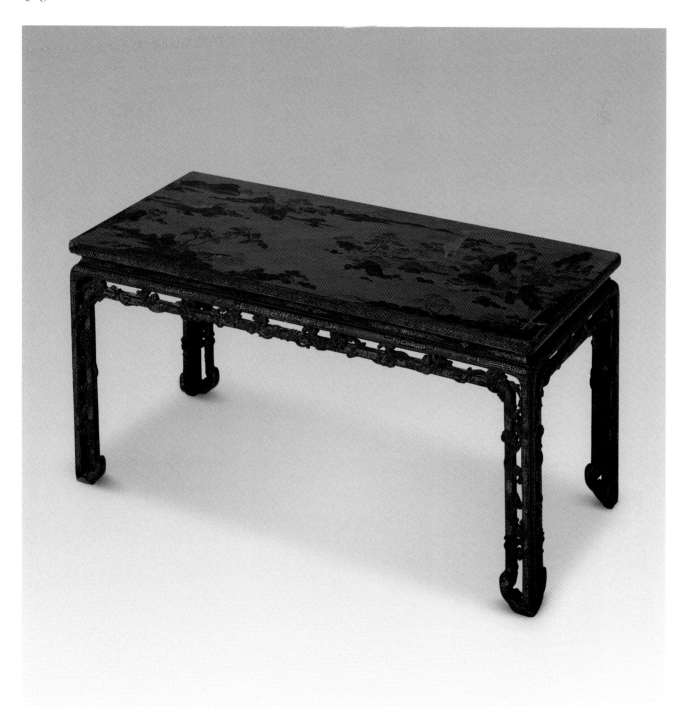

148

紫漆描金松鶴圖斑竹炕几
清
高38.5厘米　長123厘米　寬49厘米
清宮舊藏

Purple, lacquered kang[14] table, decorated with a pine and crane picture made from gold tracery and inlaid mottled bamboo
Qing Dynasty
Height: 38 5cm　Length: 123cm
Width: 49cm
Qing Court collection

炕几紫漆鑲斑竹製。几面描金彩繪《松鶴圖》，畫面上六隻仙鶴或在空中盤旋，或立於山石之上，旁邊襯以松樹、靈芝，有祝頌長壽之意。面下斑竹攢成拐子式牙條，側面兩腿間安有斑竹橫棖，上雕拐子紋。外翻拐子形足。

據《清檔》記載：「雍正十年六月二十七日，……着傳旨年希堯……再將長三尺至三尺四寸，寬九寸至一尺，高九寸至一尺小炕案亦做些，或彩漆、鑲斑竹，款式亦要文雅，欽此。」即指此類家具。

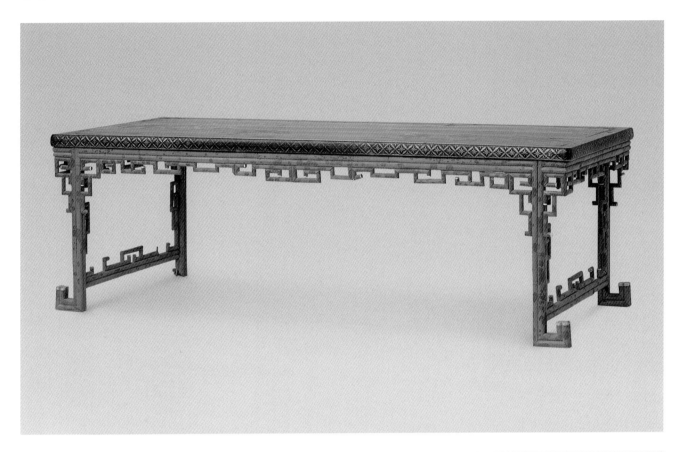

149

紫檀龍紋香几
清乾隆
高92厘米　長41.5厘米　寬29厘米
清宮舊藏

**Red sandalwood censer table, decorated
with carvings of dragons**
Qianlong Period, Qing Dynasty
Height: 92cm　Length: 41.5cm
Width: 29cm
Qing Court collection

几面長方形，面下束腰處嵌透孔的縧
環板，板上雕龍紋，束腰卜有扎腮，
牙條、四腿及橫棖上透雕纏繞蜿蜓的
龍紋。足間有透雕龍紋牙子，下承覆
蓮瓣紋台座。

香几為香爐的承具，此几紋飾繁複生
動，用材厚重，結構嚴謹，給人穩重
的感覺。

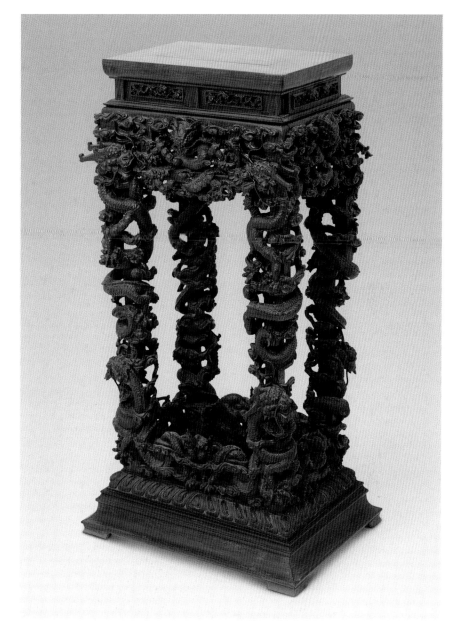

150

楠木嵌竹絲迴紋香几
清乾隆
高92厘米　面徑42.5厘米
清宮舊藏

Nanmu² wood censer table, decorated
with a key-fret pattern made with inlaid
bamboo strips
Qianlong Period, Qing Dynasty
Height: 92cm　Diameter of top: 42.5cm
Qing Court collection

香几楠木製，嵌竹絲、紫檀絲裝飾。
几面方形，面下束腰包鑲竹黃，再挖
槽嵌夔龍紋玉飾件，雕拐子紋花牙。
几面側沿、牙條、腿全部用紫檀絲和
竹絲貼嵌成迴紋，稜角處均以紫檀絲
鑲嵌，迴紋的輪廓亦用紫檀絲貼嵌。
足下承托泥。

此几所用的竹絲和紫檀絲均為1毫米
粗細的圓絲，貼嵌圖紋精美，不見瑕
疵，工藝極其精湛。

151

紫檀蟬紋香几
清乾隆
高89.5厘米　面徑39厘米
清宮舊藏

**Red sandalwood censer table, decorated
with carvings of cicadas**
Qianlong Period, Qing Dynasty
Height: 89.5cm　Diameter of top: 39cm
Qing Court collection

几面下束腰，四角雕迴紋，中部雕雲
紋。束腰上下托腮，牙條雕蟬紋，腿
間安有雕夔紋羅鍋棖，棖上鑲雕海水
紋板心。棖下輔以雲紋托角牙，牙子
及腿部邊緣起陽綫。雕夔紋內翻馬
蹄，下承方形須彌座，座下有龜腳。

152

紫檀夔龍紋香几
清乾隆
高90.5厘米　長55厘米　寬41厘米
清宮舊藏

**Rectangular, red sandalwood censer
table, decorated with carvings of Kui[1]-
dragons**
Qianlong Period, Qing Dynasty
Height: 90.5cm　Length: 55cm
Width: 41cm
Qing Court collection

几面攢框裝板，面下高束腰飾長方形
縧環板，板內雕夔龍紋，束腰上下托
腮分別雕仰覆蓮瓣紋。透雕拐子紋花
牙，拱肩展腿，外翻雲紋足，下承須
彌座式方托泥。

153

紫檀雕西番蓮紋香几
清乾隆
高88厘米　長42厘米　寬31.5厘米
清宮舊藏

**Red sandalwood censer table, decorated
with carvings of dahlias**
Qianlong Period, Qing Dynasty
Height: 88cm　Length: 42cm
Width: 31.5cm
Qing Court collection

几面四圍起攔水綫，面下高束腰，開
長方形透光，內透雕西番蓮紋，束腰
四角有雕花角牙，上下有雕仰覆蓮瓣
紋托腮，牙條浮雕迴紋，牙頭透雕拐
子紋，展腿雕捲雲紋翅，外翻雲頭形
足，下承托泥。

154

紫檀嵌黃楊木蓮花紋香几
清乾隆
高105厘米　面徑39厘米
清宮舊藏

Red sandalwood censer table with boxwood inlay, decorated with carvings of dahlias
Qianlong Period, Qing Dynasty
Height: 105cm　Diameter of top: 39cm
Qing Court collection

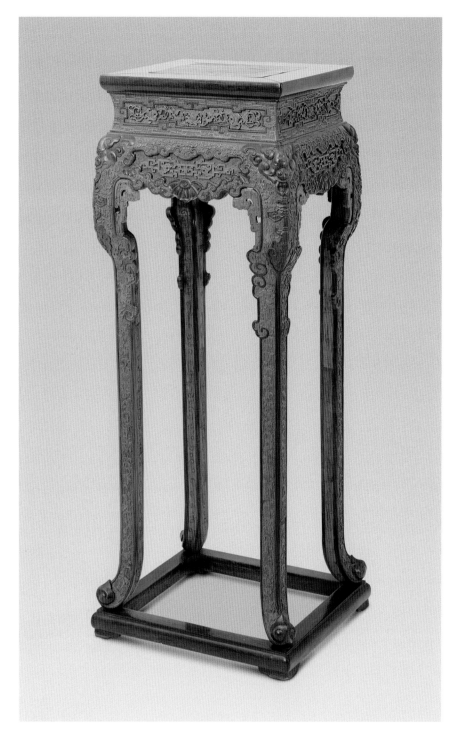

几面打槽鑲杏木板心。面下均以紫檀木鑲嵌黃楊木製成，高束腰以斜卍字錦為地，上飾拐子紋，束腰中心為變形的拐子紋開光，內雕西番蓮紋。牙條滿地雕西番蓮紋，正中為迴紋拐子開光，開光內在卍字紋錦地上雕夔龍紋，牙頭雕西番蓮紋，夔龍紋角牙。雲紋展腿，拱肩部雕獸面啣環，下飾懸磬及如意雲頭紋，外翻雲頭形足，下承托泥。

155

紫檀瓶式香几
清乾隆
高104厘米　面徑35厘米
清宮舊藏

**Square, red sandalwood censer table
with narrow waist**
Qianlong Period, Qing Dynasty
Height: 104cm　Diameter of top: 35cm
Qing Court collection

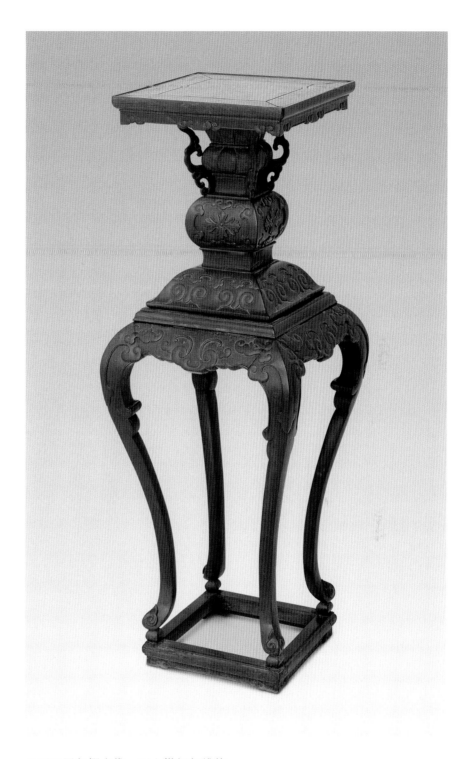

几面四圍起攔水綫，面上攢框打槽鑲
板，側沿飾雲紋垛邊，面下為瓶式束
腰，瓶頸四角有捲草紋耳，瓶腹上有
如意雲頭紋開光，內雕十字花紋。瓶
下有雕如意雲頭紋雙托腮，牙條上剷
地浮雕雲紋至腿的拱肩處。三彎腿，
上部起雲紋翅，外翻雲頭形足，下踩
圓珠，方形托泥帶龜腳。

156

紫檀西番蓮紋六方香几
清乾隆
高87厘米　面徑39厘米
清宮舊藏

**Hexagonal, red sandalwood censer table,
decorated with carvings of dahlias**
Qianlong Period, Qing Dynasty
Height: 87cm　Diameter of top: 39cm
Qing Court collection

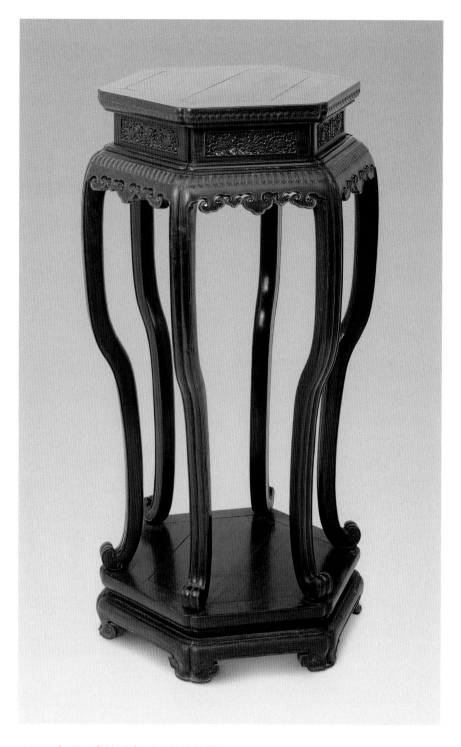

几面六角形，邊抹委角，側沿雕仰蓮
瓣紋一周，面下高束腰嵌透雕西番蓮
紋的縧環板。束腰上下托腮，牙條飾
覆蓮瓣紋一周，與面沿相對應，邊緣
鎪成如意雲頭形。拱肩三彎腿，外翻
豹腳形足，下承六方須彌式底座，帶
龜腳。

157

紫檀蓮瓣紋香几
清乾隆
高89.5厘米　面徑37.5厘米
清宮舊藏

**Red sandalwood censer table, decorated
with lotus-petal patterns**
Qianlong Period, Qing Dynasty
Height: 89.5cm
Diameter of top: 37.5cm
Qing Court collection

几面心髹黑漆，冰盤沿，面下打窪束
腰雕蓮瓣紋。拱肩直腿，腿間上下各
裝有雕迴紋直棖，腿、牙亦浮雕迴
紋，並與棖子迴紋交圈。內翻迴紋馬
蹄。

158

剔紅雲龍紋香几
清乾隆
高80厘米　長32厘米　寬25厘米
清宮舊藏

**Rectangular, carved, red lacquered
censer table, decorated with dragon and
cloud patterns**
Qianlong Period, Qing Dynasty
Height: 80cm　Length: 32cm
Width: 25cm
Qing Court collection

香几通體剔紅。几面雕雲龍紋，冰盤
沿雕迴紋，面下束腰雕迴紋及夔龍
紋。托腮、牙條及腿部雕迴紋，牙條
下另安透雕夔龍紋花牙，迴紋足下承
迴紋托泥。

此几原為千秋亭所用之物。千秋亭位
於御花園內，是清皇室供奉佛像的地
方。

159

黑漆描金雙層如意式香几
清
高98厘米　面徑48厘米
清宮舊藏

**Black lacquered censer table, with ruyi[11]-
sceptre-shaped top and gold tracery
decorative patterns**

Qing Dyansty
Height: 98cm　Diameter of top : 48cm
Qing Court collection

几面如意雲頭形，側沿飾描金捲雲紋
及水波紋，面下飾描金雲頭紋花牙。
三彎腿兩端如意形，恰似三支如意鼎
立，上飾描金團花及捲雲紋。隔板下
的三彎腿與上層相對稱。下承如意形
須彌座，座側沿飾描金拐子、蝙蝠、
花卉紋，帶龜腳。

此几造型新穎奇特，裝飾精美華麗，
富於變化，靜中有動，給人以雋永的
美感。

160

花梨迴紋香几
清
高92厘米　面徑33厘米
清宮舊藏

Square, rosewood censer table, decorated with key-fret patterns
Qing Dynasty
Height: 92cm　Diameter of top: 33cm
Qing Court collection

香几呈爐形。面沿起四層細綫，上下
兩層高束腰，每面正中皆凸起透雕勾
雲紋，兩側透雕迴紋，並上下托腮。
兩層之間向外拱出四根邊框，每根邊
框向外邊角上起兩條陽綫，下層束腰
下的牙條與腿面起八條陽綫，自拱肩

處向下至足部外撇並逐漸收細。方几
側沿、牙條、立框、托腮及透雕紋飾
展面均飾打窪綫條。

此几原為符望閣所用之物。

161

雞翅木鑲紫檀迴紋香几
清
高90厘米　面徑37厘米
清宮舊藏

Jichimu[9] wood censer table, decorated
with key-fret patterns made with inlaid
red sandalwood
Qing Dynasty
Height: 90cm　Diameter of top: 37cm
Qing Court collection

香几雞翅木製，鑲紫檀裝飾。几面側
沿較寬，上起環綫，並鑲雕迴紋紫檀
木條。面下束腰，牙條為兩個連根大
迴紋，牙、根與腿外側均鑲紫檀雕迴
紋條，腿間安有四面平管腳根，內鑲
板心。

此几原為昭仁殿所用之物。昭仁殿位
於故宮內廷，清初康熙皇帝曾在此居
住。

162

紫檀拐子紋香几
清
高95.5厘米　面徑45.5厘米
清宮舊藏

**Red sandalwood censer table, decorated
with Kui[1] patterns**
Qing Dynasty
Height: 95.5cm
Diameter of top: 45.5cm
Qing Court collection

几面四圍起攔水綫。面下束腰雕拐子
紋，下有托腮，拱肩直腿，腿間有長
方形圈口，雕迴紋，四周以卡子花和
角牙與腿連接，避免了腿間過分空曠
和呆板。迴紋馬蹄。

163

瘿木繩璧紋茶几
清
高82厘米　面徑38厘米
清宮舊藏

Square, gnarled-wood side table,
decorated with "Bi" (a round flat piece
of jade with a hole in its centre) and
rope patterns
Qing Dynasty
Height: 82cm　Diameter of top: 38cm
Qing Court collection

几面下有透雕捲草紋束腰，牙條、牙
頭透雕繩璧紋及拐子紋。方腿，邊緣
起陽綫，雙翻拐子足接管腳根，下帶
龜腳。

164

金漆三足憑几

清初

高47厘米　長88厘米　寬9厘米

清宮舊藏

Table screen with mahogany frame,
decorated with an inlaid jade fish

Qing Dynasty

Height: 47cm　Length: 88cm

Width: 9cm

Qing Court collection

几面弧形，兩端翹起作浪花狀。面下
束腰內側嵌牙雕三塊，以高浮雕手法
飾蒼龍教子圖，外側凸雕夔龍紋。三
彎式腿雕成獸頭吐水狀，在水柱落地
處捲起，恰好形成外翻馬蹄。構思巧
妙。

這種弧形憑几是供席地起居時憑伏的
一種家具，適合游牧民族使用，盛行
於南北朝時期。宋代以後主要流行在
北方少數民族地區，此几是清代皇帝
出行時在帳篷內使用的。

屏風

Screens

165

紅木蓮花邊嵌玉魚插屏
清乾隆
高39厘米　寬33.5厘米　厚10厘米
清宮舊藏

**Table screen with mahogany frame,
decorated with an inlaid jade fish**
Qianlong Period, Qing Dynasty
Height: 39cm　Width: 33.5cm
Thickness: 10cm
Qing Court collection

插屏邊座紅木製，屏心兩面皆鏤空嵌白玉鯉魚，四周雕蓮花、荷葉及水波紋。屏心正面上部刻隸書"蒲藻含輝"四字，背面上部刻隸書題乾隆御製詩一首，後署"臣 王際華敬書"隸書款並"臣"、"華"篆書描金印章兩方。屏框起混面雙邊綫，屏下餘塞板浮雕綰環板，光素站牙，迴紋框底座。

185

166

紅木嵌螺鈿三獅進寶圖插屏

清乾隆
高45厘米　寬37厘米　厚15厘米

Table screen with mahogany frame, decorated with an inlaid mother-of-pearl lion and figurine picture
Qianlong Period, Qing Dynasty
Height: 45cm　Width: 37cm
Thickness: 15cm

屏心正面嵌螺鈿《三獅進寶圖》，三個金髮捲曲的番人手持兵器，驅趕一大獅、二小獅前行。獅子被視為避邪護福的瑞獸，且與"師"諧音，太師、少師都是古代官職，圖紋寓意"官祿相傳"。背面嵌螺鈿"香稻啄餘鸚鵡粒，碧梧棲老鳳凰枝"詩句。站牙及縧環板透雕夔龍紋，披水牙雕夔鳳紋及雲紋，雙鼓式座墩，起混面雙邊綫。

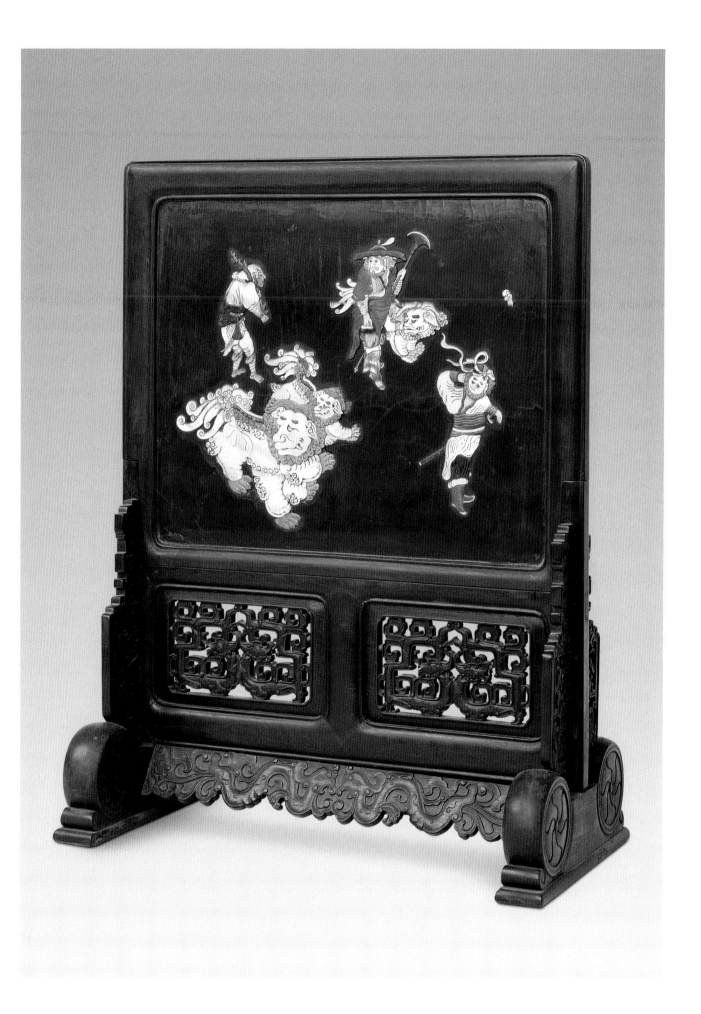

167

紫檀嵌玉雙龍鬧海圖插屏
清乾隆
高156厘米　寬234厘米　厚53厘米
清宮舊藏

Table screen with red sandalwood frame,
decorated with a jade inlay picture of
two dragons and seething waves
Qianlong Period, Qing Dynasty
Height: 156cm　Width: 234cm
Thickness: 53cm
Qing Court collection

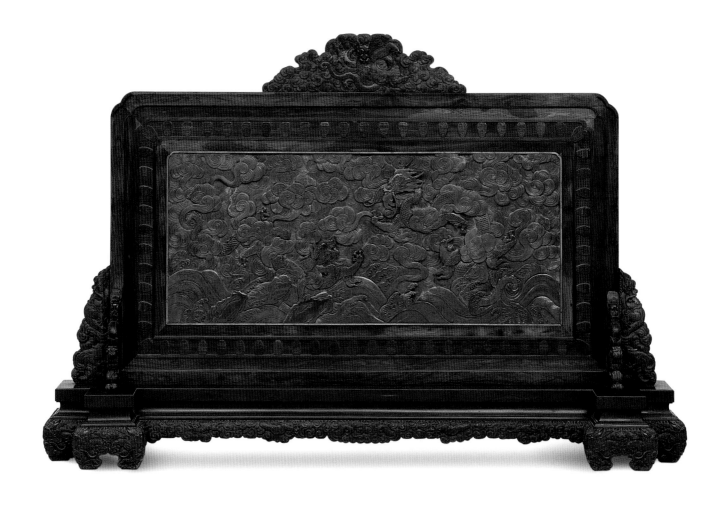

屏心正面銅邊框內嵌青玉雕《雙龍鬧
海圖》，背面描金繪相同內容。邊框
雕蟬紋，屏頂牙雕正龍，站牙雕雲龍
紋，屏下束腰，座墩及牙條雕雲龍
紋。

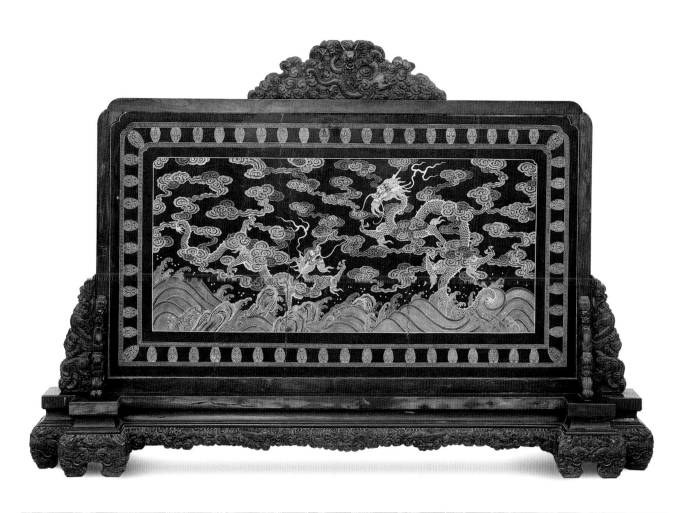

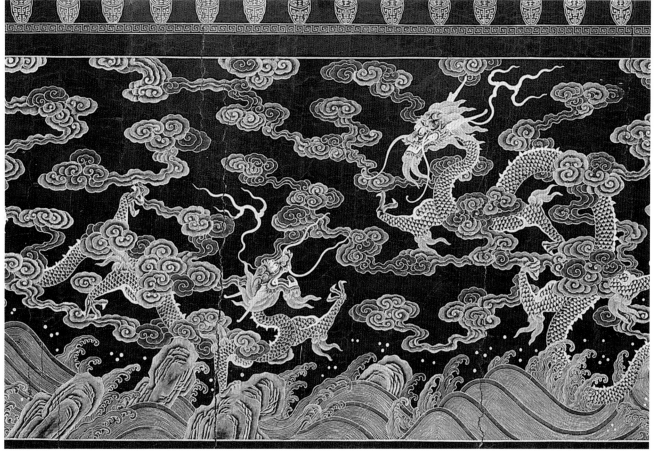

168

紫檀嵌古鏡插屏
清乾隆
高92厘米　寬73.5厘米　厚26厘米
清宮舊藏

Red sandalwood table screen, with inlaid bronze mirror
Qianlong Period, Qing Dynasty
Height: 92cm　Width: 73.5cm
Thickness: 26cm
Qing Court collection

屏心外鑲迴紋圈口，正面開圓洞，鑲
古銅鏡一面，銅鏡外圈弦紋兩道，正
中銀錠鈕。四周木板陰刻描金隸書乾
隆御題古鏡詩一首，後署“乾隆丙申
（1776）春御題”隸書款並鈐朱印。
背面陰刻于敏中、王際華、梁國治、
董誥、陳孝泳、沈初、金士鬆等大臣

的應和之作。屏框與底墩一木貫通，
以兩道橫棖連為一體，中間為鑲嵌雲
紋餘塞板。屏框、站牙、橫棖、披水
牙、座墩皆雕拐子紋。披水牙內裏分
別描金刻“漢純素鑑”、“乾隆御玩”
款識。

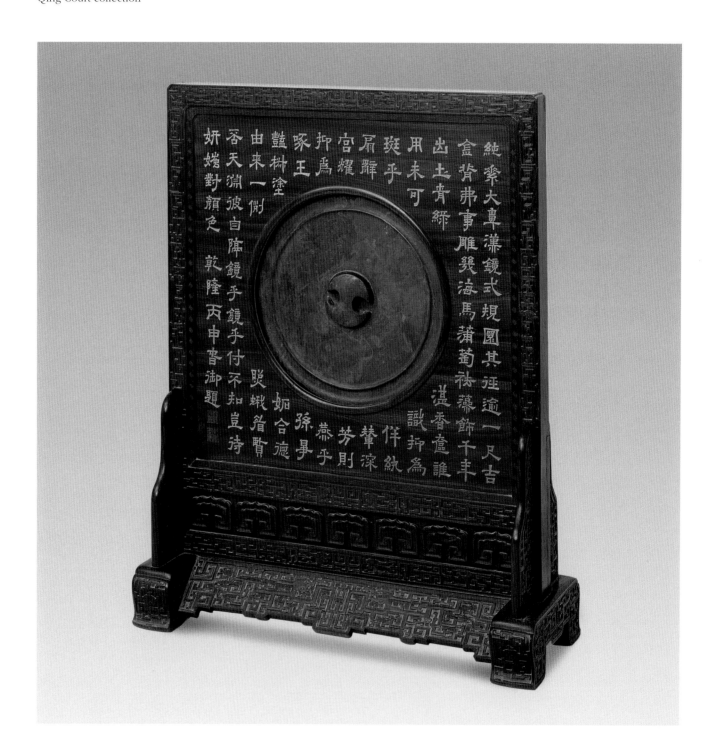

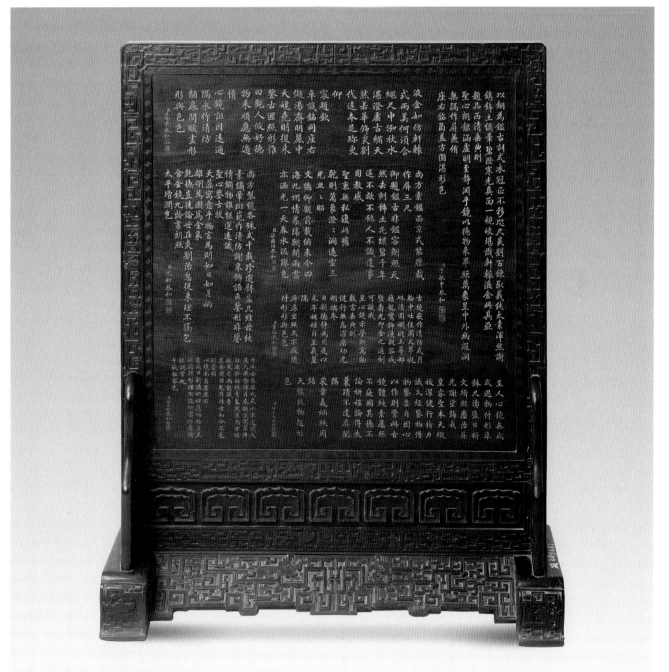

169

紫檀嵌木靈芝插屏
清中期
高101厘米　寬95厘米　厚50厘米
清宮舊藏

**Large, red sandalwood table screen,
decorated with inlaid wood and ling
zhi[12] (magic fungus) patterns**
Middle Qing Dynasty
Height: 101cm　Width: 95cm
Thickness: 50cm
Qing Court collection

插屏邊座紫檀木製。屏心正面嵌木靈
芝，古人以靈芝為長生草，故多以其
寓意長壽。背面為描金隸書乾隆御題
詠芝屏詩，後署"乾隆甲午（1774）
御題"描金隸書款，並鈐篆書印章款
兩方。光素站牙，縧環板雕如意雲頭
紋，披水牙雕迴紋，正中垂窪堂肚。

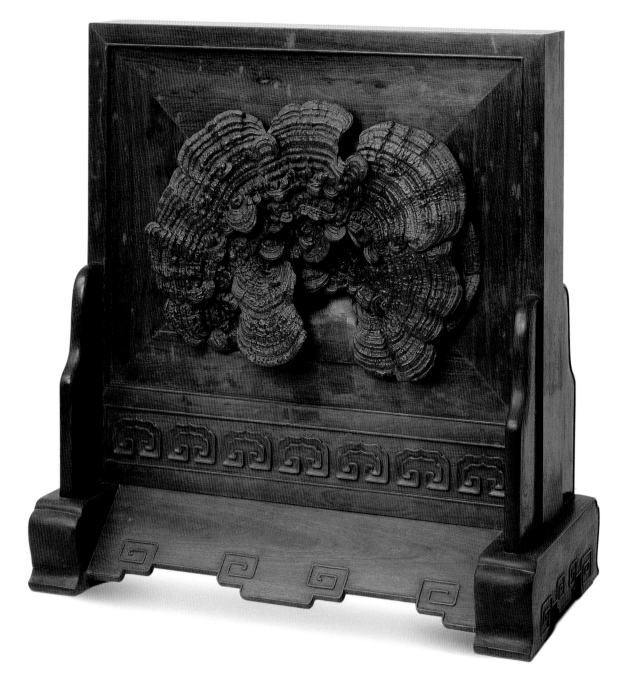

故土辟山澤新屏厨几
惟丹青難與繪雕琢未
曾施相則檀紫楩藉帷
苧白宜質猶盈尺富歲
吕數千期舜代卿雲薈
堯丰寶露滋蟬聯三秀
燦蟠錧崗苍羝底用祥
編表還嘆壽牒披塗中
思曳尾或亦似靈龜
乾隆甲午御題

170

貼簧嵌玉十六羅漢圖插屏
清乾隆
高42厘米　寬75厘米　厚20厘米
清宮舊藏

Table screen, decorated with sixteen
pictures of arhats[3] (Buddhist monks) on
inlaid jade panels
Qianlong Period, Qing Dynasty
Height: 42cm　Width: 75cm
Thickness: 20cm
Qing Court collection

插屏邊座貼竹簧。屏心兩面均分上下
兩層，每層嵌八塊白玉片，共十六
塊。每塊白玉片正面陰刻填金羅漢像
一尊；背面為乾隆御題"十六羅漢贊"
填金楷書詩句，後署"乾隆丁丑
（1757）清和御筆"楷書款。站牙、
縧環板及披水牙均用黃楊木雕捲草紋
為地，縧環板上有長圓形開光，披水
牙上雕夔龍紋，站牙下部用竹絲嵌成
圓珠形，似抱鼓墩。

花梨嵌玉璧插屏
清乾隆
高108厘米　寬82厘米　厚42厘米
清宮舊藏

Rosewood table screen, with "Bi" (a round flat piece of jade with a hole in its centre) inlay
Qianlong Period, Qing Dynasty
Height: 108cm　Width: 82cm
Thickness: 42cm
Qing Court collection

插屏邊座花梨木製。屏心正中嵌玉璧，玉璧中心有一紫檀圓形開光，開光內雕八卦中"乾"卦符號及雙夔龍紋，背面為乾隆御題詩。屏心、站牙、縧環板、披水牙、座墩皆雕夔龍紋。

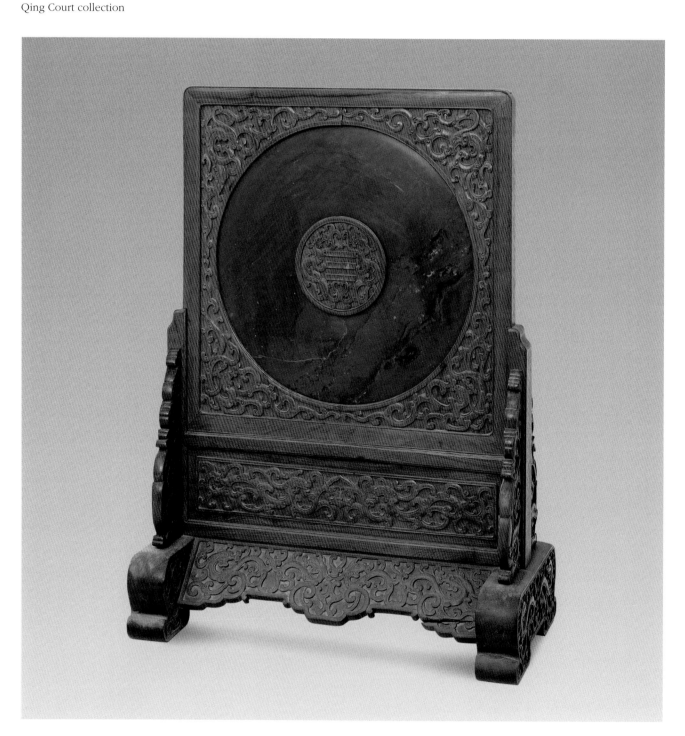

172

紫檀雕雞翅木嵌玉人插屏
清
高52厘米　寬50厘米　厚31厘米
清宮舊藏

Red sandalwood table screen, decorated with jichimu[9] wood carvings and inlaid jade figurines
Qing Dynasty
Height: 52cm　Width: 50cm
Thickness: 31cm
Qing Court collection

插屏邊座紫檀木製。屏心用雞翅木雕樹木、小船、山石，並嵌白玉雕廊樹、亭台及分別持壽桃、葫蘆、拐杖的三位老者，寓"福祿壽"之意。背面有一個一面玻璃的方型鉛筒，可放水養魚。屏座呈八字形，站牙、縧環板、披水牙均雕拐子紋，座柱外側雕清供紋，柱頭雕迴紋。

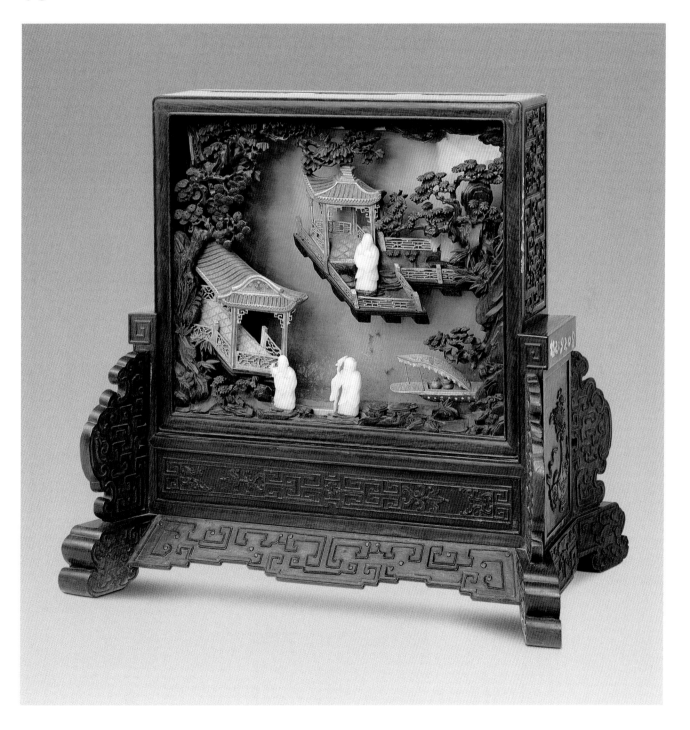

173

紫檀嵌雞翅木五福添壽圖插屏
清
高185厘米　寬85厘米　厚56厘米
清宮舊藏

Red sandalwood table screen, decorated
with a jichimu[9] wood carving, and the
characters "Wu Fu Tian Shou" (The five
blessings will prolong your life)
Qing Dynasty
Height: 185cm　Width: 85cm
Thickness: 56cm
Qing Court collection

插屏邊座紫檀木製。屏心正面鑲銅
邊，外沿雕迴紋，內用雞翅木雕山
水、亭台、人物、仙鶴、靈芝，藍漆
地上部有"五福添壽"四字。背面為黑
漆地，描金繪折枝花卉紋。屏座正中
雕夔龍團花紋，站牙、縧環板、披水
牙均雕捲雲紋及螭紋。

此屏為一對，另一屏題名為"萬年普
祝圖插屏"。

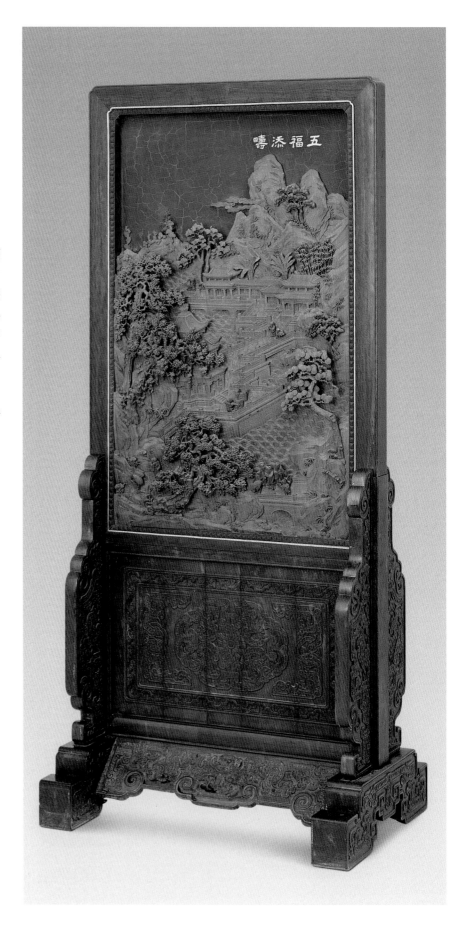

199

174

紅木嵌螺鈿三星圖插屏
清
高45.5厘米　寬43厘米　厚12.5厘米
清宮舊藏

Mahogany table screen, decorated with inlaid mother-of-pearl pictures of Three Stars
Qing Dynasty
Height: 45.5cm　Width: 43cm
Thickness: 12.5cm
Qing Court collection

插屏邊座紅木製。屏心黑漆地，正面嵌螺鈿福、祿、壽三星，五個童子及雙鹿、壽桃等圖紋，寓"福祿壽"吉祥之意。背面黑漆地上有描金"盈盤珠玉天成瑞，象餙輝煌慶德光"詩句，並署"程文光製"印章款。站牙透雕夔龍紋，縧環板雕雲龍紋，底座為捲書几式，側面起陽綫，牙條雕玉寶珠紋。

175

紫檀刻瓷四皓圖插屏
清
高55厘米　寬30厘米　厚18厘米
清宮舊藏

**Red sandalwood table screen, decorated
with a porcelain carving of four old men**
Qing Dynasty
Height: 55cm　Width: 30cm
Thickness: 18cm
Qing Court collection

屏心為綠釉瓷板戧金刻《四皓圖》，畫
面上高山聳立，林木掩映，祥雲繚
繞，殿宇隱現，四位老者在山間攀
談、漫步。站牙透雕雲紋，屏下餘塞
板光素，披水牙下鏒出壺門曲邊，階
梯狀座墩。

四皓故事出《史記》，言秦末四位老人
隱逸商山，後輔佐漢高祖之子劉盈即
位。

202

176

紫檀嵌青玉夔龍紋插屏
清
高36厘米 寬31厘米 厚17厘米
清宮舊藏

**Red sandalwood table screen, decorated
with a Kui[1]-dragon pattern carved in
sapphire**
Qing Dynasty
Height: 36cm Width: 3lcm
Thickness: 17cm
Qing Court collection

屏心正面鑲嵌青玉雕蝙蝠、夔龍紋，
在青玉空隙處由上至下對稱透雕豹、
豬、兔、羊等獸。背面光素，打槽裝
板，內有銅鏡。屏框四緣及站牙透雕
夔龍紋。

鐵畫山水四扇掛屏
清早期
長107.5厘米　寬54厘米

Four-section hanging panel, with
landscape pictures made from iron
Early Qing Dynasty
Length: 107.5cm　Width: 54cm

掛屏硬木六抹攢框，屏心上、中、下各鑲一起鼓板條，分上下兩大格，內鑲縧環板，在白絹地上分別嵌鐵畫山水，畫面簡潔而意境深遠。

鐵畫為康熙年間安徽蕪湖人湯鵬所創。其工藝是先將烙鐵打成薄片或鐵綫條，然後根據畫稿進行摺疊剪裁，再經錘鍛，最後銲接完成圖畫。

180

紫檀嵌玉菊花圖掛屏
清乾隆
長106厘米　寬61.5厘米
清宮舊藏

Hanging panel with a red sandalwood frame, featuring a picture of chrysanthemums made with inlaid jade
Qianlong Period, Qing Dynasty
Length: 106cm　Width: 61.5cm
Qing Court collection

掛屏邊框紫檀木製。屏心粉漆地，上嵌墨玉、白玉菊花、白玉洞石，襯以碧玉竹子、孔雀石花朵、蝴蝶。寓意"高節長壽"。

178

鐵畫四季花卉圖四扇掛屏　湯鵬
清康熙
高118厘米　單扇寬36厘米
清宮舊藏

Four-leafed hanging screen, with pictures made from iron of the Flowers of the Four Seasons by Tang Peng
Kangxi Period, Qing Dynasty
Height: 118cm
Each leaf: Width: 36cm
Qing Court collection

掛屏四扇成堂，硬木邊框，屏心鑲鐵製牡丹、荷花、菊花、梅花等四季花卉，末署"湯鵬"二字並二方鐵製印章款。

湯鵬，字天池，清康熙時人，蕪湖鐵工，鐵畫創始人。其鍛鐵作畫，凡花鳥草蟲，曲盡生致，又通作山水大幅，或合四面成一燈，錘鑄之巧，前所未有。帶有作者款識的鐵畫作品故宮現存僅此一件，十分珍貴。

179

剔紅嵌五彩螺鈿山水圖掛屏
清雍正至乾隆
長102.5厘米　寬71.5厘米
清宮舊藏

Hanging panel with a carved, red
lacquered frame, and a landscape picture
made from variegated, inlaid mother-of-
pearl
Yongzheng-Qianlong Period, Qing Dynasty
Length: 102.5cm　Width: 71.5cm
Qing Court collection

屏心黑漆地上以極薄的五彩螺鈿及螺
鈿碎沙貼嵌出山水圖，畫面上山石聳
立，水波不興，花樹垂柳，點綴坡
岸，樓台亭榭，掩映其中。邊框剔紅
飾纏枝蓮紋，裏側刻迴紋。

此屏嵌螺鈿工藝精湛，構圖細膩，實
為精品。

180

紫檀嵌玉菊花圖掛屏
清乾隆
長106厘米　寬61.5厘米
清宮舊藏

Hanging panel with a red sandalwood
frame, featuring a picture of chrysanthe-
mums made with inlaid jade
Qianlong Period, Qing Dynasty
Length: 106cm　Width: 61.5cm
Qing Court collection

掛屏邊框紫檀木製。屏心粉漆地，上
嵌墨玉、白玉菊花、白玉洞石，襯以
碧玉竹子、孔雀石花朵、蝴蝶。寓意
"高節長壽"。

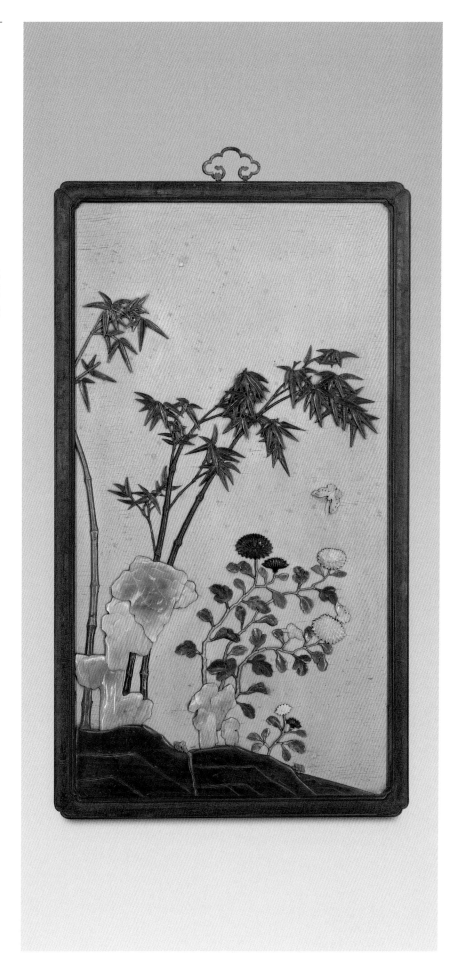

181

剔紅蘭亭雅集圖掛屏
清乾隆
長139厘米　寬29厘米
清宮舊藏

Carved, red lacquered hanging panel,
with a picture of a gathering of scholars
in Lanting
Qianlong Period, Qing Dynasty
Length: 139cm　Width: 29cm
Qing Court collection

掛屏通體剔紅。屏心雕《蘭亭雅集
圖》，上部為遠山浮雲，山下有竹
林，竹林間有各式人物高談闊論，河
邊有人正在垂釣。松林間有小亭臨
水，亭中有老者觀景，水中白鵝游
弋。山側一老者攜琴前來。畫面借王
羲之蘭亭雅集故事，表現一派祥和安
寧的景象。屏上有乾隆御題詩。

御題詩：茂林修竹此間多，展卷居然
晉永和。千載由人摹禊帖，孰傳骨髓
孰傳訛。

紫檀百寶嵌梅花圖掛屏
清
長111厘米　寬76厘米
清宮舊藏

**Hanging panel with a red sandalwood
frame, featuring a picture of plum
blossoms made from inlaid gems**
Qing Dynasty
Length: 111cm　Width: 76cm
Qing Court collection

掛屏邊框紫檀木製。屏心正面黃漆
地，上用螺鈿、染牙、松石、孔雀
石、玉石等料，嵌老樹梅花、山茶、
洞石、靈芝、坡地，寓意"長壽吉

祥"。背面為黑漆描金《洪福齊天
圖》，繪九隻蝙蝠在祥雲間飛舞。

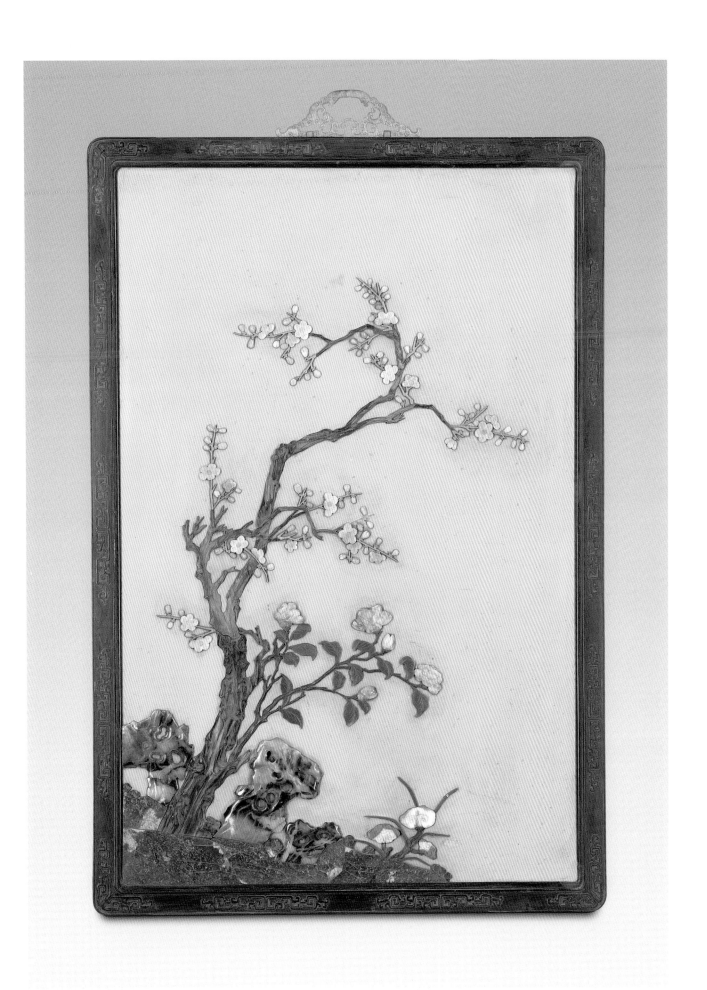

183

紅木染牙作坊圖掛屏
清
長139.5厘米　寬37.5厘米

Hanging panel with a picture of a small workshop made with stained ivory
Qing Dynasty
Length: 139.5cm　Width: 37.5cm

掛屏邊框紅木製，框上有透雕如意雲頭紋、銅鍍金掛環。屏心外沿鑲銅鍍金迴紋，正中淡綠色漆地上嵌《作坊圖》，表現有紡織、繅絲、以糧易酒等場面，其中房舍、人物、樹木、流雲均以染牙做成，山石堤岸則以雞翅木製。

184

紫檀嵌玉玉堂富貴圖掛屏
清
長112厘米　寬78厘米
清宮舊藏

Hanging panel with red sandalwood frame, featuring a picture made with inlaid jade
Qing Dynasty
Length: 112cm　Width: 78cm
Qing Court collection

掛屏邊框紫檀木製。屏心外沿雕迴紋，藍絨地上嵌白玉玉蘭花、孔雀石玉蘭樹及白玉山石、玉製牡丹，一隻綬帶鳥展翅飛翔，寓"玉堂富貴"之意。上框凸起，內捲成迴紋形狀，下框內凹。

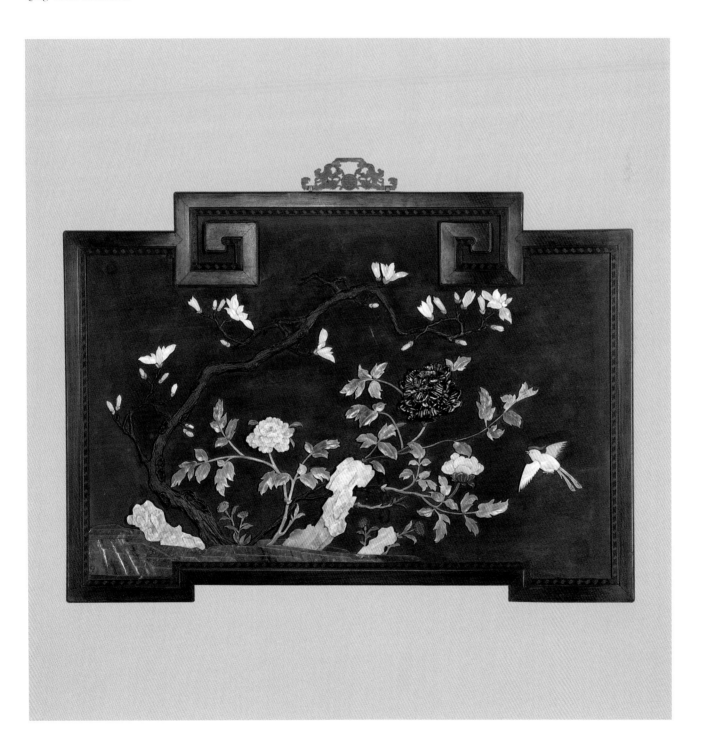

185

刻灰描金彩繪羣仙祝壽圖圍屏
清早期
高323.5厘米　通寬600厘米
單扇寬49.5厘米
清宮舊藏

**Inlaid lacquer folding screen, decorated
with a colored, gold tracery picture of a
group of Immortals celebrating a
birthday**
Early Qing Dynasty
Height: 323.5cm　Overall width: 600cm
Width of each leaf: 49.5cm
Qing Court collection

圍屏共十二扇，每扇之間用掛鈎連
接，可開合。屏心正面彩繪《羣仙祝
壽圖》，仙山之中，各洞府神仙會
聚，祥雲之上，西王母乘車而來。背
面彩繪《百鳥朝鳳圖》，正中刻一隻鳳
凰，周圍點綴鴛鴦、綬帶、黃鸝、八
哥等瑞鳥，並有百花襯托。兩面四圍
雕填一圈博古紋，裏外各飾一圈描金
花邊。

刻灰，又名款彩、大雕填，是先在漆
地上凹刻花紋，再填漆色、油色或金
銀的一種裝飾技法，因在刻去漆面的
同時也刻去漆灰而得名。

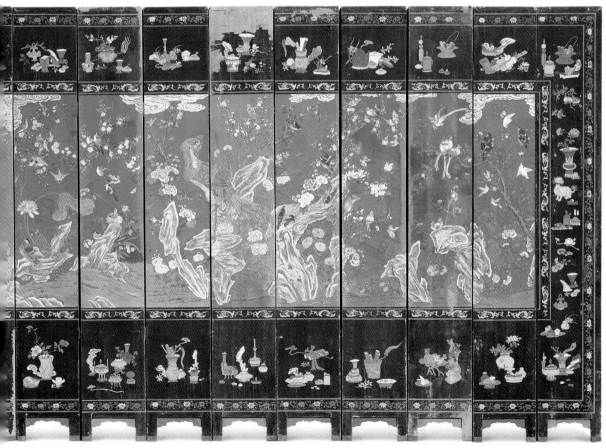

186

刻灰描金彩繪子儀祝壽圖圍屏
清早期
高323.5厘米　通寬600厘米
單扇寬49.5厘米
清宮舊藏

**Inlaid lacquer folding screen, decorated
with a colored, gold tracery picture of
Guo Ziyi wishing someone a happy
birthday**
Early Qing Dynasty
Height: 323.5cm　Overall width: 600cm
Width of each leaf: 49.5cm
Qing Court collection

屏心正面彩繪唐代元帥郭子儀祝壽故
事，畫面上帥府兩進，廳堂寬敞，人
物眾多。背面彩繪五彩雉雞、白鷺、
鷂鷹、白頭以及松樹、牡丹、玉蘭，
寓意"玉堂富貴"、"子孫滿堂"。兩
面四圍飾博古紋，裏外各飾一圈描金
花邊。

此屏與前圖圍屏為一套，二者工藝、
結構相同，圖紋內容雖不同，但均為
祝壽之吉祥寓意。

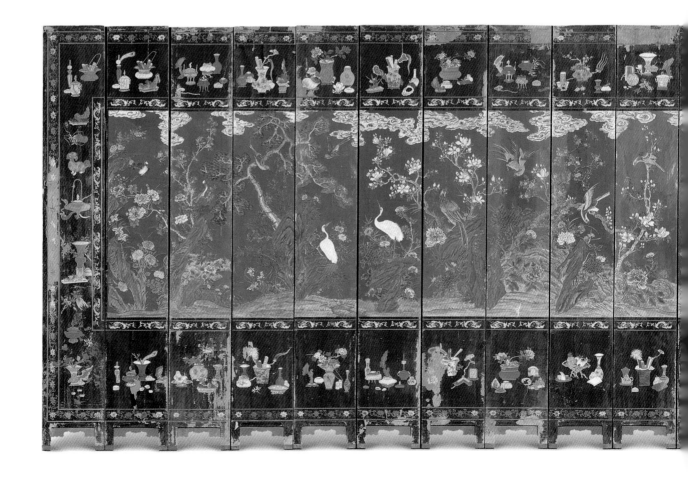

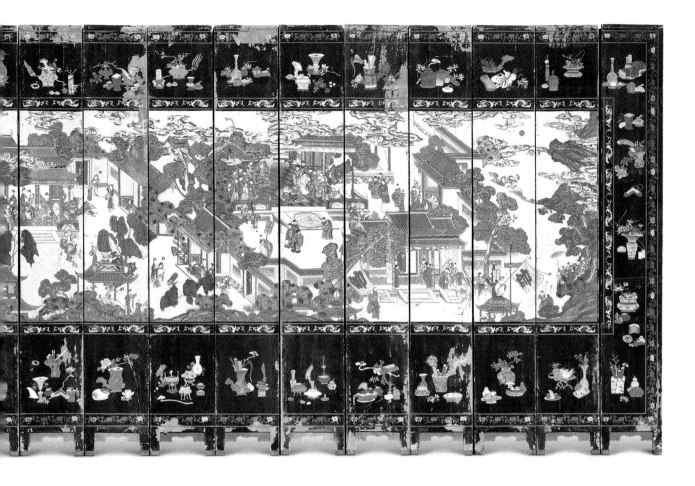

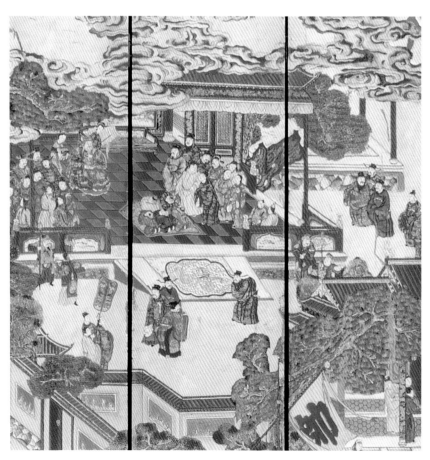

187

康熙御書唐詩圍屏
清康熙
高186厘米　單扇寬50厘米
清宮舊藏

Folding screen inscribed with a Tang Dynasty poem composed by the Qing Emperor Kangxi
Kangxi Period, Qing Dynasty
Height: 186cm
Width of each leaf: 50cm
Qing Court collection

圍屏邊框花梨木製，以織錦兩面交叉裱糊連接，可完全折合，共八扇。屏心兩面糊紙，每屏上為康熙御書唐人七言絕句一首，後署"丙戌（1706）口外避暑　秋前書"款。下鑲浮雕勾雲紋縧環板，牙條下垂窪堂肚。飾勾雲紋包銅套足。

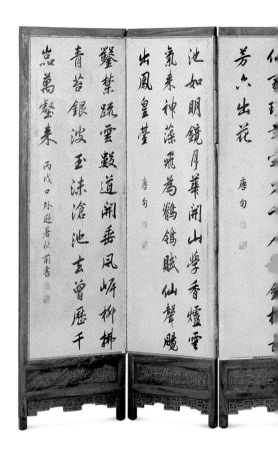

188

黑漆點翠萬花獻瑞圖圍屏
清雍正至乾隆
高174厘米　通寬390厘米
清宮舊藏

Folding screen with black lacquered frame, decorated with a kingfisher feather appliqué picture of flowers
Yongzheng-Qianlong Period, Qing Dynasty
Height: 174cm　Overall width: 390cm
Qing Court collection

圍屏邊框髹黑漆，點翠紋飾，共十二扇。屏心玻璃面內以點翠工藝鑲嵌通景《萬花獻瑞圖》，中央有牡丹、芍藥，四周有海棠、百合、繡球、蓮花、秋葵、芙蓉、水仙、梅花相托，並襯有松、竹、柿、桃、枇杷、佛手等。圖中題"萬花獻瑞"隸書字。圖上下兩端描金縧環板內飾朵雲紋。裙板四角飾朵雲紋，中間為描金蝙蝠與折枝花卉紋。上有蓮花紋屏帽，下承須彌式八字形底座，飾海水紋，外罩金漆。

此屏裝飾豔麗、雍容華貴且寓意吉祥，具有典型的清式家具裝飾特點。

乘輿執玉已登壇 紬州沾衣春
殿寒昨夜雲生幨 初月萬年甘
露水精盤　唐句

宮連太液見滄波 暑氣微消秋
意多一夜輕風驚 末起露珠翻
畫淵池荷　唐句

入雲晴屬蔡舉還 日暮逢迎水
石間看待詩人無 別物半潭秋
水一房山　唐句

浮雲不共此山齋 齋著々堂
轉迷曉月暫飛千 樹裏秋河隔
在嶽峯西　唐句

菖蒲翻葉柳交枝 暗上蓮舟鳥
不知更到蓋花家 梁愛玉蕭金

萬葉欷端

189

花梨湘妃竹緙絲花鳥圖圍屏
清雍正至乾隆
高132厘米　通寬288厘米
清宮舊藏

Folding screen with rosewood frame, decorated with a silk tapestry featuring mottled bamboo patterns and pictures of birds and flowers
Yongzheng-Qianlong Period, Qing Dynasty
Height: 132cm　Overall width: 288cm
Qing Court collection

圍屏邊框花梨木製，共九扇，以鈎鈕連接，五抹回格。屏心以湘妃竹攢成拐子紋，當中海棠式開光，兩面夾心，上飾黃地雙面緙絲花鳥，有繡球、山茶、梅花、秋葵、牡丹、荷花、虞美人等花卉。上眉及中腰較窄，內鑲黃地雙面緙絲流雲紋，裙板海棠式開光，飾鑲黃地雙面緙絲折枝花卉圖紋。下為湘妃竹攢拐子紋花牙。

190

紫檀嵌玉石花卉圖圍屏
清乾隆
高237厘米　通寬304厘米
清宮舊藏

Red sandalwood-framed screen, decorated with pictures of flowers and plants made from inlaid jade
Qianlong Period, Qing Dynasty
Height: 237cm　Overall width: 304cm
Qing Court collection

圍屏邊框紫檀木製，共九扇，活頁八字形。屏心正面為米黃色漆地，上嵌茶花、石榴、紫藤、梅花、天竺、牡丹、玉蘭、菊花、臘梅等玉石花卉，每幅均有乾隆御題詩。背面為黑漆描金雲蝠紋。屏側及上下端均為紫檀開光，雕西番蓮紋。邊框嵌鑿繩紋銅綫牙，雕如意雲邊開光西番蓮紋毗盧帽，下承三聯木座。

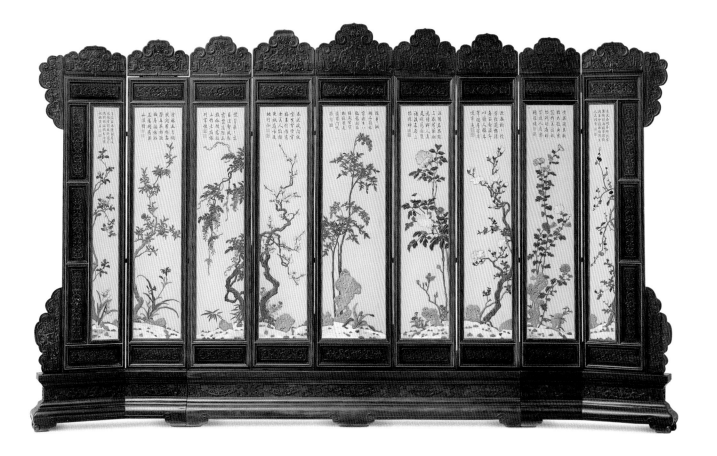

191

乾隆御書消夏十詠詩圍屏

清乾隆

高280厘米　通寬530厘米

清宮舊藏

Folding screen inscribed with ten Odes To Summer written

Qianlong Period, Qing Dynasty

Height: 280cm　Overall width: 530cm

Qing Court collection

圍屏共十扇，木框包絹連接，可摺疊。屏心紙地上乾隆御題行書《消夏十詠》詩，詩題分別為《荷》、《蟬》、《扇》、《蛙》、《螢》、《冰》、《月》、《雨》、《瓜》、《蜑》，末署"壬申（1752）秋月御筆"款，後鈐二方朱文印章。屏身上下各裝雙抹，落堂鑲雲紋板心，包銅套足。

192

乾隆御書夜亮木賦圍屏
清乾隆
高275厘米　通寬336厘米
清宮舊藏

**Folding screen inscribed with an ode
about Luminous Wood written by
Emperor Qianlong**
Qianlong Period, Qing Dynasty
Height: 275cm　Overall width: 336cm
Qing Court collection

圍屏共八扇，木框包錦，六抹攢框，
可摺疊。屏心紙地上乾隆御題行書
《夜亮木賦》，末署"乾隆壬申
（1752）秋八月駐蹕避暑山莊御製並
書"款。眉板、腰板、裙板、底板落
堂鑲心，飾拐子龍紋。牙條正中垂拐
子紋窪堂肚，包銅套足。

193

紫檀嵌玉乾隆御書千字文圍屏

清乾隆

高86.5厘米　通寬319.5厘米　厚20厘米

清宮舊藏

Folding screen with red sandalwood frame, featuring a one thousand word essay written by Emperor Qianlong made with inlaid jade

Qianlong Period, Qing Dynasty

Height: 86.5cm

Overall width: 319.5cm

Thickness: 20cm

Qing Court collection

圍屏邊座紫檀木製，共九扇。屏心正面嵌玉乾隆御題草書《千字文》，後署"懷素草書千字文　庚寅（1770）小年夜　御臨"款。背面藍地上描金繪梅、桃、梨、桂等花果樹木。裙板落堂踩鼓做，嵌雕染牙花卉，下承長方形須彌台座。

此圍屏做工精湛，書法嫻熟，紋飾精美，為清乾隆年間的家具精品。

194

紙織字圍屏
清乾隆
高241厘米　通寬690厘米
清宮舊藏

Folding screen, decorated with poems made from woven paper strips
Qianlong Period, Qing Dynasty
Height: 241cm　Overall width: 690cm
Qing Court collection

圍屏共十二扇，木框包錦連接，可雙向摺合。屏心以紙絲編織乾隆御題詩十二首。下鑲金漆夔紋縧環板，下有雕夔紋牙條。

紙織字或紙織畫工藝為福建永春州所特有，已有近一千二百年的歷史，其工藝「以羅紋紙箋剪為片，五色相間，經緯成文，凡山水、人物、花鳥皆具」。

195

彩繡白鳳圍屏
清中晚期
高227厘米　通寬536厘米
單扇寬67厘米
清宮舊藏

Folding screen, featuring an embroidered white phoenix
Middle-late Qing Dynasty
Height: 227cm　Overall width: 536cm
Width of each leaf: 67cm
Qing Court collection

圍屏邊框髹黑漆，八扇成堂，鉤鈕連接。屏心寶藍色綢地上通景彩繡松樹、菊花，屏心正中用白色絲綫繡出引項高鳴的白鳳，單腿落在松樹上，寓「吉祥長壽」之意。每扇下框兩端安轉向腳輪，可以隨意調整圍屏的位置和方向。

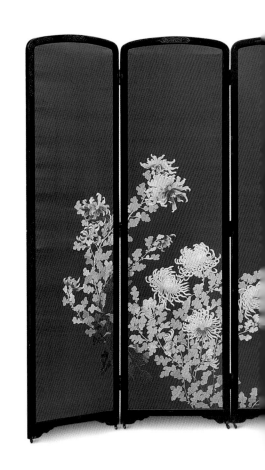

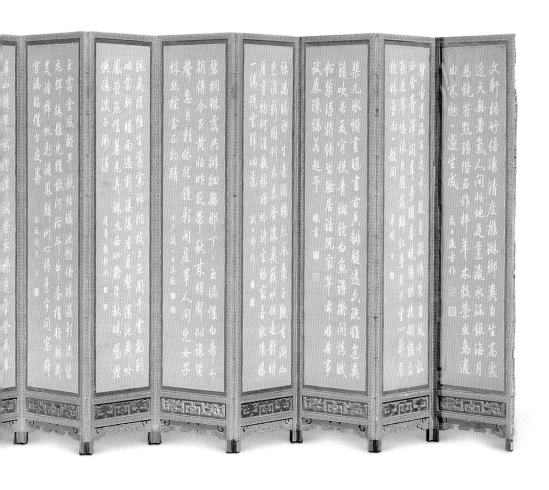

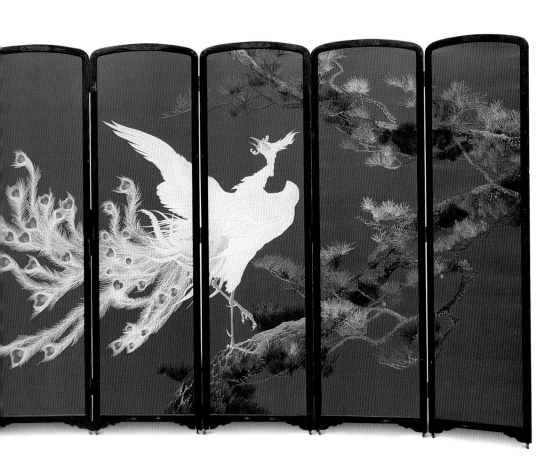

196

紫檀嵌螺鈿皇子祝壽詩屏風
清康熙
高356厘米　通寬1128厘米
單扇寬70.5厘米
清宮舊藏

Red sandalwood screen, decorated with
mother-of-pearl inlays and poems written
by the princes to celebrate Emperor
Kangxi's birthday
Kangxi Period, Qing Dynasty
Height: 356cm　Overall width: 1128cm
Width of each leaf: 70.5cm
Qing Court collection

屏心正面紙地上以石青顏料書寫詩
句，每扇五十六字，為康熙六十歲壽
辰時十六位皇子為其作的祝壽詩。背
面米色絹地上用彩綫繡成不同形態的
"壽"字一萬個，每個字以黑絲綫鑲
邊，使字跡更為明顯。框頂端飾眉
板，透雕正龍捧珠紋。正面四邊飾螺
鈿夔龍紋，裏框飾描金蝠壽紋，裙板
兩面浮雕雙龍捧壽紋，橫根下有銅質
鍍金托角牙，包銅鍍金套足。

屏風一套三十二扇，分皇子、皇孫製
詩兩組，每組各十六扇。此組為皇子
製詩。

鈞運更昌舜日常明光八表
地同悠久恩重君親慶永長
億侍吾皇
臣胤禎

197

紫檀嵌螺鈿皇孫祝壽詩屏風
清康熙
高356厘米　通寬1128厘米
單扇寬70.5厘米
清宮舊藏

Red sandalwood screen, decorated with
mother-of-pearl inlays and poems written
by the imperial grandsons to celebrate
Emperor Kangxi's birthday
Kangxi Period, Qing Dynasty
Height: 356cm　Overall width: 1128cm
Width of each leaf: 70.5cm
Qing Court collection

屏心正面紙地上以石青顏料書寫詩
句，詩句分上下兩層，各有五言律詩
一首，係康熙的三十二位皇孫為其所
作的祝壽詩，背面繡一萬個"壽"字。
眉板、邊飾、裏框、裙板裝飾等與前
圖屏風相同。

此組屏風與前圖屏風同為一套，為皇
孫製詩。

198

黑漆平金九龍屏風
清雍正
高275厘米　通寬375厘米　厚120厘米
清宮舊藏

Screen with a black lacquered frame,
featuring embroideries of nine dragons
made with gold thread
Yongzheng Period, Qing Dynasty
Height: 275cm　Overall width: 375cm
Thickness: 120cm
Qing Court collection

屏風共九扇。屏心米色綢地上彩繡海
水江崖、雲蝠及暗八仙紋，正中以平
金工藝繡九條金龍。眉板以拐子紋攢
框，以金漆彩繪手法描飾雲紋，下部
落堂踩鼓鑲板，正中飾描金山水圖，
周圍金漆彩繪各式皮球花，下承三聯
八字形須彌座，高束腰飾描金彩繪各
式花卉。

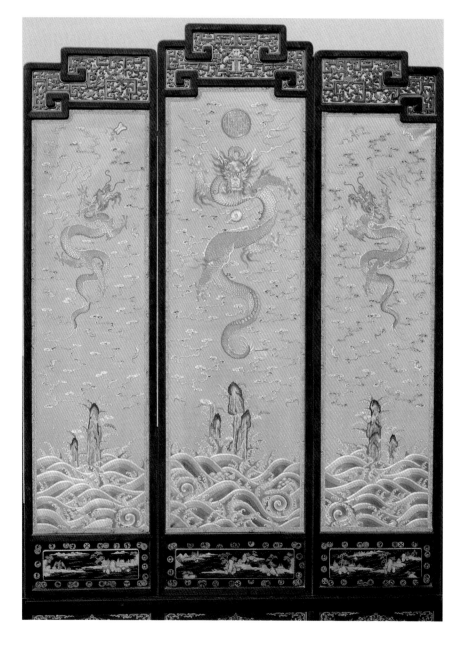

199

紫檀歲登圖屏風
清雍正
高320厘米　通寬360厘米　厚90厘米
清宮舊藏

**Red sandalwood screen, featuring
carvings of Lantern Festival scenes**
Yongzheng Period, Qing Dynasty
Height: 320cm　Overall width: 360cm
Thickness: 90cm
Qing Court collection

屏風紫檀木製，共三扇。屏心紫檀鑲板，雕正月十五鬧花燈的景象，老者站在廳堂前，庭院內擺放火盆，內院孩童放爆竹、拉象車、舞燈籠。門外賓客絡繹不絕，周圍襯以松柏、臘梅。有"竹報平安"、"萬象更新"、

"五穀豐登"等吉祥寓意。屏帽為盔頂式，下有捲草紋山花，頂端五個火珠上雕《五嶽真形圖》。兩側角各雕一鷂鷹俯視下方，與屏框與底座把角處雕二老鼠相呼應。三聯八字形底座浮雕仰覆蓮瓣、團花、火珠等紋飾。

200

黑漆描金邊納繡屏風
清雍正至乾隆
高191厘米　通寬237厘米　厚73厘米
清宮舊藏

**Petit-point gauze screen, with black
lacquered frame decorated with gold
tracery patterns**
Yongzheng-Qianlong Period, Qing
Dynasty
Height: 191cm　Overall width: 237cm
Thickness: 73cm
Qing Court collection

屏風共五扇。屏心米色紗地上以各種
彩綫雙面納繡牡丹、菊花、芙蓉、天
竺、靈芝、水仙、山石及蝙蝠，寓
"福壽如意"、"富貴長壽"之意。滾
框飾描金纏枝花及蝙蝠紋，上端板心
正中為描金"壽"字，兩側飾描金雲蝠
及暗八仙紋。下承八字形須彌式座，
高束腰正中飾描金正龍，兩側為雙龍
戲珠紋，束腰下飾描金拐子及花卉
紋。

235

201

紫檀嵌雞翅木山水圖屏風
清乾隆
高275厘米　通寬290厘米　厚63厘米
清宮舊藏

**Red sandalwood screen, featuring a
landscape scene made from inlaid,
carved jichimu[9] wood**
Qianloug Period, Qing Dynasty
Height: 275cm　Overall width: 290cm
Thickness: 63cm
Qing Court collection

屏風邊座紫檀木製，共三扇。屏心天
藍色漆地上用雞翅木碎料雕刻樹石、
樓閣、人物，上有乾隆題御詩。邊框
上裝紫檀木雕七龍戲珠紋屏帽，兩側
站牙各飾一龍，合為九龍。下承三聯
八字形須彌座，座上浮雕蓮瓣紋及拐
子紋，捲雲紋龜腳。

202

剔紅山水圖屏風
清乾隆
高287厘米　通寬268厘米　厚67厘米
清宮舊藏

**Three-leafed, carved, red lacquered
screen, featuring a landscape scene**
Qianlong Period, Qing Dynasty
Height: 287cm　Overall width: 268cm
Thickness: 67cm
Qing Court collection

屏風通體剔紅，共三扇。屏心正面雕
山水樓閣，樹石花卉及祥雲，數位仙
人漫步其間，雲間一仙人乘鶴而來，
寓有"羣仙祝壽"之意。背面為描金雲
蝠和壽桃紋，寓意"福壽"。框雕纏枝
蓮紋，裏側方格錦紋圈邊。屏帽雕雲
紋和龍戲珠紋為地，上剔紅如意紋間
纏枝蓮紋。下承三聯八字形須彌式
座，雕蓮花紋。

203

紫檀嵌玻璃畫屏
清
高280厘米　通寬340厘米　厚70厘米
清宮舊藏

**Red sandalwood screen, decorated with
floral patterned carvings and paintings
on inlaid glass panels**
Qing Dynasty
Height: 280cm　Overall width: 340cm
Thickness: 70cm
Qing Court collection

畫屏紫檀木製，共五扇。每扇屏心分
三部分，上下各一塊雕捲草紋縧環
板，中間一塊雕捲草紋白檀木心上嵌
三幅玻璃畫，分別繪有仙閣、花卉、
"海屋添籌"等內容，畫法上吸收西洋
技法。屏上及邊側有透雕西洋花紋屏
帽及邊牙，下承八字形須彌式座，上
雕蓮瓣及夔紋。

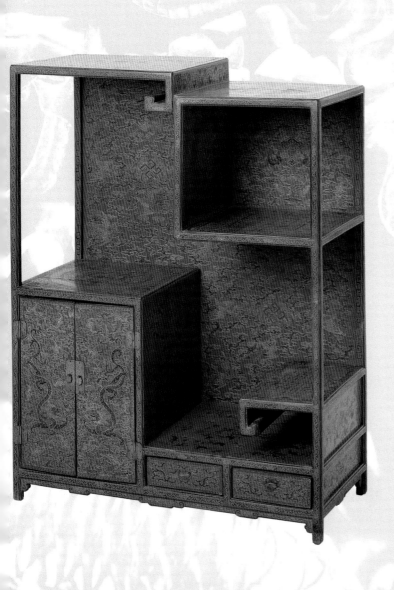

櫃格箱架

***Cabinets,
Shelving,
Chests and
Stands***

204

紫檀雍正耕織圖立櫃
清中期
高200.5厘米　長94厘米　寬42厘米

Red sandalwood closet, decorated with
Yongzheng Period carvings of people
ploughing and weaving
Middle Qing Dynasty
Height: 200.5cm　Length: 94cm
Width: 42cm

立櫃對開兩扇門，門板上有對稱的滿
月式、梅花式、海棠式、花瓣式及委
角長方形開光，內中雕《雍正耕織
圖》，共十一幅，開光之外襯以雲紋
地。邊框嵌銅面頁和活頁，安魚形拉
環。四腿直下，包銅套足。

此櫃四件組成，俗稱四件櫃，每兩件
為一對，此為其中一對，其造型、工
藝均體現清前期的家具風格。

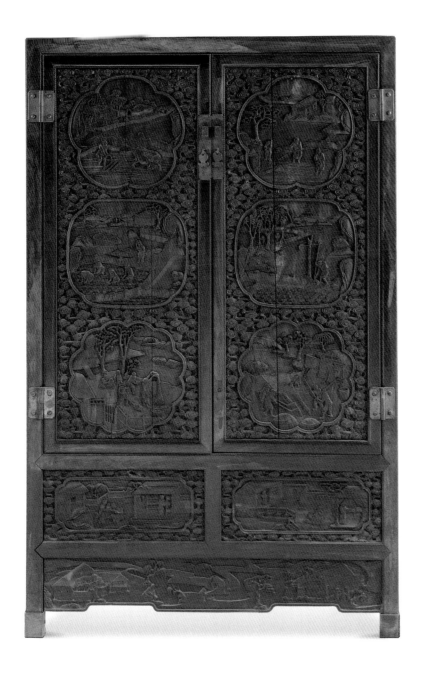

205

紫檀龍鳳紋立櫃
清
高162厘米　長83.5厘米　寬32厘米
清宮舊藏

**Red sandalwood closet, decorated with
carvings of dragons and phoenixes**
Qing Dynasty
Height: 162cm　Length: 83.5cm
Width: 32cm
Qing Court collection

立櫃對開兩門，間有活動立栓，框內
落堂鑲板，雕夔龍、夔鳳上下飛舞，
邊框嵌銅鍍金鏨花面頁和活頁，安雲
形拉環。櫃內有抽屜架，安抽屜兩
具。門下為櫃膛，膛面雕雙夔龍紋，
櫃膛內有悶倉，悶倉上有兩個活動倉
板。四腿直下，包銅套足。

此櫃做工精美，雕飾繁縟，為清代家
具珍品。

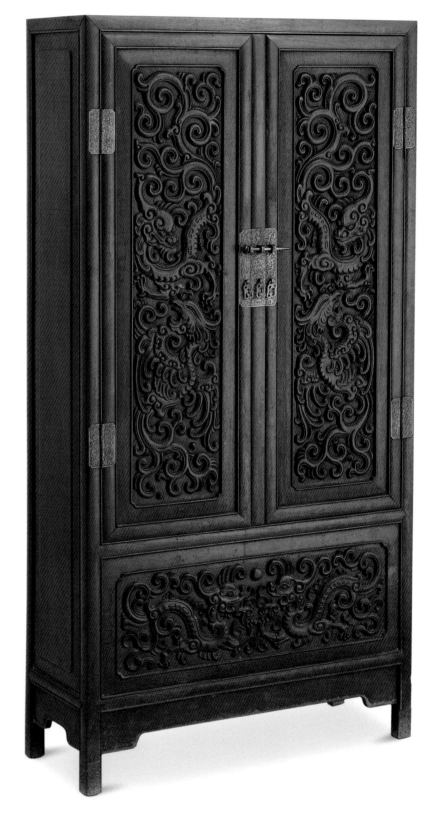

206

紫檀暗八仙紋立櫃
清
高162厘米　長90厘米　寬35.5厘米
清宮舊藏

Red sandalwood closet, decorated with carved symbols of the Eight Immortals
Qing Dynasty
Height: 162cm　Length: 90cm
Width: 35.5cm
Qing Court collection

立櫃對開兩門，門框內落堂鑲板，剗地雕雲紋間暗八仙紋，寓祝頌長壽之意。邊框嵌銅面頁和活頁，安雲形拉環。門下有櫃肚，剗地雕海水江崖間雲蝠紋，寓"福如東海"之意。兩側面山板雕拐子紋間錦結葫蘆。

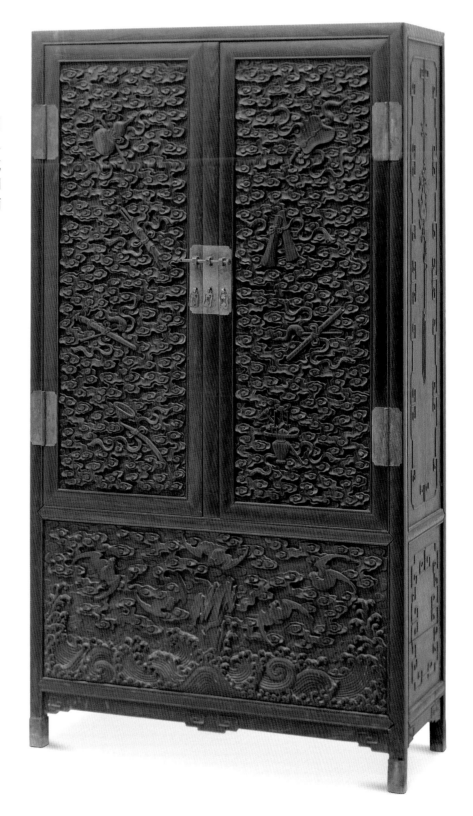

紫檀冰梅紋頂豎櫃
清乾隆
高161厘米　長103厘米　寬42厘米
清宮舊藏

**Red sandalwood, two-sectioned cabinet,
decorated with ice crackle and plum
blossom patterns**
Qianlong Period, Qing Dynasty
Height: 161cm　Length: 103cm
Width: 42cm
Qing Court collection

頂豎櫃由頂櫃及豎櫃兩部分組成。兩
櫃均為對開兩門，中間有活動立栓。
門心板嵌銀絲冰梅紋，邊框上安銅鏨
花面頁、扭頭和吊牌。

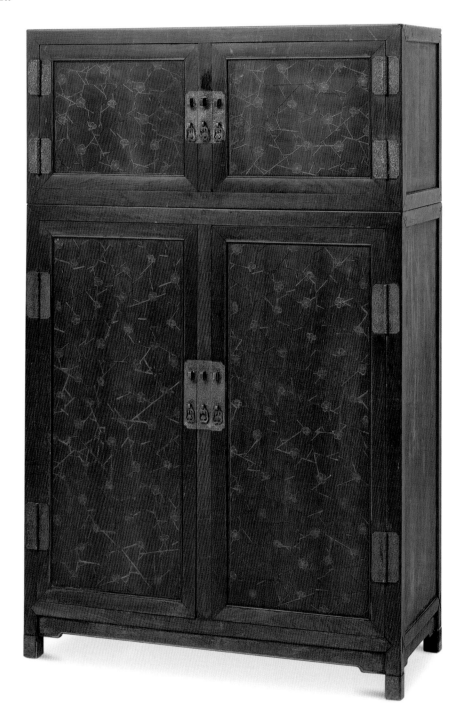

208

紫檀西番蓮紋頂豎櫃
清乾隆至嘉慶
高164厘米　長102厘米　寬35厘米
清宮舊藏

**Red sandalwood, two-sectioned cabinet,
decorated with carvings of dahlias**
Qianlong-Jiaqing Period, Qing Dynasty
Height: 164cm　Length: 102cm
Width: 35cm
Qing Court collection

頂豎櫃的門心板剷地浮雕西番蓮紋，
邊框嵌安銅面頁和活頁，安雲形拉
環。門內裝樘板設抽屜。門下安有西
番蓮捲草紋牙條。

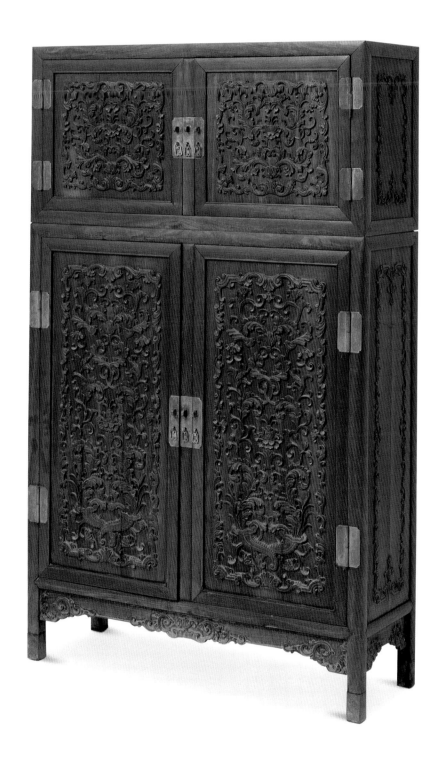

209

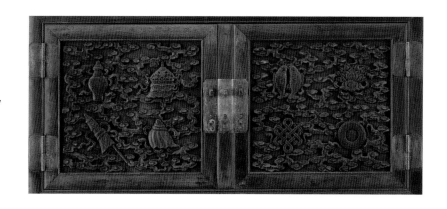

紫檀八寶八仙紋頂豎櫃

清
高161厘米　長89.5厘米　寬35.5厘米
清宮舊藏

Red sandalwood, two-sectioned cabinet,
decorated with carvings of the Eight
Treasures and the Eight Immortals
(Buddhist sacred emblems)
Qing Dynasty
Height: 161cm　Length: 89.5cm
Width: 35.5cm
Qing Court collection

頂豎櫃的門正面打槽裝板，落堂踩
鼓。頂櫃門心板雕藏傳佛教的八寶紋
及雲紋；豎櫃門心板雕暗八仙紋間雲
紋。兩側面山板雕錦結蝠磬葫蘆紋。
邊框安銅鏨螭紋鍍金活頁及面頁。

此櫃從做工特點看，係出自清宮造辦
處工匠之手。

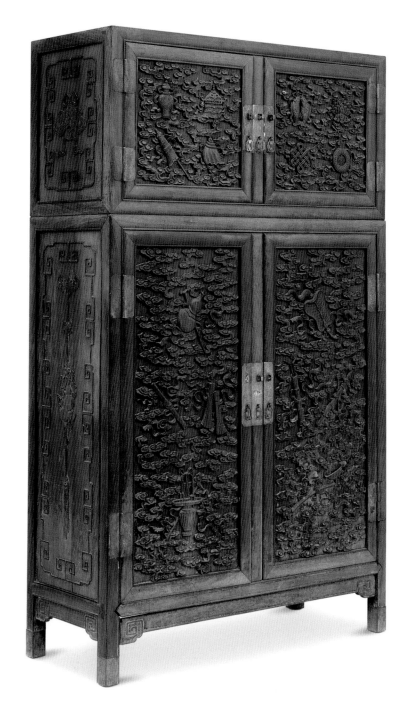

210

剔紅八龍鬧海紋頂豎櫃
清
高129厘米　長71厘米　寬36厘米
清宮舊藏

Carved, red lacquered, two-sectioned
cabinet, decorated with carvings of eight
dragons frolicking in the sea
Qing Dynasty
Height: 129cm　Length: 71cm
Width: 36cm
Qing Court collection

頂豎櫃通體剔紅。上下門心板對稱雕
飾八龍鬧海紋，邊框雕纏枝蓮紋。櫃
門下有悶倉，俗稱"櫃肚"。櫃身框架
雕纏枝蓮紋，兩側山板起地雕捲草
紋。

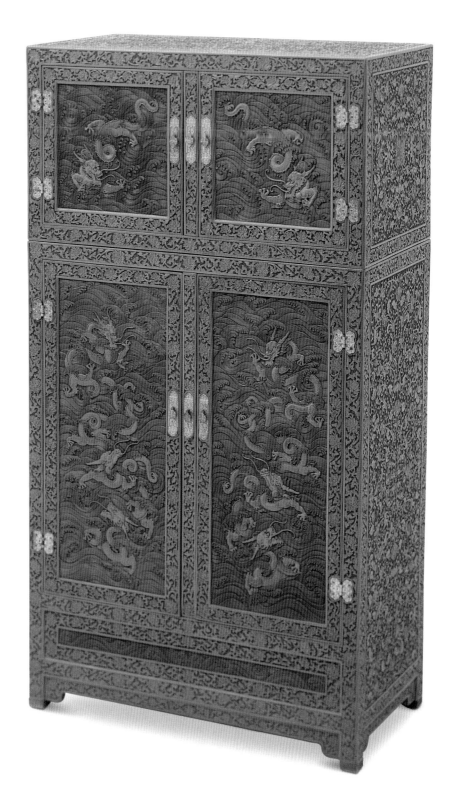

211

花梨雲龍紋立櫃

清

高129厘米　長77厘米　寬38.5厘米

清宮舊藏

**Rosewood closet, decorated with
carvings of dragons and clouds**

Qing Dynasty

Height: 129cm　Length: 77cm

Width: 38.5cm

Qing Court collection

立櫃櫃門皆落堂踩鼓做，門心板對稱
雕雲龍紋。邊框雕燈草綫，安如意雲
頭形銅活頁、銅鎖鼻。櫃門下縧環板
亦雕雲龍紋。四腿直下，雕燈草綫直
足。

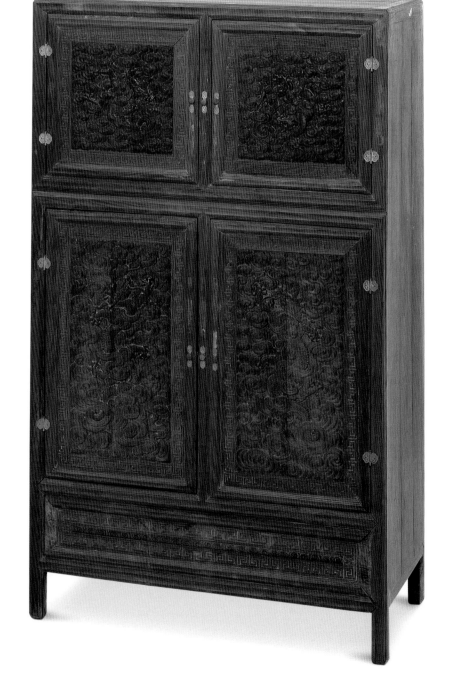

212

紫檀嵌瓷花鳥圖小櫃

清晚期
高89厘米　長42厘米　寬21厘米
清宮舊藏

Small, red sandalwood cabinet, decorated with pictures of birds and flowers on inlaid porcelain panels
Late Qing Dynasty
Height: 89cm　Length: 42cm
Width: 21cm
Qing Court collection

小櫃形似頂竪櫃，紫檀一木連作。正面分三層，對開六扇門，框內嵌堆塑加彩瓷片，分別為茶花綬帶、春桃八哥、牡丹鳳凰、玫瑰公雞等花鳥圖，寓意"官運通達"、"丹鳳朝陽"、"功名富貴"等。迴紋邊框嵌銅鍍金活頁及面頁，門下垂兩塊牙子，鑲花卉紋瓷片。兩側面山板上分四層鑲縧環

板，雕"五福捧壽"紋和以蝙蝠、錢、盤腸結組成的"福泉綿長"紋。

此櫃彩瓷以貼胎上釉的方法燒製而成，使圖案高於平面，立體感強，且色彩豔麗，形象逼真，在故宮諸多家具藏品中僅此一件。

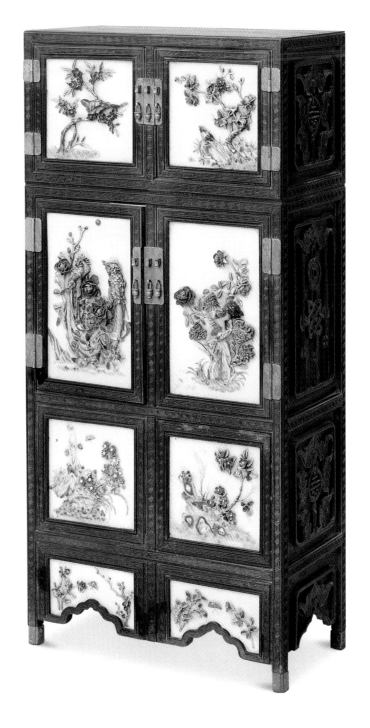

213

黑漆拐子紋門式多寶格
清早期
高158.5厘米　長159.5厘米　寬31.5厘米
清宮舊藏

Black lacquered display cabinet, built in the shape of a doorway, decorated with Kui[1] patterns
Early Qing Dynasty
Height: 158.5cm　Length: 159.5cm
Width: 31.5cm
Qing Court collection

多寶格門式。架格當中設小格，高低錯落，富於變化，大小無一相同且四面透空。框架外面起混面雙邊綫，間飾拐子紋花牙，所有邊綫及牙子邊緣飾金漆。兩側几架四框落地，拐子紋足。

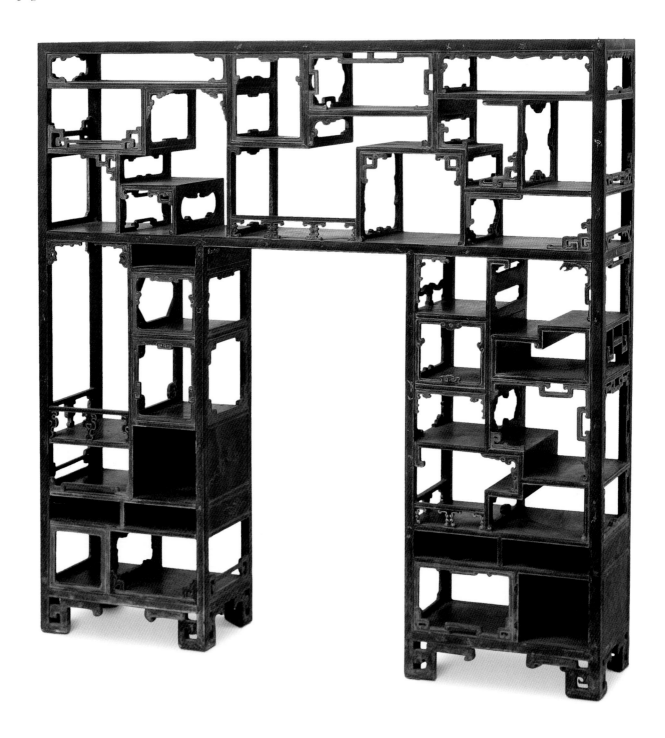

214

填漆戧金花蝶圖博古格

清雍正
高174.5厘米　長97.5厘米　寬51.5厘米
清宮舊藏

Antique shelving, decorated with inlaid lacquer and gold patterns
Yongzheng Period, Qing Dynasty
Height: 174.5cm　Length: 97.5cm
Width: 51.5cm
Qing Court collection

博古格齊頭立方式。上部右側安板門
一扇，下方平設二抽屜，門心板及抽
屜正面紅漆地飾填漆戧金折枝花蝶圖
紋。左側和下方設高低錯落的亮格，
分別鑲夔紋叉角花和拐子紋花牙。最
下層左側設一壺門小几，格內黑漆
地，後背板上部飾描金花蝶圖，下部
右側有圓形開光洞。格側面與門對應
處鑲嵌鏤空拐子紋和花卉紋檔板。邊
框紅漆地，有花瓣形開光，內飾填漆
戧金折枝花卉圖紋。格下有飾花卉紋
牙條，四腿直下，包銅套足。

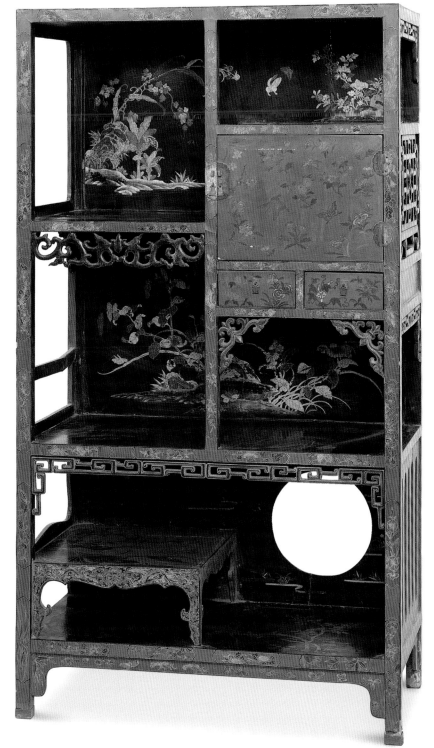

215

填漆描金蘆雁圖格
清雍正
高175.5厘米　長97.5厘米　寬51厘米
清宮舊藏

Shelving with black lacquered inner sections, decorated with gold tracery pictures of reeds and wild geese
Yongzheng Period, Qing Dynasty
Height: 175.5cm　Length: 97.5cm
Width: 5l cm
Qing Court collection

格齊頭立方式。正面設七格，高低錯落，中間左側有帶雙環拉手的抽屜一具。裏背板髹黑漆描金繪《蘆雁圖》及梅花、茶花、竹子、凌霄等圖紋。邊框紅漆地上有花瓣形開光，內飾花卉圖紋。兩側面山板上開壺門圈口，其

他開有滿月式、窗欞式開光或方形透空、圈口、開光四周紅漆地上分別飾描金花果、祥雲及雙龍捧壽等紋飾。格下有飾花卉紋牙條，四腿直下，包銅套足。

216

紫檀描金花卉山水圖多寶格
清雍正至乾隆
高57厘米　長54厘米　寬18厘米
清宮舊藏

**Red sandalwood display cabinet,
decorated with gold tracery landscape
and flower patterns**
Yongzheng-Qianlong Period, Qing
Dynasty
Height: 57cm　Length: 54cm
Width: 18cm
Qing Court collection

多寶格齊頭立方式。五層，每層有透
雕夔龍紋花牙、欄杆，立板髹黑漆描
金繪折枝花卉及山水圖。側面板繪蝙
蝠、葫蘆，寓意"福祿萬代"。後立板
背面繪描金花鳥圖。

此格為一對，並排陳設，層與層相
連，圖紋相接，如同一體。

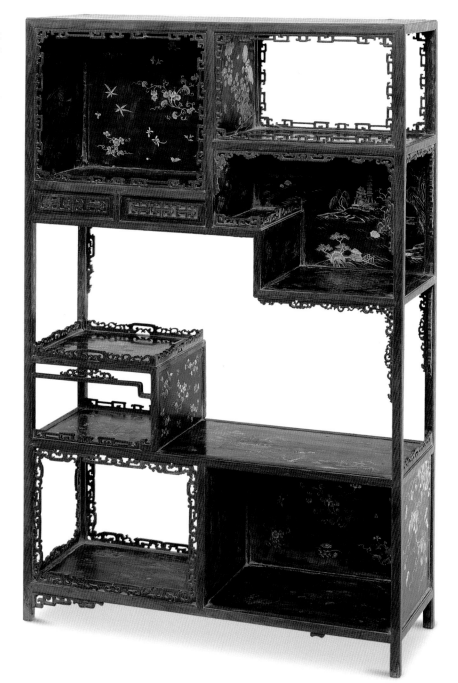

217

紫檀嵌竹絲格
清雍正至乾隆
高86厘米　長91厘米　寬28.5厘米
清宮舊藏

Red sandalwood shelving, decorated with inlaid bamboo strips
Yongzheng-Qianlong Period, Qing Dynasty
Height: 86cm　Length: 91cm
Width: 28.5cm
Qing Court collection

格邊框紫檀木製，齊頭立方式，外包鑲竹絲。正面中間為空敞格子，內髹黑漆，上下各有對開兩扇門，左右有相對的上下門，門心板、兩側山板為竹絲網編製，後面背板髹黑漆。正面內彎雙拐子腿，腿上三面安棖。

此格在紫檀木邊框上貼嵌竹絲的工藝，是典型的清代家具製作手法之一。

255

218

紫檀多寶格
清雍正至乾隆
高155厘米 長107厘米 寬50厘米
清宮舊藏

Red sandalwood display cabinet
Yongzheng-Qianlong Period, Qing
Dynasty
Height: 155cm Length: 107cm
Width: 50cm
Qing Court collection

多寶格邊框紫檀木製，共四層，每層
以隔斷板錯落間隔，隔斷板髹黑漆，
有如意雲頭形及各式花形開光。格板
亦髹黑漆，邊框細雕夔龍紋花牙。

此格為一對，無腿足，其所採用的以
紫檀木做邊框、內部為髹漆板的做
法，具有典型的清代蘇作家具工藝特
點。

219

填漆描金花卉紋格
清雍正至乾隆
高166厘米　長94.5厘米　寬48.5厘米
清宮舊藏

Shelving decorated with flower patterns
made with gold tracery and inlaid
lacquer
Yongzheng-Qianlong Period, Qing
Dynasty
Height: 166cm　Length: 94.5cm
Width: 48.5cm
Qing Court collection

格齊頭立方式，正面分上、中、下三
部分，上部分兩層四面全敞，中間部
分為三行並列的九個抽屜。抽屜面上
委角長方形開光；中有海棠形拉手；
下部正面為魚肚圈口，三面裝板。格
體正面框架自上而下分別飾描金西番
蓮紋和雙夔龍戲珠紋，兩面側板描金
繪梅花翠竹。腿間安有羅鍋棖，棖上
有矮老。包銅套足。

220

楸木描金夔鳳紋多寶格

清乾隆
高95.5厘米　長96厘米　寬32厘米
清宮舊藏

**Display cabinet made from Manchurian
catalpa wood, decorated with gold
tracery Kui[1]-phoenix patterns**
Qianlong Period, Qing Dynasty
Height: 95.5cm　Lenght: 96cm
Width: 32cm
Qing Court collection

多寶格齊頭立方式。正面及兩側面透
敞，正面開大小相錯孔洞，描金折枝
花紋邊框，鑲夔龍紋、雲紋坐牙或托
角牙。格右上角有對開兩扇門，開光
內描金繪夔鳳紋。門下及格底部抽屜
屜面鏤空，飾團螭紋卡子花拉手。格
底有攢框式落曲齒根。

竹絲鑲玻璃小格

清乾隆
高48.5厘米　長39厘米　寬29.5厘米
清宮舊藏

Small, glass cabinet, decorated with inlaid bamboo strips
Qianlong Period, Qing Dynasty
Height: 48.5cm　Length: 39cm
Width: 29.5cm
Qing Court collection

小格齊頭立方式。正面對開兩扇門，門框飾迴紋並鑲貼竹絲，框內鑲玻璃，呈對稱"弓"字形。格內分左右兩間，每間自上而下錯落有致地懸着三個小抽屜，構思奇巧。兩側板亦飾迴紋框鑲玻璃。內翻拐子紋足。

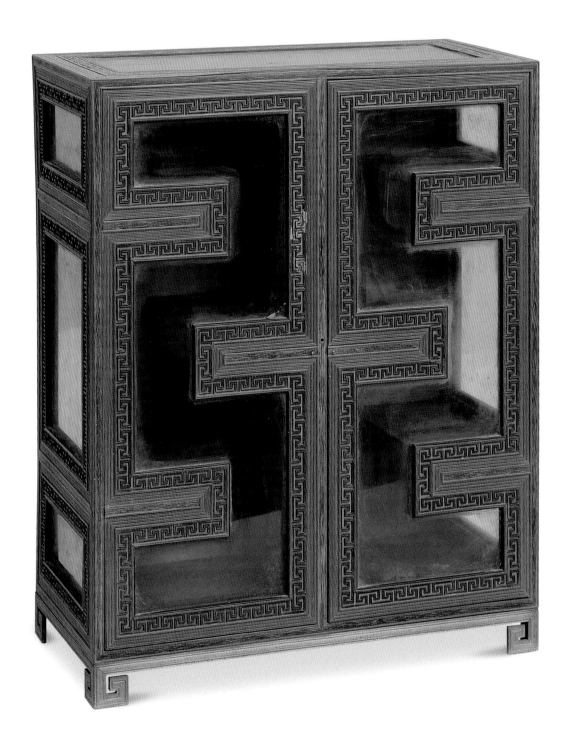

填漆戧金雲鶴紋多寶格
清乾隆
高91厘米　長69.25厘米　寬34厘米
清宮舊藏

**Display cabinet decorated with crane
and cloud patterns made from inlaid
lacquer and gold**
Qianlong Period, Qing Dynasty
Height: 91cm　Length: 69.25cm
Width: 34cm
Qing Court collection

格面高低錯落，正面左下部設對開兩
扇門，右下部設抽屜兩具。其餘三面
開敞。格身內外屜板、立牆戧金飾雲
鶴卿雜寶紋，門板飾雲蝠、夔龍紋，
抽屜飾夔龍紋，邊框飾捲雲紋及拐子
紋。格下有細牙條，下垂捲雲紋窪堂
肚。

223

紫檀鑲玻璃書格
清
高141厘米　長99厘米　寬43.5厘米
清宮舊藏

Red sandalwood bookshelf, decorated with glass paneling
Qing Dynasty
Height: 141cm　Length: 99cm
Width: 43.5cm
Qing Court collection

書格框架紫檀木製，通體飾打窪綫條，框架空隙處以黃花梨木攢框鑲心。格分三層，每層安裝雙棖，以矮老分為四格，內鑲紫檀圈口，鑲嵌玻璃心。格楣雕螭紋，間鏤橢圓形開光，內鑲玻璃。格兩側鑲雕螭紋縧環板，正中開光鑲玻璃。背板每層均開三個海棠式開光洞，鑲玻璃。格下有落曲齒加雙環卡子花牙子。包銅套足。

224

黃花梨梅花紋多寶格
清晚期
高112.5厘米　長80厘米　寬32厘米
清宮舊藏

**Huanghuali[6] wood display cabinet,
decorated with plum blossom patterns**
Late Qing Dynasty
Height: 112.5cm　Length: 80cm
Width: 32cm
Qing Court collection

多寶格齊頭立方式。正面開七孔，高低錯落，開孔上部鑲透雕花牙，下部鑲瓶柱式欄杆。格下部正中對開兩門，門心板對稱浮雕梅花，門內有小抽屜一具。門下為垂雲紋窪堂肚下牙。格兩側為四段攢框鑲縧環板，分別浮雕拐子紋及博古紋。

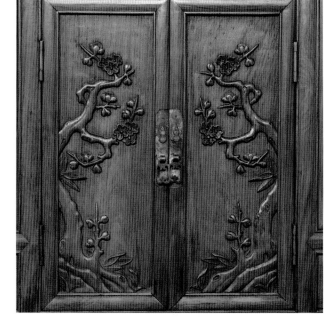

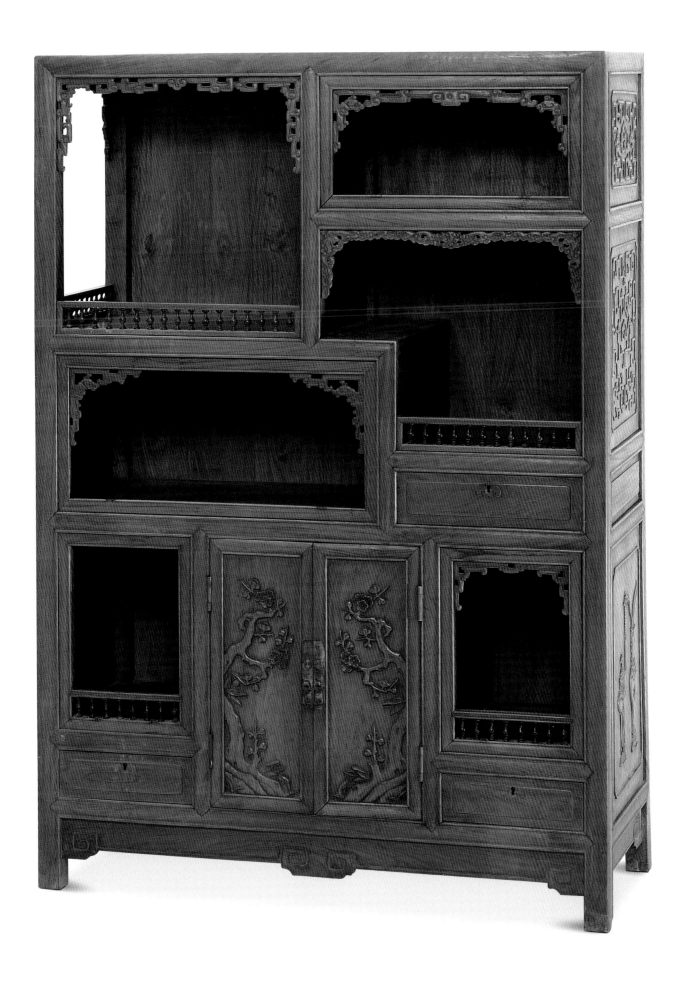

225

紫檀萬福紋櫃格
清乾隆
高109.5厘米　長99.5厘米　寬30.5厘米
清宮舊藏

Red sandalwood, multi-partition cabinet, decorated with cloud and bat[4] patterned carvings on a swastika brocaded background
Qianlong Period, Qing Dynasty
Height: 109.5cm　Length: 99.5cm
Width: 30.5cm
Qing Court collection

櫃格齊頭立方式。正面開十六格，門攢框鑲縧環板，以透雕斜卍字錦紋為地，上剷地浮雕雲蝠紋，寓"萬福"之意。門內有隔牆，門邊框飾如意雲頭，兩側靠內的如意雲頭為活插銷，兩側外的豎框內側上下有軸，撥動活插銷，可以開啟小門。包銅套足。

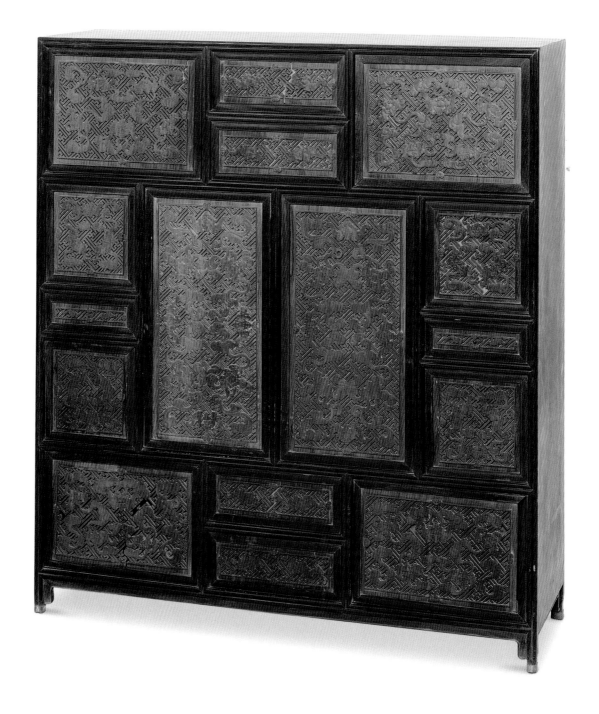

226

湘妃竹雕漆博古圖櫃格
清乾隆
高110.5厘米　長94.5厘米　寬25.5厘米
清宮舊藏

Carved lacquer, multi-partition cabinet,
decorated with mottled bamboo patterns
and pictures of antique objects
Qianlong Period, Qing Dynasty
Height: 110.5cm　Length: 94.5cm
Width: 25.5cm
Qing Court collection

櫃格木胎，包湘竹皮剔紅裝飾。齊頭
立方式，上格下櫃。橫豎框、根部雕
至竹皮露出梭子形輪廓，有如開光。
上部各格孔四邊均飾雕漆雲紋圈口。
下部橫排四門，正中對開兩扇門，可
開啟。框上安有銅鏨花活頁及面頁。
四門板上均雕《博古圖》，並雕出竹
地。四腿直下，包雲頭形銅套足。格
下承樖。

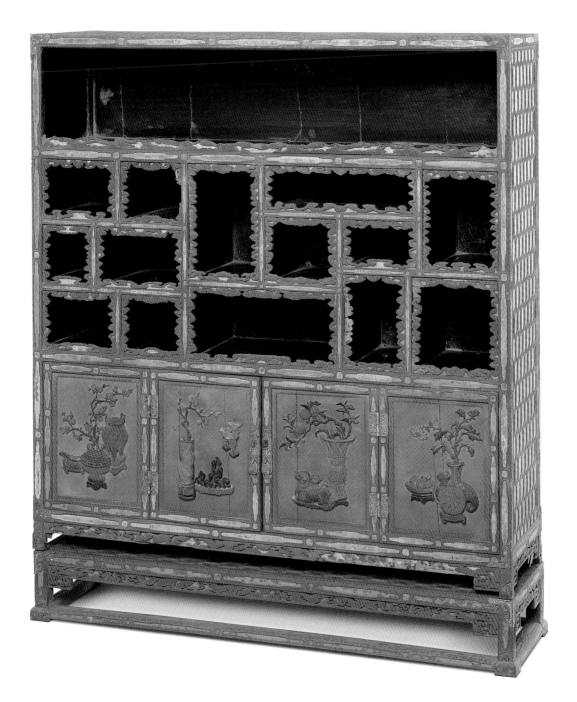

紫檀山水人物圖櫃格
清中期
高182厘米　長109厘米　寬35厘米
清宮舊藏

Red sandalwood, multi-partition cabinet, decorated with carvings of figurines in a landscape setting
Middle Qing Dynasty
Height: 182cm　Length: 109cm
Width: 35cm
Qing Court collection

櫃格齊頭立方式，格上裝鏤空套疊方勝形橫楣。格下為抽屜，兩大四小，皆有銅拉手。屜下為對開兩扇門，中間立栓，四角攢邊門框雙混面雙邊綫，框內鑲門心板，一面雕《桐蔭對奕圖》，另一面雕《觀瀑圖》。櫃格下承須彌座式橛。

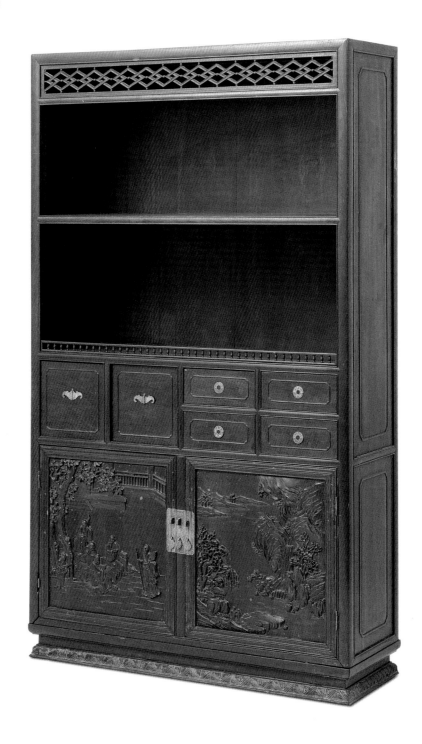

228

紫檀西洋花紋小櫃格
清中期
高129厘米　長64厘米　寬38厘米

Small, red sandalwood, multi-partition
cabinet, decorated with Western style
carvings
Middle Qing Dynasty
Height: 129cm　Length: 64cm
Width: 38cm

小櫃格齊頭立方式。上部多寶格每格
大小不一，內均有圈口牙子，或雕夔
紋，或雕迴紋，或雕西洋捲草紋。格
下為對開兩扇門，中間立栓，邊框安
有銅活頁及面頁。門心板雕西番蓮
紋。櫃底橫棖下裝浮雕迴紋牙條。

此櫃格體積雖小，但工藝精湛，應屬
炕櫃一類。

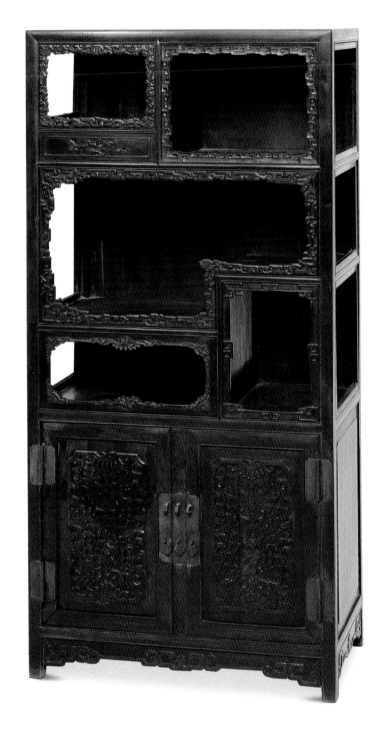

紫檀描金山水圖博古格
清中期
高121.5厘米　長89厘米　寬34.5厘米
清宮舊藏

Display cabinet for antiques, with red
sandalwood frame, decorated with gold
tracery landscape scenes
Middle Qing Dynasty
Height: 121.5cm　Length: 89cm
Width: 34.5cm
Qing Court collection

博古格紫檀木製框架，正面開五孔，
鑲鏤空圈口花牙。左下部有板門兩扇
並小抽屜一具。格內背板、立牆和屜
板均木胎髹紫漆，飾描金山水風景和
折枝花卉圖。格兩側面分別開兩孔，
並飾鏤空圈口花牙。格下有拐子紋角
牙。

此格所採用的硬木做框加漆心彩繪的
工藝，是清代中期蘇作家具的常見工
藝。

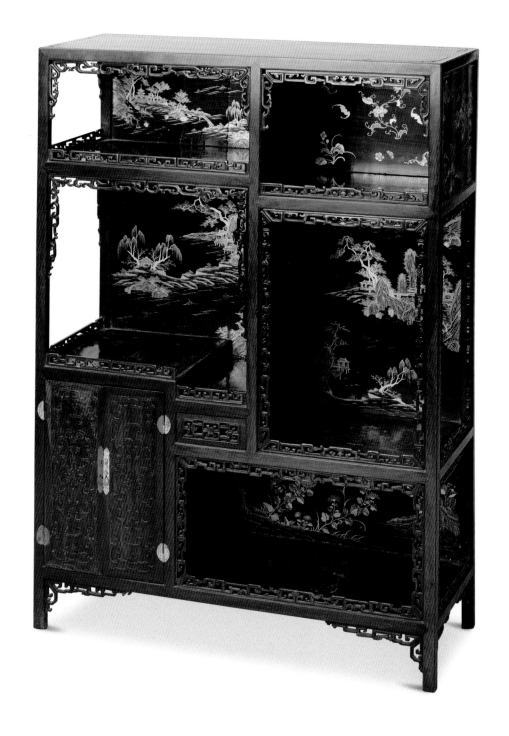

230

黃花梨勾雲紋櫃格
清
高179厘米　長97厘米　寬36厘米
清宮舊藏

Huanghuali[6] wood, multi-partition
cabinet, decorated with scrolled cloud
pattern carvings
Qing Dynasty
Height: 179cm　Length: 97cm
Width: 36cm
Qing Court collection

櫃格齊頭立方式。上部多寶格欄板及券口牙均雕連續勾雲紋。中部有三個抽屜，屜下對開兩扇門，中間有立栓，邊框安有銅活頁及面頁。櫃底棖下裝拐子紋牙條。四腿直下，雕迴紋足。

此櫃格兩件一對，為對稱設計，可並排或對稱擺設。

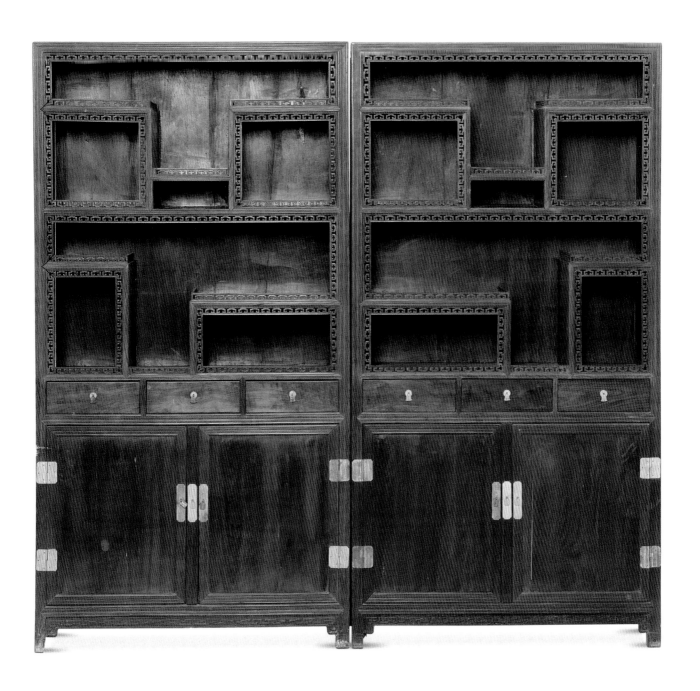

231

紫檀雲龍紋櫃格
清
高162厘米　長112厘米　寬38厘米
清宮舊藏

Red sandalwood, multi-partition cabinet,
decorated with carved dragons and
clouds
Qing Dynasty
Height: 162cm　Length: 112cm
Width: 38cm
Qing Court collection

櫃格齊頭立方式，上部兩層格中間平
設三個抽屜，抽屜面起一圈委角縧環
綫，中心安銅拉手。格邊沿鑲雕花圈
口，櫃下部對開兩扇門，櫃門四邊攢
框，安銅活頁、銅鎖鼻，中心板雕雲
龍紋。兩側面山板分為上下兩段，雕
有山水、樓閣、樹木、人物圖。櫃門
下有雕迴紋牙子，中間下垂窪堂肚。

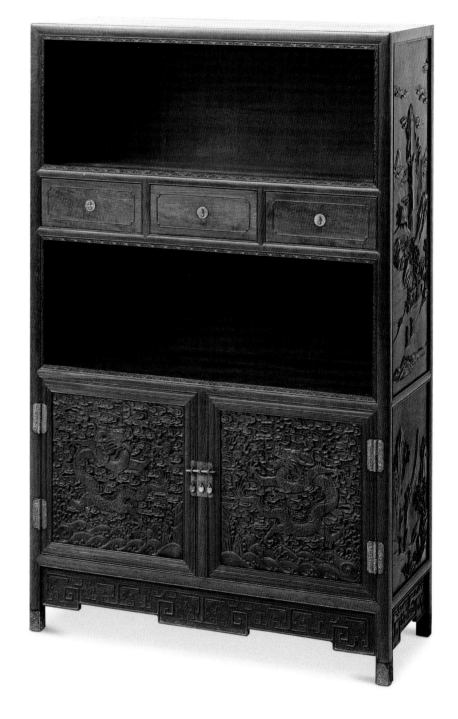

232

紫檀欞門櫃格
清
高193.5厘米　長101.5厘米　寬35厘米
清宮舊藏

**Red sandalwood shelving, with lattice
style doors in the center sections**
Qing Dynasty
Height: 193.5cm　Length: 101.5cm
Width: 35cm
Qing Court collection

櫃格齊頭立方式，上層和下層為格，
四面全敞，中間兩層為櫃，結構相同
而方位相反，每層分二間，一間三面
有豎棖，正面無門，另一間有欞窗似
的門。格下有角牙，四腿直下。

此櫃格看上去四面透風而又有欄，所
以又稱“氣死貓”，但其樣式結構與明
式“氣死貓”櫃格有較為明顯的區別。

233

紫檀嵌畫琺瑯雲龍紋櫃格
清
高185厘米　長96厘米　寬42厘米
清宮舊藏

Red sandalwood, multi-partition cabinet,
decorated with enameled picture panels
featuring dragon and cloud patterns
Qing Dynasty
Height: 185cm　Length: 96cm
Width: 42cm
Qing Court collection

櫃格紫檀木製框架，齊頭立方式。上
部多寶格開五孔，正面及兩側透空，
每孔上部鑲拐子番蓮紋琺瑯券口牙
子，下部裝矮欄。格背板裏側鑲玻璃
鏡。格下平設抽屜兩具，屜面鑲銅質
鏤空番蓮花。再下為櫃門，鑲畫琺瑯
鏤空雲龍紋。兩側面為嵌琺瑯雲蝠紋
縧環板。櫃下有嵌琺瑯纏枝蓮紋牙
條。

234

黑漆識文描金九龍紋長套箱

清雍正

外箱通高49厘米　長189厘米　寬50厘米

內箱通高35.5厘米　長178厘米

寬40.5厘米

Long, black lacquered, nested chest set, decorated with gold tracery pictures of nine dragons

Yongzheng Period, Qing Dynasty

Outer chest: Overall height: 49cm

Length: 189cm　Width: 50cm

Inner chest: Overall height: 35.5cm

Length: 178cm　Width: 40.5cm

套箱分內外兩層，紋飾相同，均黑素漆裏，不露木胎。每層箱體兩端均有銅提環。外箱蓋面上有滿漢對照識文描金 "雍正元年（1723）吉月　孝陵所產蓍草六蔟計三百莖敬謹貯內" 文字。外箱下有鑲垛邊底座，內箱四角下有矮足，與垛邊齊平，正好放進垛邊裏口。內箱箱壁較高，上蓋較窄，有豎牆。

識文是用漆灰堆作陽綫花紋或平地堆起顯現陽綫花紋，花紋與漆地同一顏色的髹飾技法，在這些花紋上飾金的，稱為識文描金。

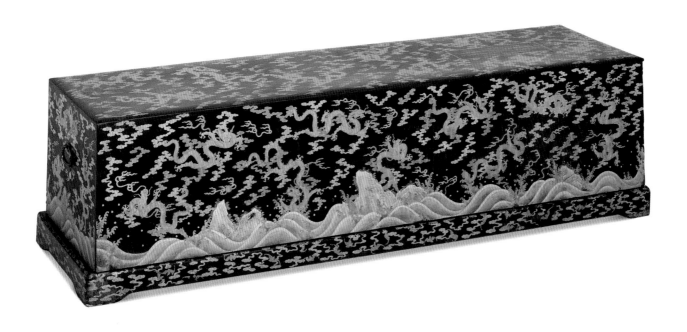

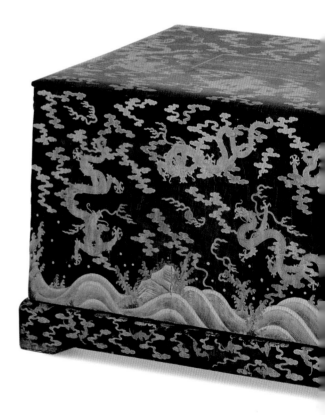

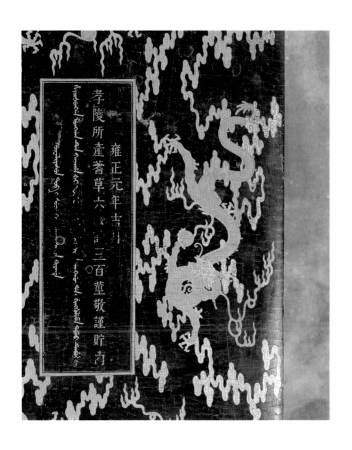

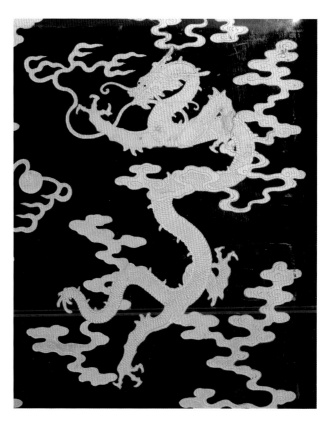

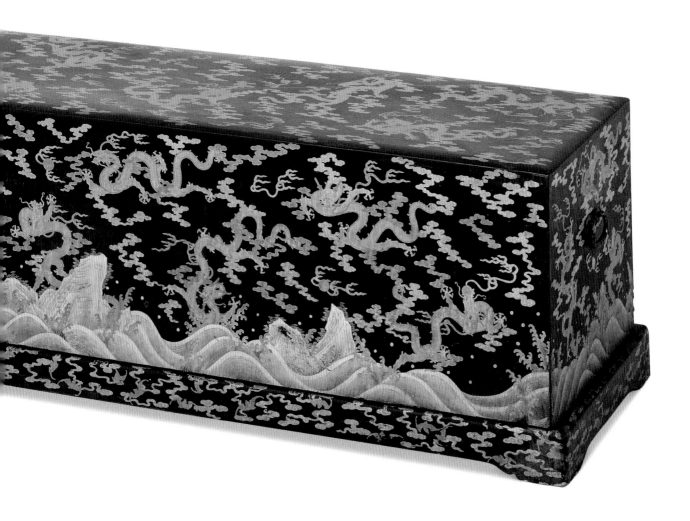

235

紫檀銀包角雙龍戲珠紋箱
清中期
高49.5厘米　長98.5厘米　寬66厘米
承几高19厘米　長103厘米　寬70厘米
清宮舊藏

Red sandalwood chest with silver corner sheathings, decorated with carvings of twin dragons playing with a pearl
Middle Qing Dynasty
Height: 49.5cm　Length: 98.5cm
Width: 66cm
One stand attached: Height: 19cm
Length: 103cm　Width: 70cm
Qing Court collection

箱蓋、箱體皆雕雙龍戲珠紋，箱四角均包鑲銀鍍金鏨花包角，前後兩面安銀鍍金鏨花龍紋合頁及拍子。下有紫檀束腰箱座，座面、束腰及牙條四角亦包鑲銀鍍金鏨花包角，牙條下有十二腿足支撐。

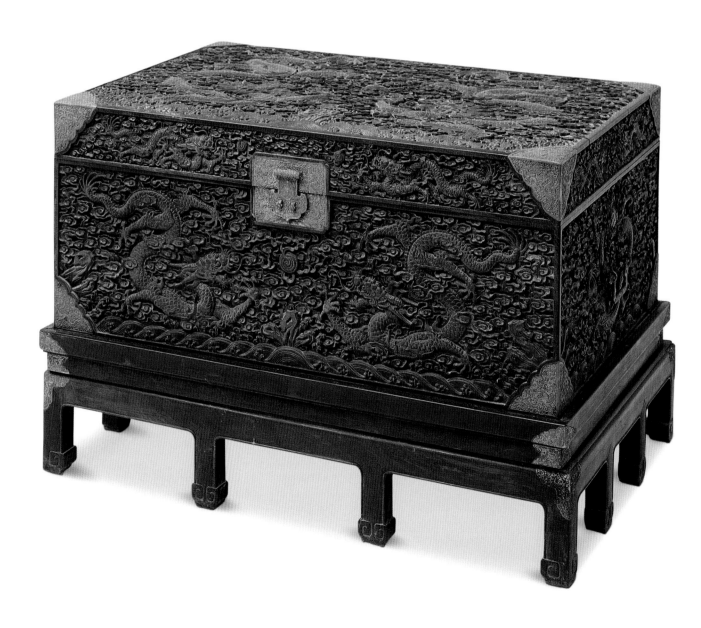

236

柏木冰箱
清
高82厘米　長91厘米　寬90厘米
清宮舊藏

Icebox made from cypress wood
Qing Dynasty
Height: 82cm　Length: 91cm
Width: 90cm
Qing Court collection

冰箱上有一對箱蓋，蓋上有四個銅錢紋開光，用於將箱蓋提起。箱內四壁均用鉛皮包鑲，並設有一層格屜，由兩個長方形的格屜組成。冰箱外壁銅箍三道，兩側面安有銅提環。箱下承柏木座，座面、束腰四角及鼓腿拱肩部均包鑲銅片，足下連托泥。

237

红木龍首衣架
清
高200厘米　長256厘米　寬67厘米
清宮舊藏

**Mahogany clothes rack, decorated with
carved dragon heads**
Qing Dynasty
Height: 200cm　Length: 256cm
Width: 67cm
Qing Court collection

衣架上方的搭腦兩端雕出回首相顧的
兩個龍首，龍首下方透雕雲紋掛牙，
中牌子分三段嵌裝透雕雙龍戲珠紋縧
環板，縧環板下有透雕龍紋卡子花與
其下的橫棖相連，橫棖下方兩端有透
雕雲龍紋托角牙。兩側立柱前後用站
牙抵夾，立於墩子上，站牙、墩子及
披水牙上滿地雕雲龍紋。

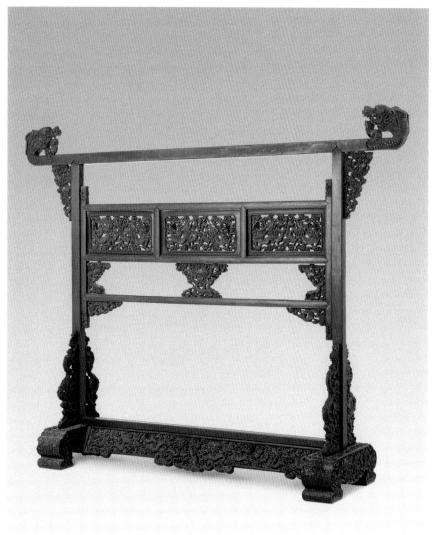

238

紅木龍首盆架
清
高180厘米
清宮舊藏

**Mahogany basin stand, decorated with
carved dragon heads**
Qing Dynasty
Height: 180cm
Qing Court collection

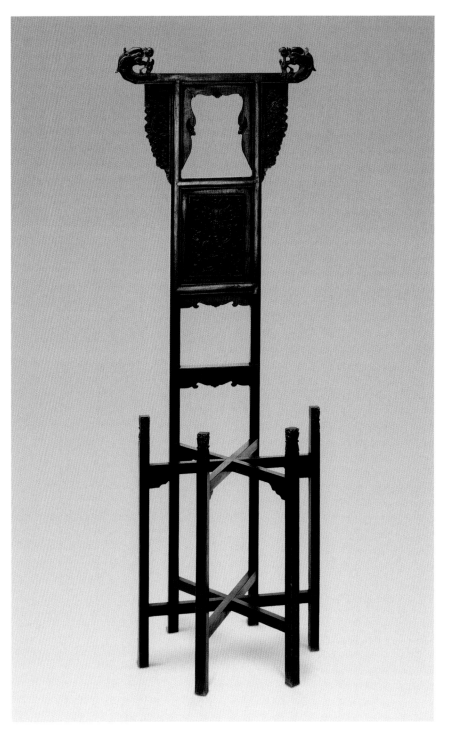

盆架紅酸枝木製。後柱上的搭腦兩端
雕出回顧的龍首。搭腦下方鑲壺門式
券口牙子。兩側裝雲龍紋托角牙，架
框正中鑲中牌子，雕雲龍紋。下裝一

橫棖，兩空當中各安壺門式牙條。架
間安上下兩組橫棖，分別由三條橫棖
交叉結合而成，上層橫棖與腿連接處
安托角牙。六腿直下。

239

紅木竹節紋盆架
清
高52厘米　直徑51厘米
清宮舊藏

**Mahogany basin stand, carved to
resemble jointed bamboo**
Qing Dynasty
Height: 52cm　Diameter: 51cm
Qing Court collection

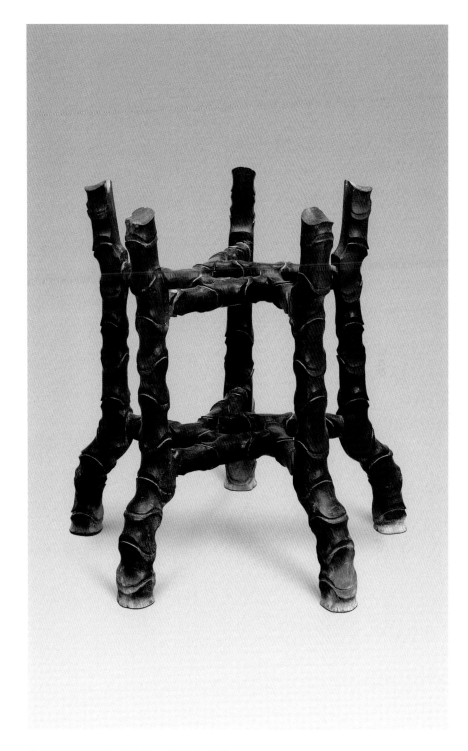

盆架通體圓雕龜背竹紋，架間上下設
兩層冰紋棖，上層棖用來放置盆體。
架下五足外撇。

240

酸枝木鳳紋盆架
清晚期
高75厘米　直徑84厘米
清宮舊藏

**Mahogany basin stand, with legs shaped
in a phoenix pattern**
Late Qing Dynasty
Height: 75cm　Diameter: 84cm
Qing Court collection

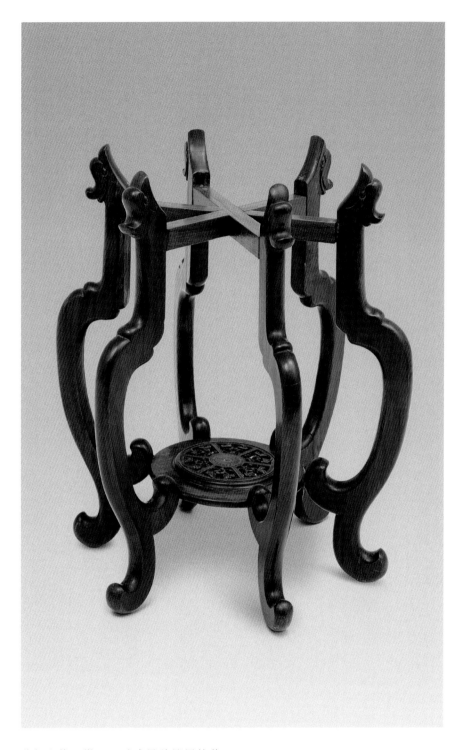

盆架六條三彎腿，雕成昂首捲尾的夔
鳳形，鳳首上仰，身體彎曲，鳳尾部
自然形成外翻足，腿上部橫棖連接，
腿下部捲曲處則以一圓形棖銜接而
成，棖中間安有圓板，雕花卉紋。

天然木家具

Natural Wood Furniture

241

天然木圓桌
清乾隆
高84厘米　面徑126厘米
清宮舊藏

Round table constructed from naturally shaped wood
Qianlong Period, Qing Dynasty
Height: 84cm　Diameter: 126cm
Qing Court collection

桌面柴木做，面下牙條及腿足均用樹根拼鑲而成，之間無卯榫連接，腿上部為一獨柱，下部分開為三足，形態各異。

凡以天然樹根或樹枝製作的家具，即為天然木家具，因保持其天然形態而得名。

242

天然木圓桌

清

高84厘米　面徑126厘米

清宮舊藏

Round table constructed from naturally shaped wood

Qing Dynasty

Height: 84cm　Diameter: 126cm

Qing Court collection

桌面攢框鑲板，框外用天然樹根攢接包鑲，面下桌牙與五條彎曲的桌腿銜接自然，沒有拼縫的痕跡，工藝水平頗高。

此桌與天然木椅配套使用，造型古樸典雅。

243

天然木平頭案
清乾隆
高90.5厘米　長252厘米　寬69.5厘米
清宮舊藏

**Long, narrow table with straight ends,
constructed from naturally shaped wood**
Qianlong Period, Qing Dynasty
Height: 90.5cm　Length: 252cm
Width: 69.5cm
Qing Court collection

案面為柴木做，面下牙條及腿足為一
體，均用樹根拼鑲而成，之間無卯榫
連接，兩側腿間有樹根拼鑲的檔板，
足下連柴木做托泥。

244

天然木羅漢牀
清
高114厘米　長217厘米　寬135.5厘米
清宮舊藏

Arhat[5] bed constructed from naturally shaped wood
Qing Dynasty
Height: 114cm　Length: 217cm
Width: 135.5cm
Qing Court collection

牀圍由三段天然木根拼接，牀面打槽
裝板，上立天然木小炕几。面側沿的
牙子及牀的腿、足部亦皆由天然木拼
鑲而成。牀前有天然木腳踏。

此牀整體造型依形度勢，隨體曲折，
天然成趣。

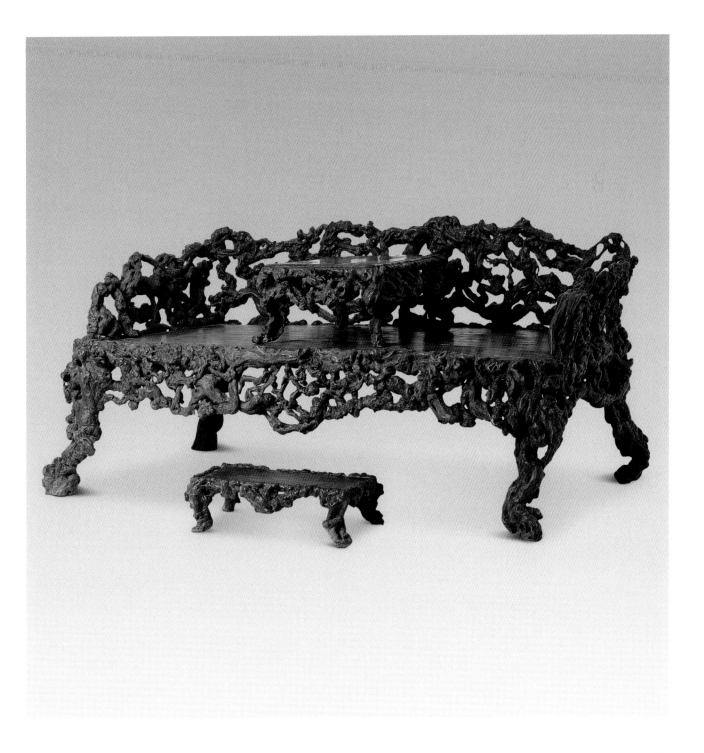

245

天然木椅
清
高97厘米　長80厘米　寬57厘米
清宮舊藏

**Chair constructed from naturally shaped
wood**
Qing Dynasty
Height: 97cm　Length: 80cm
Width: 57cm
Qing Court collection

椅靠背及兩側扶手利用天然木根拼接
攢成，座面以木根做成圍框，上鋪木
板，面下的牙子及腿、足均以木根拼
鑲而成。

此椅可成對與天然木桌一起擺設，造
型奇特，古樸高雅。

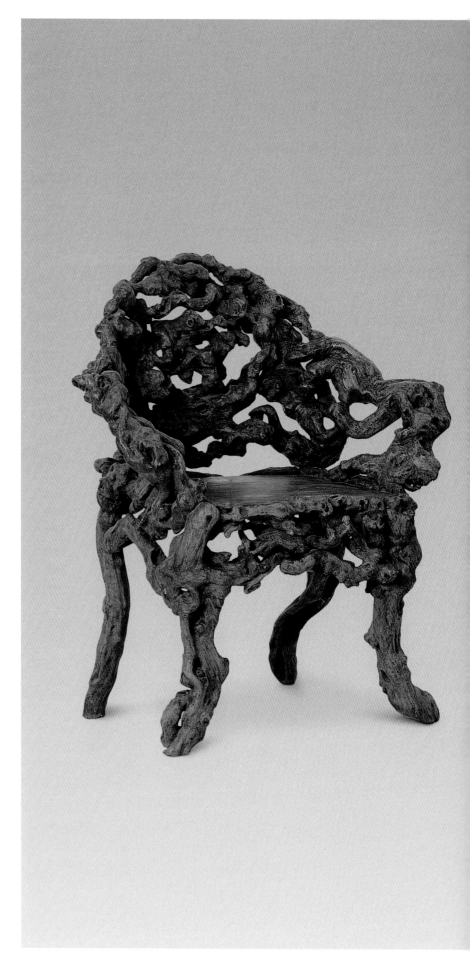

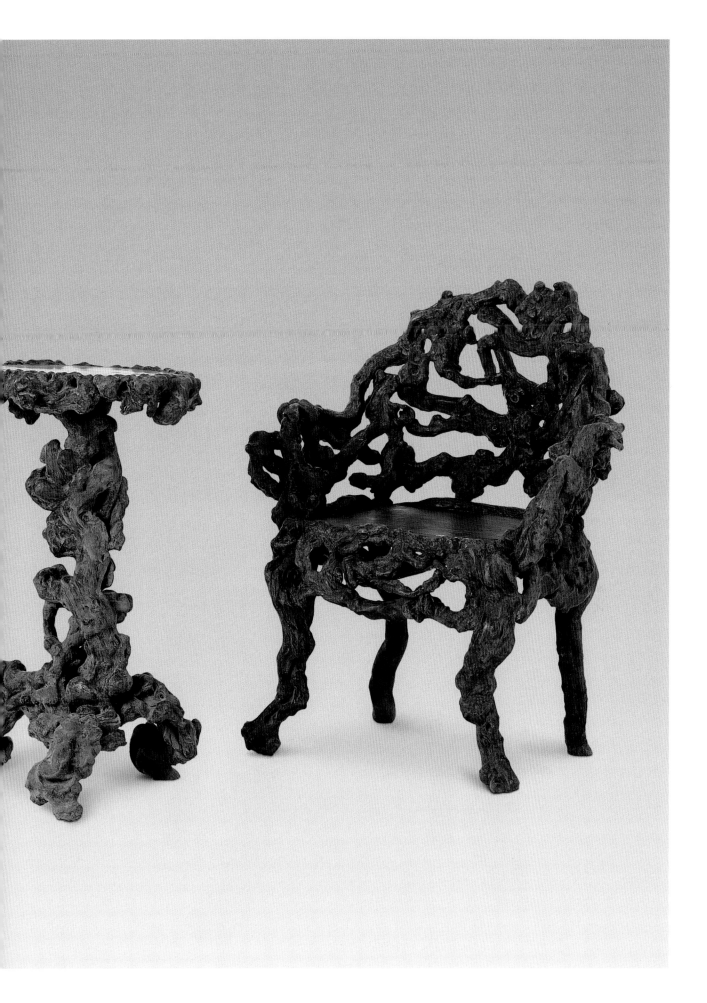

246

天然木椅
清
高95.5厘米　長81厘米　寬58厘米
清宮舊藏

**Chair constructed from naturally shaped
wood**
Qing Dynasty
Height: 95.5cm　Length: 81cm
Width: 58cm
Qing Court collection

椅靠背及扶手由枝幹蒼虬的木根拼鑲
而成，座面面心嵌裝光素木板，四周
則包鑲木根，面下的牙子及腿、足皆
由木根拼接而成。

此椅造型依形度勢，與木根自然形態
結合為一體。

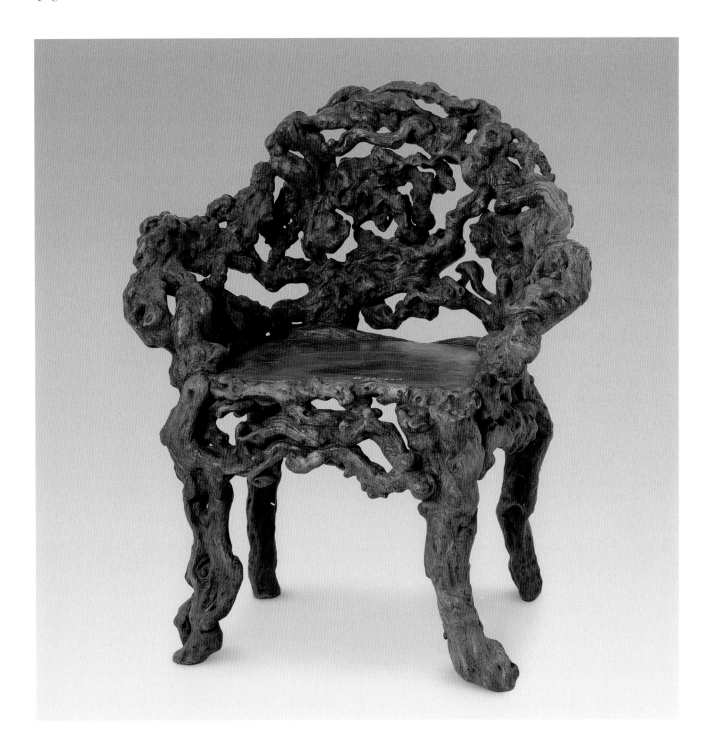

家具實景陳設

Palace
Furniture
Displays

太和殿內陳設

Furnishings in the "Hall of Supreme Harmony" (Tai He Dian)

太和殿位於紫禁城中央，是皇權的象徵。清代皇帝登基、祝壽、大婚等重大典禮活動都在這裏舉行。殿內陳設都有嚴格規定，清代專門制定了《欽定宮中現行則例》，以規範紫禁城內十二宮正殿內的陳設。殿正中為須彌式高台，陳設金漆龍紋寶座和屏風，兩旁有香几、仙鶴燭台、香筒。台前置高香几四個，上為銅胎掐絲琺瑯香爐。殿兩側有高大的紫檀雕雲龍紋頂箱立櫃。

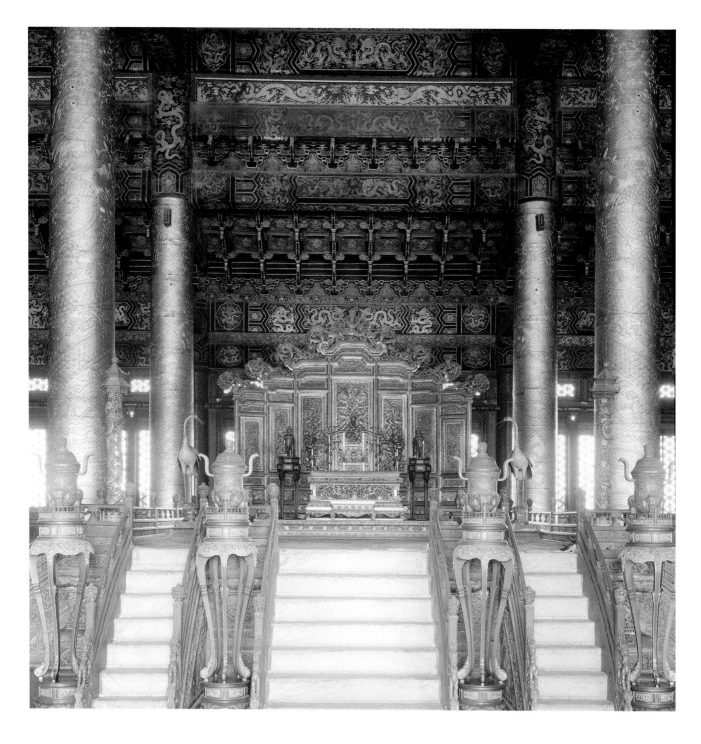

248

乾清宮內陳設

Furnishings in the "Palace of Heavenly
Purity" (Qian Qing Gong)

乾清宮位於故宮內廷，是明代和清初
皇帝居住、處理政務的地方。其陳設
為清康乾時期的原貌。殿內正中的三
級高台上設金漆龍紋寶座，座前有書
案，後為金漆龍紋屏風。兩側陳設用
端、香筒、仙鶴燭台等。台前香几上
承琺瑯質香爐，台兩側各有廡爐。整
體顯得金碧輝煌，莊嚴肅穆。

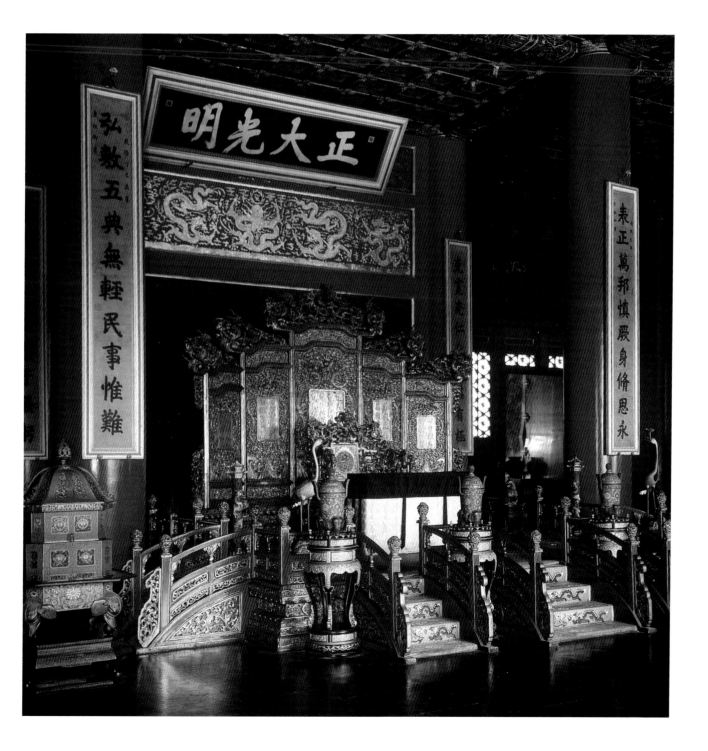

249

養心殿後寢殿內的紫檀雲龍紋櫃

Red sandalwood cabinet, decorated with dragon and cloud patterns, located in the bedroom behind the "Hall of Mental Cultivation" (Yang Xin Dian)

養心殿位於故宮內廷，是清代雍正至宣統八個皇帝居住、理政的地方。養心殿後寢殿（西次間）北牆陳設一對紫檀雲龍紋櫃，其間為一紫檀小櫃，三櫃合為一體，兩高櫃之間的空當上部作一垂花罩門，既美觀又莊重，且恰與牆的尺寸吻合，是專門為這裏設計定做的。

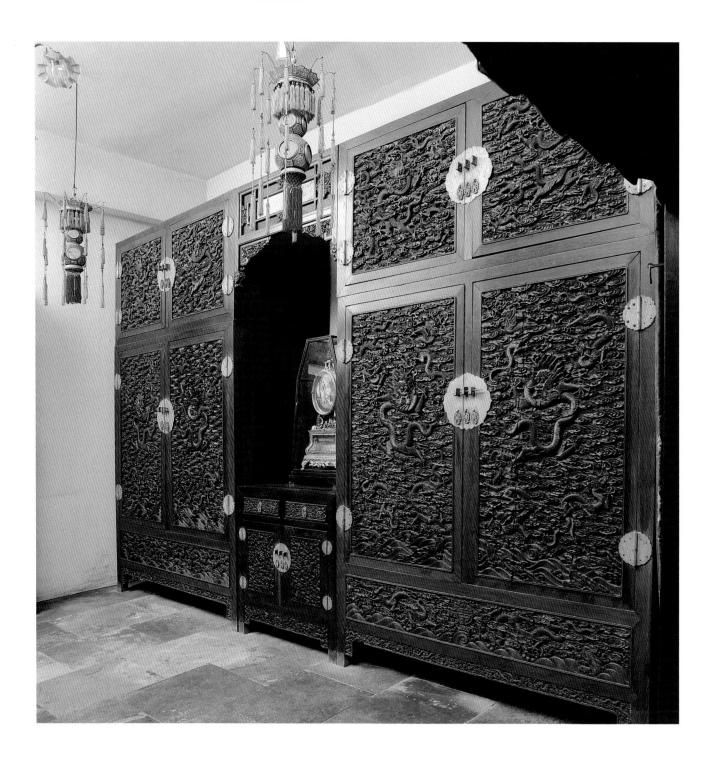

250

養心殿西過道門內的穿衣鏡

Full length mirrors located in the west passageway in the "Hall of Mental Cultivation" (Yang Xin Dian)

在養心殿正間西過道門內，由於地方狹小，立一紫檀木半出腿穿衣鏡，鏡子的背面靠牆，不但節省了空間，而且可以為大臣覲見皇帝時整肅儀容之用，是當時專門為這裏製造的具有清代宮廷特色的家具。

251

儲秀宮西間北窗陳設

Furnishings by the north window of the
west room in the "Palace of Gathering
Excellence" (Chu Xiu Gong)

儲秀宮為故宮內廷西六宮之一，是清
代嬪妃們居住的地方，晚清時，慈禧
太后曾在這裏居住。炕上陳設有紫檀
百寶嵌炕櫃、炕桌、炕几等家具，炕
前有腳踏。西牆上有大幅的掛屏。光
緒十年（1884 ），慈禧五十歲生日
時，曾對室內重新裝修。紫檀百寶嵌
炕櫃就是為其祝壽特製並陳設的。

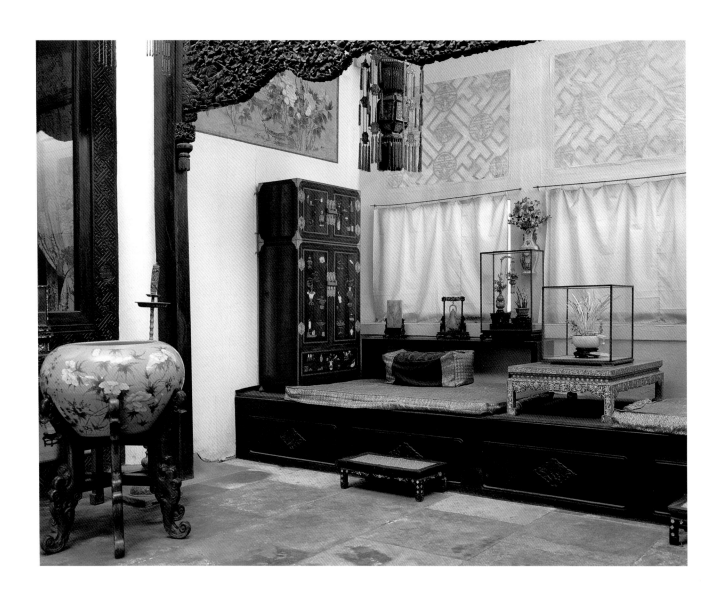

252

儲秀宮東梢間陳設

Furnishings in the room at the east end
of the "Palace of Gathering Excellence"
(Chu Xiu Gong)

儲秀宮按照清末慈禧太后生前情景原
狀陳設。東梢間東牆上掛壁掛，靠牆
設黑漆嵌螺鈿翹頭案，案上陳設鐘錶
和一對象牙寶塔。案前為炭爐，左側
有紫檀嵌琺瑯坐墩和八角落地罩，罩
內有桌案等陳設。

253

儲秀宮內黃花梨嵌玉盆架

Huanghuali[6] wooden washstand, decorated with inlaid jade, in the "Palace of Gathering Excellence" (Chu Xiu Gong)

儲秀宮東梢間為慈禧太后臥室，各種家具一應俱全。牆角處放置的黃花梨嵌螺鈿盆架，就是慈禧當年使用過的，盆架全身嵌螺鈿，中間架牌嵌《進寶圖》，寓意吉祥，應是為慈禧太后祝壽所用。

254

長春宮東次間陳設

Furnishings in the second east room of the Palace of "Eternal Spring" (Chang Chun Gong)

長春宮位於故宮內廷，為西六宮之一，是清代后妃的居所，乾隆皇帝的皇后和慈禧太后都曾在這裏居住。東次間為后妃日常生活和休息的地方，室內陳設有紫檀頂豎櫃、紫檀點翠花鳥插屏、紫檀雕花條案、香几等家具，充滿生活氣息。

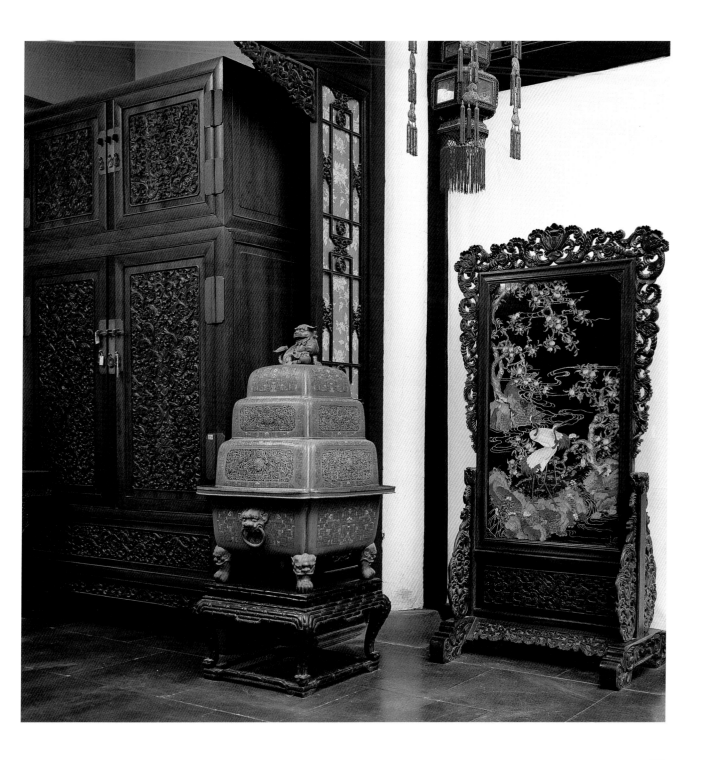

255

長春宮西次間挑桿燈

Lamp in the second west room of the "Palace of Eternal Spring" (Chang Chun Gong)

長春宮西次間的炕前陳設有紫檀挑桿燈，燈為紫檀邊框，有帶寶蓋的玻璃燈屏，寶蓋四角垂掛燈穗，此燈既可用於照明，又有裝飾居室的作用。在炕上陳設有炕几，室內還有腳踏和半圓桌等家具。

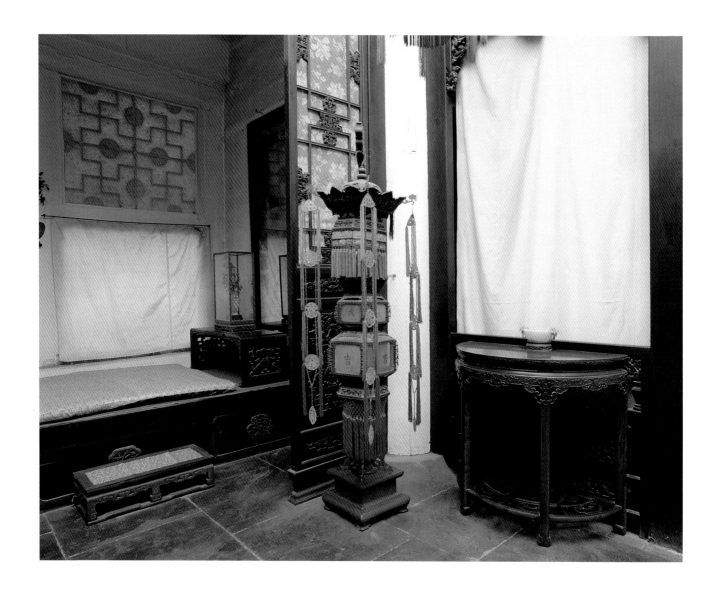

256

太極殿西次間南窗炕上家具陳設

Furnishings on the kang[14] by the south
window of the second west room in the
"Hall of Great Supremacy" (Tai Ji Dian)

太極殿位於故宮內廷，為西六宮之
一，是清代後期嬪妃們居住的地方。
在其西次間靠南窗的炕上陳設着炕
桌、炕案，炕下有腳踏，兩側有繡
墩。其整體家具佈局帶有濃厚的滿族
風俗習慣。

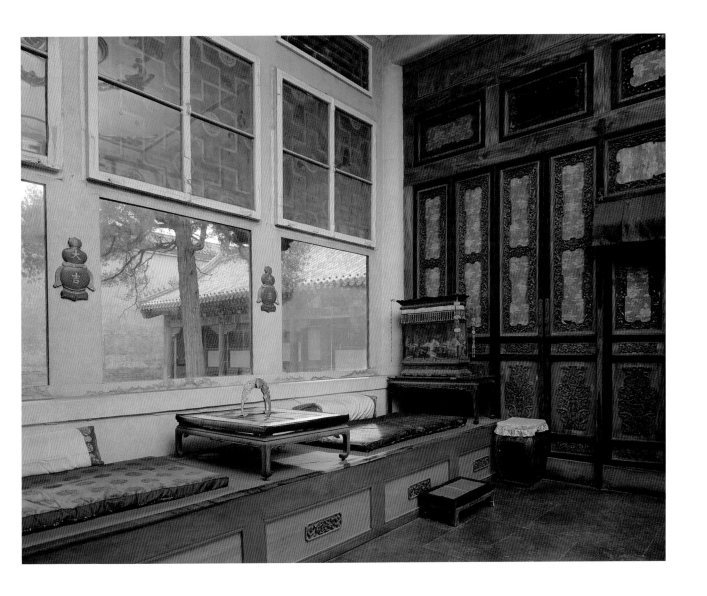

257

崇敬殿正間內陳設

Furnishings in the main room of the "Hall of Great Reverence" (Chong Jing Dian)

崇敬殿位於故宮內廷，是重華宮的前殿，原為乾隆作皇子時的居所，乾隆五年（1740）擴建。殿內正上方為乾隆作寶親王時書寫的"樂善堂"匾額。

殿正中台上設寶座，座後為三扇屏風，兩側為宮扇、香几、香筒等，香几上承太平有象和甪端各一對。此陳設為乾隆登基後御臨重華宮所用。

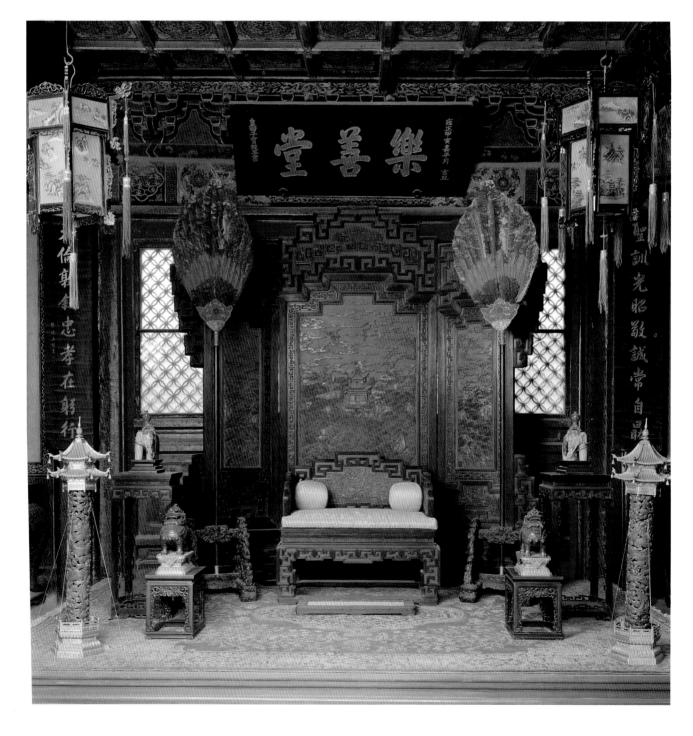

258

重華宮東梢間炕屏

Kang[14] screen in the room at the east
end of the "Palace of Double Brilliance"
(Chong Hua Gong)

重華宮位於故宮內廷，原為西二所，由於乾隆作皇子時在這裏居住並完婚，故在乾隆年間改名為宮。其東梢間為乾隆御臨重華宮的休息之所，室內東面為一通炕，上靠牆置十二扇炕屏，屏心雕十二月花卉圖。屏前為炕几，兩側為炕案，案上陳設帽架和文玩。炕前放置香爐。

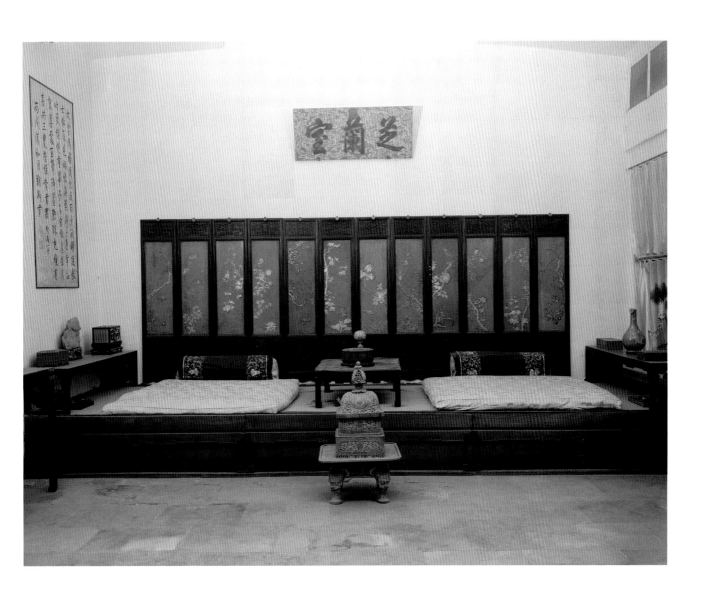

259

重華宮東梢間陳設一角

Part of the furnishings in the room at the east end of the "Palace of Double Brilliance" (Chong Hua Gong)

重華宮東梢間為原狀陳設。炕的外側靠牆置一紫檀長桌，桌上為茶具及文玩，牆上掛玳瑁框象牙地的《鶴鹿同春圖》掛屏，寓意吉祥。炕上置有炕几，上方有乾隆御書的字幅點綴。

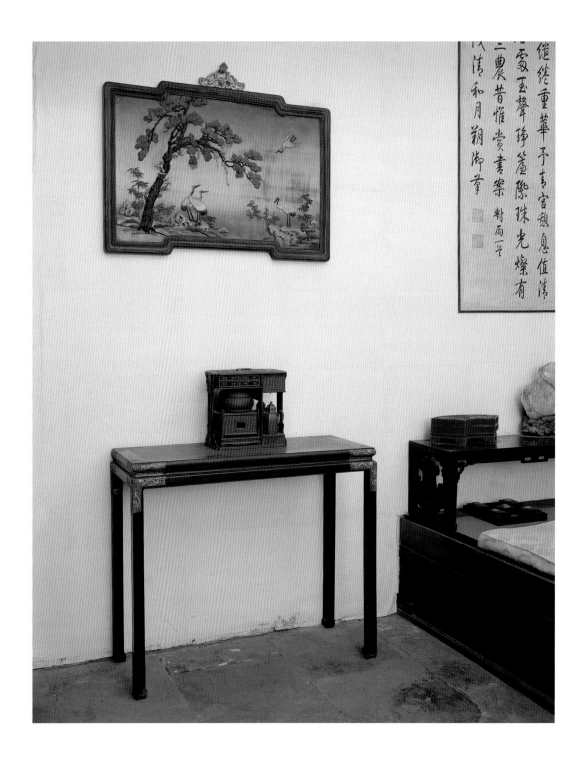

260

重華宮西次間家具陳設

Furnishings in the room at the west end
of the "Palace of Double Brilliance"
(Chong Hua Gong)

重華宮西次間為乾隆皇帝賜羣臣茶
宴、賦詩聯句、休息觀戲的地方，其
北牆靠牆陳設紫檀雕花頂豎櫃，西牆
陳設紫檀雕花平頭案，案上置紫檀透
雕樓閣嵌玉人插屏。屏上方的牆上有
乾隆御筆的貼落。

261

翠雲館內陳設一角

Part of the furnishings in the "Hall of Green Cloud" (Cui Yun Guan)

翠雲館為重華宮後殿，乾隆皇帝作皇子時在這裏讀書並大婚，婚後其大福晉在這裏居住。在祥雲門側黑漆描金插屏及門內靠牆的紫檀長桌等家具陳設，均為乾隆時期的原狀。

262

翠雲館內的隔扇及掛屏

Hanging panel and screen partitioning in the "Hall of Green Cloud" (Cui Yun Guan)

翠雲館的間隔用四扇金漆山水圖隔扇
組合而成，隔扇上部為勾雲紋窗櫺，
做工精細，隔扇一側牆上掛有紫檀百
寶嵌博古圖掛屏，另一側對稱掛有紫
檀框漆地百寶嵌花鳥圖掛屏。

263

翠雲館西梢間陳設

Furnishings in the room at the west end of the "Hall of Green Cloud" (Cui Yun Guan)

翠雲館西梢間北牆裝飾為上下兩層，上層為閣樓式，下層為炕。閣樓上有八扇花鳥圖屏風，炕上陳設炕桌和炕案，兩側是紫檀框雙面繡的隔扇。炕下一側陳設紫檀雕花大案，另一側為書格式簾子隔塵。整體佈局設計精巧得當。

Notes 註 釋

1 Kui 夔

When used alone this term translates 拐子紋 (guai zi wen) literally "a cripple or lame person" pattern, an I-shaped reel pattern. Sometimes also used together with "dragon", 夔龍紋, (kui-dragon pattern). The kui-dragon has a turned-up snout, and is usually shown in profile with only one leg visible. It is found in the decoration of Chinese bronzes from the Shang dynasty, and became a popular motif on various types of archaistic wares. Also used together with "phoenix", 夔鳳紋, (kui-phoenix pattern).

2 Nanmu 楠木

Nanmu (cedar) is a silvery-brown softwood considered one of the best materials for furniture manufacture, because it does not warp or split, and can be sanded and polished to create a smooth, hard surface. The knot patterns in Nanmu are often used for decorating cabinet doors and table panels. More than thirty varieties of Nanmu are found in southern China and Vietnam.

3 Arhat 羅漢

Luo han. The name given by Buddhism to disciples or monks who have freed themselves from all desire and anger.

4 Bats 蝠

Bats are often used to symbolize "blessing" (福 fu), because the Chinese word for "bat"(蝠 fu) sounds like the word for "blessing".

5 Hai Wu Tian Chou 海屋添籌

Hai Wu Tian Chou. An expression wishing an aged person a longer span of life.

6 Huanghuali 黃花梨

Huanghuali. Literally "yellow flowering pear", huanghuali wood (Dalbergia Odorfera) is a warm-colored, strong hardwood with an attractive grain, related to the rosewood family. Grown mostly on Hainan Island, it was used mostly for specially commissioned classical Chinese furniture because of its high cost.

7 Wan Fu 萬福紋

Wan Fu (ten thousand blessings) pattern, represented by a swastika and bat (see Footnote 4 above).

8 Fu Qing 福慶紋

Fu Qing (blessing celebration) pattern, represented by a bat (see Footnote 4 above) holding a stone in its mouth.

9 Jichimu 雞翅木

Jichimu (chicken wing wood) An indigenous Hainan Island hardwood, with a jagged, feather-like patterned grain, ranging in color from brown to gray.

10 Fencai 粉彩

Fencai (powder colors), known in the West as famille rose, is a type of enamel which was developed for use on porcelain in the first quarter of the 18th century. Most of these enamels are opaque or semi-opaque and do not flow when fired. Typical colors are rose, opaque yellow and opaque white.

11 Ruyi 如意紋

The ruyi pattern, resembling a leaf or stylized cloud, appears as a motif in many forms of Chinese decorative art. The characters ru-yi carry the meaning, "May everything go as you wish it to."

12 Lingzhi 靈芝

Lingzhi, a fungus (polyporous lucidus) associated with Daoism, which symbolizes immortality in Chinese art. Sometimes translated as "magical fungus". Used in Chinese medicine.

13 Lappet 垂飾

Lobe or flap-like projection, fold, overlapping piece (of garment, flesh, membrane, etc)

14 Kang 炕

Kang, the raised part of a room used as a bed, made of bricks and able to be heated.